Engaging Diverse Communities

ENGAGING DIVERSE COMMUNITIES

A Guide to Museum Public Relations

MELISSA A. JOHNSON

UNIVERSITY OF MASSACHUSETTS PRESS

Amherst and Boston

Copyright © 2020 by University of Massachusetts Press
All rights reserved
Printed in the United States of America

ISBN 978-1-62534-542-4 (paper); 541-7 (hardcover)

Designed by Deste Roosa
Set in Futura and New Caledonia
Printed and bound by Books International, Inc.

Cover design by Frank Gutbrod
Cover photo: NCMA's *Threads of Africa celebration*,
Courtesy of the North Carolina Museum of Art.

Library of Congress Cataloging-in-Publication Data

Names: Johnson, Melissa A., 1954– author.
Title: Engaging diverse communities : a guide to museum public relations /
Melissa A. Johnson.
Other titles: Guide to museum public relations
Description: Amherst : University of Massachusetts Press, [2020] | Includes
bibliographical references and index. |
Identifiers: LCCN 2020019275 | ISBN 9781625345424 (paper) | ISBN
9781625345417 (hardcover) | ISBN 9781613767870 (ebook) | ISBN
9781613767887 (ebook)
Subjects: LCSH: Museums—Public relations—United States. | Communication
in museums—United States. | Museums and minorities—United States. |
Museums and community—United States.
Classification: LCC AM124 J64 2020 | DDC 659.2/9069—dc23
LC record available at https://lccn.loc.gov/2020019275

British Library Cataloguing-in-Publication Data
A catalog record for this book is available from the British Library.

This book is dedicated to my mother, Elaine

CONTENTS

CONTENTS

ACKNOWLEDGMENTS

MY SINCERE THANKS ARE extended to all the museum professionals who provided materials, answered questions, or participated in interviews, including Karin Abercrombie, Kasia Balutowski, Corey Cavagnolo, Beatrice Chen, George O. Davis, Ellen Endo, Sharif Fink, Bianca Friundi, Marianna Gatto, Susan Golden, Francesca Guerrini, Kat Harding, Elizabeth Ingrassia, Shannon Jowett, Maria Klimchak, Rena Lee, Jenny Leung, Andreina Maldonado, Alexa Ortega-Mendoza, Elaine Merguerian, Solimar Salas, Suzy Salazar, Victoria Sanchez de Alba, the late Kenneth Smikle, Annie Tsang, Sarah Tung, and Leslie Unger. With their leadership it is no surprise that museums in the United States are such a vibrant sector.

I am also grateful for the project funding provided by competitive grants from the Association of Educators in Journalism and Mass Communication and North Carolina State's College of Humanities and Social Sciences. Funding and support from the head of North Carolina State's Department of Communication Kenneth S. Zagacki were instrumental in completing the research.

Much appreciation goes to Department of Communication graduate student Dustin Harris and undergraduate student Elena Price for their rigorous website and social media data collection. Special mention goes to the doctoral students in North Carolina State University's Communication, Rhetoric, and Digital Media program for their co-authored work with me that informed this book: Katreena Alder, Larissa Carneiro, Candice L. Edrington, Kelly Norris Martin, Keon M. Pettiway, and William Sink. In addition, the continued technical assistance of the Department of Communication's Robert Bell has been especially helpful.

Recognition is also extended to the experts at the University of Massachusetts Press who guided or promoted this project. They include Courtney

Andree, Matt Becker, Rachael DeShano, Sally Nichols, and Eric Schramm. Indexer Joan D. Shapiro was another contributor.

The elements of this book were inspired decades ago. Much gratitude goes to David M. Dozier and the late Glen M. Broom for introducing me to public relations scholarship and for their ethical, ground-breaking work in the field. I am also indebted to former Worcester Art Museum Director Richard Stuart Teitz and Public Relations Director Elizabeth Densmore for two summer undergraduate internships in public relations, which opened the window on museum communication professionalism.

Most of all, I thank my sons, Ryan and Rhett, the joys of my life.

Engaging Diverse Communities

PART ONE

IDENTITY AND MUSEUM
PUBLIC RELATIONS

CHAPTER 1

Communicating Cultural Identity

The Role of Museum Public Relations

A REVIEW OF THE last few decades of museum public relations research would reveal little about how practitioners should communicate about race and ethnicity or reach diverse publics. In fact, stand-alone books about museum public relations on any topic are rare, even though there are 35,000 museums in the United States, all with public relations challenges (Institute of Museum and Library Services 2014). However, given the changes in US and global societies, along with the shifts in emphasis among museums, more needs to be understood about public relations and cultural identity in museum settings.

This dilemma in public relations research parallels a trend in museum studies—a call for more attention to race and ethnicity. Thus, this chapter provides an overview of the museum public relations and marketing knowledge to date, along with a brief synthesis of race- and ethnicity-related research in the museum studies field. It then outlines relevant public relations and identity research. While recognizing the vital roles that public relations practitioners play in helping museums meet their organizational goals, the chapter concludes with a call for society-focused museum public relations, along with models of museum communicators' roles and museum public relations programming. Finally, an overview of the book is delineated.

Museum Public Relations:
A Dearth of Published Knowledge

Public relations is defined as the function in an organization that initiates and maintains mutually beneficial relationships between an organization and its publics (e.g., Broom 2009). Although communication is central, the focus is on the relationship outcomes sought by the organization or publics. However, the study of public relations is not only concerned with such organizational relationships, but "the intended and unintended consequences of those relationships for individuals and society as a whole" (Dozier & Lauzen 2000, 4).

Despite the importance of the museum sector, both at the organizational level and because of the institutions' impacts on society, only one book about US museum public relations is available. Authored by G. Donald Adams, it was published in 1983 by the American Association for State and Local History. Adams responded to industry needs at the time by addressing communication areas that a survey of public relations members in the American Alliance of Museums had deemed were typical tasks. Given that Adams produced his book before the Internet and mobile media, the focus was on public relations research, planning, budgeting, descriptions of publics, media relations, and publications. To his credit, Adams mentioned organizational issues management, although topics related to race relations were not included.

On the other hand, most of the journal articles about museum public relations in the past decade concerned digital or social media. The majority demonstrated low usage of the interactive capabilities of each medium. These studies will be discussed in the chapters about websites, social media, and digital newsrooms.

In addition, survey research of managers responsible for communication (not all public relations practitioners) at 111 Catalan museums concluded that the museums relied on transactional communication, rather than strategic communication that involved long-term planning and evaluation (Capriotti 2013). Public relations program research was limited and tended to be visitor-centric rather than community-oriented. Moving beyond programming to outcomes, a survey of US art museum members found that

those who ranked high on organization-public relationship (OPR) variables perceived their relationships with the museums as long-term (Banning & Shoen 2007). The authors noted such data could also be employed to identify respondents at risk of lapsed memberships, linking relationship outcomes with suggestions about public relations tactics. Again, however, the focus was on museum goals rather than expanded to objectives that would improve society.

In short, the thrust of the aforementioned studies concerned museums' under-utilization of twenty-first-century communication tactics, along with a lack of strategic orientation or broad views of the community. According to these investigators, museums continued to rely on one-way communication with traditional approaches, thus falling short of public relations' promise of using communication to benefit museums along with their communities. Race and ethnicity were not broached in this set of research studies.

Museum Marketing: Tips and Tricks Outdo Research Foundations

As just described, little attention has been paid to museum public relations in books or communication journals. Given the dearth of museum public relations research, students and professionals are forced to turn to marketing resources. In fact, most overviews of museum public relations in books have been subsumed under marketing (French & Runyard 2011; Kotler & Kotler 1998; McLean 1997). Such texts have concentrated on the tasks that practitioners must accomplish to achieve museum goals such as building attendance. As a rule, the marketing texts are organization-oriented and not preoccupied with societal benefits.

"How-to" guides include overviews and tips on branding (Wallace 2006), conducting consumer research (Wallace 2010), and event management (Freedman & Feldman 2007). Newer marketing texts mention websites (e.g., Rentschler & Hede 2007; Wallace 2006) but not social media or configuring digital communication for mobile devices. Marketing researchers have delved into a variety of other topics, including marketing to special segments, branding, or atmospherics (French & Runyard 2011; Kottasz 2006; Lehman 2009; Mokhtar & Kasim 2011; Neilson 2003; Pusa & Uusitalo

2014). Most of these are practitioner-oriented, rather than research-based, and race or ethnicity are hardly mentioned.

For example, French and Runyard's marketing and public relations book, which is UK-centered, reviewed definitions and skills for public relations practitioners without citing research (2011). Deborah Pitel's (2016) marketing text is another how-to guide, but it is directed toward US institutions, with a special focus on small museums that have limited budgets and staff. It contains useful tips about various technologies, specific instructions for setting up and promoting museum Facebook pages, and similar practical advice. Additionally, in a book centered on Twitter, a UK collection of essays by museum directors, curators, and marketing directors provided UK industry statistics, instructions, content suggestions, and brief first-person accounts about Twitter use by international museums (Landon, Wallis, & Davies 2010). These are functional handbooks.

Museums and Digital Media

A more scholarly text on museums and social media (Drotner & Schrøder 2013) examined a variety of digital communication forms, from blogs to social networking platforms. Although it mentioned their application in museum communication, most of the chapters revealed uses of digital media in curatorial practices rather than in public relations. However, in one chapter emphasizing technologies and audiences, Kelly (2013) demonstrated that Australian museum visitors used online media and social media more frequently than non-museum goers. In terms of "the participatory museum," the researcher said that new technologies allowed museums to join with citizens to tackle problems on which museums can take a position, such as social justice. Although she urged museum experts to develop more knowledge about digital platforms, she did not specifically mention museum public relations professionals.

Norris and Grams (2008) investigated the use of technologies for building relationships over distances. Their analysis of arts organization websites and blogs found that most were not maximizing the technological platforms, similar to studies described in Chapter 6. However, the authors discovered successful use of MP3 players and cell phones, especially as museum exhibit

guides. Although email marketing campaigns and websites were mentioned, much of the rest of the technological discussion in this text was about non-public relations areas in museum management.

Likewise, Connolly and Bollwerk (2016) devoted most of their content to directors, museum educators, and curators. For example, one chapter discussed digital preservation of artifacts, digital museum displays, and training (Billeaudeaux & J. Schnabel 2016). Nevertheless, there were over-views about social media, platforms such as Google maps, and making pro-grams or lectures available online that could be helpful to public relations practitioners.

To conclude, the extant museum public relations and marketing literature is incomplete in its range and largely shuns research-based foundations in its counsel to public relations professionals. Although the marketing guides offer instructive advice for reaching organizational goals, they eschew public relations' broader mission to contribute to societal goals. In addition, race, ethnicity, and cultural identity are seldom noted. Further, museum studies texts focused on digital communication are largely directed at directors, curators, and museum educators—not public relations experts. Although they are not integrated with public relations, the next section reviews some examples from the museum studies literature that attend to contemporary concerns about race and ethnicity.

Identity and the Twenty-First-Century Museum

Once institutions to serve elites, museums in the United States and beyond have changed in the past few decades from organizations that served White upper-class visitors to museums that wish to attract a wide group of audiences (American Alliance of Museums 2002; French & Runyard 2011; Hooper-Greenhill 1997; Smithsonian Institution 1994). Museum scholars have denoted the need to cross class and ethnic boundaries to reach different groups, regardless of the institutions' founding missions.

Hooper-Greenhill's (1997) edited work on developing more diverse museum visitors in Britain presented some of the ideas that have been used to build museum relationships with a range of publics. This included not only ethnic groups, but women and White working-class residents. She

noted that traditionally British museums chose staff based on collection expertise that tended toward "Modernist canons," but it is now important to also employ museum staff able to offer more diverse interpretations of collections and who understand particular audiences (8–9).

However, a 2019 Andrew W. Mellon Foundation study that examined demographics among 30,000 employees in 332 art museums found that 76 percent of museum employees were White. Although significant progress had been made since the last survey in 2015, just 20 percent of museum leadership, curatorial, conservation, and education positions were held by professionals of color (Westermann, Schonfeld, & Sweeney 2019). Thus, museums need multiple resources beyond merely employees as a bridge to various constituencies.

Nevertheless, Sandell (2007) noted that museums can be sites for cross-cultural dialogue and "institutional agents in the combating of prejudice" (136), although they are not the only societal institutions that can affect attitudes. Further, Sandell said, "There are opportunities to develop exhibitions with an acknowledgement of their potential to serve as resources which expand visitors' capacities for mutual understanding, which challenge, complicate, and begin to unravel prevalent negative stereotypes, and which offer ways of understanding difference which reflect adherence to principles of social justice and equity" (195). These ideas summarize the larger missions of museums in their communities, even though they do not envelop the public relations discipline.

Instead of confronting prejudice directly, Grams and Farrell (2008) focused on how the arts can contribute to their communities and encourage participation from a broader range of participants. They asserted that one impetus for museums' interest in change was shifting US demographics, not just in urban areas but even in small rural communities. For example, one chapter discussed examples of how arts organizations such as museums diversified their employee bases, generated programs of interest to appeal to diverse visitors, and developed innovative communication techniques to reach a variety of publics (2008).

For institutions with broad missions such as those just described, the definition of the International Council of Museums (2018) is employed in this book: "A museum is a non-profit, permanent institution in the service

of society and its development, open to the public, which acquires, conserves, researches, communicates and exhibits the tangible and intangible heritage of humanity and its environment for the purposes of education, study and enjoyment." Chapter 2 will address culture-specific museums, whose definitions differ slightly.

To conclude, some museum studies scholars have delved into race and ethnicity, but most have been concerned with curation and education rather than public relations. Admirably, the aforementioned researchers have positioned museums as societal institutions with the wherewithal and responsibility to tackle cultural identity and intercultural relations. Correspondingly, ethnicity and race has been considered by some public relations scholars in the last few decades, albeit rarely in museum contexts. The next section discusses these findings.

Identity and Public Relations

Communication researchers have used the terms race, ethnicity, and culture to explore identities and public relations. Ethnicity is defined as identity with a heritage or culture (e.g., Liu, Volčič, & Gallois 2011). Culture is transmitted via informal and formal channels over time, and encompasses beliefs, worldviews, rituals, and practices (Waymer 2012). Cultural identity is "the enactment and negotiation of social identifications by group members in particular settings" (Chen & Collier 2012, 45), a definition that recognizes the relational nature of identity, along with its social constructions. As Oetzel (2009) asserted, identity is both enduring and yet ever-changing. Scholars noted that distinctions among race, ethnicity, and culture are not always clear, and often the terms are used as equivalent (Waymer 2012; Liu, Volčič, & Gallois 2011). This book rejects definitions of race that rely on genetically inherited physical traits, for reasons described in other chapters. Thus, in this text, the terms will be used interchangeably.

Researchers who have investigated the intersection of identity and public relations have tended to be international or domestic in their approaches. Few combine these contexts, although Zaharna (2000; 2001) and Valentini (2007) have explored forms of integrating culture with global considerations. Whether within the domestic or international public relations domains, the

primary emphases of race and ethnicity research in public relations have included practitioner-oriented studies, audience-focused research, and research about strategies and tactics.

The best-studied area concerns practitioners. Looking inward at the field, US-based research about race and ethnicity has concluded that ethnic and racial variation among practitioners is unequal to population variables, and discrimination is manifest in many iterations (Brown, White, & Waymer 2011; Diggs-Brown & Zaharna 1995; Kern-Foxworth 1989; Len-Ríos 1998; Logan 2011; Pompper 2004, 2007; Qiu & Muturi 2016; Tindall 2009). If one adheres to the concept of requisite variety, which posits that there must be as much variation inside the organization as there is in the society in which it functions (Grunig, Grunig, & Ehling 1992), then this is problematic. It is a concern not only for individual practitioners but for the organizations they serve, because the public relations departments are not maximizing the potential of public relations programming. It also devalues the discipline and its contribution to society (Hon & Brunner 2000). Beyond the United States, the racial or cultural identities of public relations practitioners in non-US locations also have received some attention. For instance, research has observed that practitioners in Britain have been subject to institutional racism (Edwards 2013, 2015), and despite lip-service to diversity, Australian practitioners remain White Anglo-Saxons (Wolf 2016). In addition, rather than examine practitioner demographics and discipline constraints, Daymon and Hodges (2009) explored the cultural variables that affect analyzing public relations occupations in Mexico. Cultural concepts included collectivism and *palanca*, the power generated from a network of personal relationships. They also noted that their study participants believed that their public relations efforts contributed to Mexico's democratic transitions, a relevant finding for this text's discussion of museum public relations' role in society.

A second focus in the cultural literature has been on publics—the groups with whom the organization establishes relationships. Examples of studies in this vein include Fatima Oliveira's discussion about crisis communication and multicultural publics (2013), Gibson's descriptions of tactics for Hispanic publics (2002), and Vardeman-Winter's analysis of health campaigns (2011). When one sees public relations or marketing references to the Hispanic market or African American market, it commonly refers to considerations

not only of culture, but of specific groups' purchasing power (Veresiu & Giesler 2018). As Waymer noted, communication motivations related to race often are not about a group's welfare (2012). More often, it is the group's current or prospective contribution to the organization's bottom line that is the focus. Thus, this dimension of stakeholder identity and public relations requires further study.

A third set of investigations are inquiries about identity and public relations tactics, such as websites (Carneiro & Johnson 2015; Johnson & Pettiway 2017; Würtz 2006), brochures (Springston & Champion 2004), or color palettes for various tools (Madden, Hewett, & Roth 2000; Moriarty & Rohe 1991). According to the logic of some of these studies, public relations practitioners need to understand cultural differences or similarities—such as the variables proposed in Hofstede (2001) or Hall (1976)—to improve public relations programming (Zaharna 2000; 2001). Although the essay does not mention publics or tactics specifically, in this vein Servaes (2016) delineated how the Chinese cultural norms of *guanxi* (interrelationships) and *mianzi* (face) act to improve harmony in society, and the importance of understanding such values in public relations. This knowledge is useful for strategic planning as well as for understanding occupational cultures, although it is not overtly discussed in the article.

A fourth group of studies have dealt with public relations' contribution to civil rights. These are discussed in the next section on societal contributions of public relations. Otherwise, in conclusion, public relations research delving into race or ethnicity has been limited, with most of the focus on the lack of practitioner diversity.

Public Relations' Contributions to Society

As Hodges (2006) observed, "A 'profession' traditionally claims to serve society" (82). In fact, the Code of Athens and other public relations codes emphasize that the practice should be in the public interest, gesturing toward the societal role of public relations. But as researchers have noted, public relations theories have rarely investigated questions about society (Benecke et al. 2017; Dozier & Lauzen 2000; Edwards 2015; L'Etang 2012; Valentini, Kruckeberg, & Starck 2012; Waymer 2012). Dozier and Lauzen

launched this argument with their landmark study—reminding scholars that if public relations research truly is an intellectual domain, it cannot confine itself to the meso-level of organizational analysis (2000), where publics are in service to organizations. Also, scholars must concede that powerless publics exist (2000). Researchers also have asserted that public relations research has "mostly failed to engage with the wider social and cultural implications of the practice" (Macnamara & Crawford 2013, 298). Echoing the comments of others, they said that public relations is created from cultural factors and "in turn, contributes to the ongoing maintenance and shaping of culture" (299).

The most substantial US influence on identity-related public relations' contribution to society has concerned civil rights communication, starting with Hon's touchstone article about the Southern Christian Leadership Conference (SCLC) (1997). She demonstrated how the SCLC's public relations programs employed tactics such as speeches, special events, media relations, and the like in order to secure outcomes such as voting rights and voter registration, although other goals such as African American economic progress remained unmet. Hon also mentioned that White businesses' recognition of Black purchasing power was one consideration in adopting some of the sought changes. Other research in this vein concerned Black women's organizational newsletters (Straughan 2006), civil rights–related campaigns (Murphree 2004), and activists' use of digital media (Hon 2015, 2016).

For example, looking back even earlier than the 1960s Civil Rights Movement, Straughan's (2006) historical analysis of the National Association of Colored Women's (NACW) *National Association Notes* (1897–1920) stated that because many areas of the United States were not served by Black newspapers, organizational media such as the NACW's newsletter played a vital societal role. Although its content served organizational goals such as providing news about the NACW's conferences, the newsletter also educated members on US issues such as Black education, women's suffrage, and public health. Signifying societal benefits, it featured women considered to be Black role models, engendered a sense of belonging in the racial group, and reinforced pride in Black women's accomplishments.

In Murphree's 2004 analysis of documents from the US Student Non-violent Coordinating Committee (SNCC), such as communication plans, press releases, reports, and controlled tools, she concluded that "almost every

SNCC activity was fueled to some degree by public relations" (15), describing how the organization's activities contributed to social change. An important element was the role of visual communication (such as the Black Panther and Black Power symbols), not only aimed at television journalists but at Black citizens with low literacy levels. She also related the sociopolitical contexts that were the impetus for the shift from religious-based, nonviolent message strategies and tactics of groups like the Southern Christian Leadership Conference to a Black Power message where Blacks were encouraged to defend themselves against injustices. SNCC campaign outcomes included increasing registrations among Black voters and "communicating a message of cultural unity" nationwide (27). Much of the current text elaborates on the promise of visual communication in museum communication.

Understanding messaging and digital media tactics in contemporary race-related social movements has been another research area. Discussing outcomes, Hon (2015) found that although the Justice for Trayvon [Martin] campaign resulted in the social media campaign's goal of an arrest of the murderer, George Zimmerman, he was ultimately acquitted. As Hon noted, this campaign outcome had the effect of perpetrating among Americans the belief that the United States was "not the post-racial society many thought Obama's election as president augured" (311). In her separate analysis of the Million Hoodies Facebook campaign, Hon found that goals such as increasing participation in protests were met (2016). Again, this lent evidence to the effectiveness of short-term goals for digital activism campaigns, although more research is needed to discern long-term achievements.

In summary, the aforementioned research about organizations or activist movements that focused on Black Americans provides useful insights for scholars, along with practitioners implementing public relations programs or grassroots communicators interested in diversity-related topics. However, there is a glaring gap in the public relations literature about other cultural groups who are vital stakeholders in public relations programming such as Latinos, American Indians, or Asian Americans in the United States.

Outcomes of Pro-Social Communication

The studies reviewed above not only analyzed public relations tactics with race-related publics and organizations. They delineated what results were

achieved by the communication. There were organizational outcomes, such as increasing participation in the organizations, but more importantly there were societal outcomes, too, such as increased voter registrations. Thus, the next section outlines additional literature about pro-social identity outcomes discussed in communication research.

A few studies have gazed beyond specific organizational goals and explored these topics. The earliest was Blythe's 1947 article, perhaps the first to use the term ethnic public relations: "Public relations to improve racial and cultural, or intergroup, relations attempts to influence the attitudes and behavior of strategic publics toward action for, or at least acceptance of, full democracy for ethnic minorities" (342). Although she bemoaned that prejudice has a function—albeit irrational—of allowing individuals to justify their own self-worth, Blythe also linked improved intergroup relations with strengthening democracy. In short, in terms of outcomes sought from race-related public relations, Blythe delineated reducing prejudice, influencing attitudes, and affecting behaviors—all bolstering democratic traditions.

Another outcome that can be sought from ethnic public relations programming is cross-cultural empathy. Although not a public relations study, Davis (2004) discussed how US media celebrity Oprah Winfrey and her televised book club programs boosted cross-racial empathy. Davis argued that unlike sympathy, which connotes pity and perhaps unequal power relations, empathy is a type of sympathy with an element of identification embedded. In her analysis of book club discussions, Davis found that empathetic identification with literary characters galvanized anti-racist emotions and fostered cross-cultural understanding. According to the researcher, "Emotional connections with African American characters thus encouraged these readers to feel political solidarity with Black protests against injustice. Rather than serving as a substitute for action, feeling inspired these readers to desire political change" (411).

Thus, along with cognitive-oriented goals such as reducing prejudice, changing attitudes, or reducing negative behaviors, improving intercultural empathy is another possible outcome of museum public relations programming. This concept provides an affective component to the cognitive dimensions also discussed. Given these possible goals for public relations programming, another body of literature in public relations is relevant.

The next section explores specialization in public relations where race and ethnicity are spotlighted.

Intercultural Public Relations and Ethnic Public Relations

Are intercultural or ethnic public relations professional specialties? Some researchers have argued that they are, and others have used even narrower terms, such as Hispanic public relations (Gibson 2002). Sha (2006) said that "intercultural public relations may be a special case of public relations in which the salient cultural identity avowed by the organization differs from the salient cultural identity avowed by the public" (54). In her article the focus is on bridging differences, as it is in much of the intercultural communication literature (e.g., Chen & Starosta 2005). Sha presented intercultural public relations as a theoretical concept, explaining that its goal was to explain "the influence of cultural identity on the public relations behaviors of organizations and their publics" (2006, 46). Her definitional focus was on difference between the cultural orientation of the organization and its publics, with the identity focus on the stakeholders. In particular, where the concept was explicated in her 2006 study, she was interested in the impact of cultural salience on perceptions and behaviors of publics. Sha's additional concern was in the "management of activist publics" in pursuit of the organization's goals, whereas other work (De Moya & Bravo 2016; Johnson & Sink 2013) advocates use of public relations to further culture-related activist groups' goals that will benefit society, rather than those of one organization. Among museums, Sha's concept is most useful to mainstream museums who seek to attract more diverse museum visitors.

Ethnic public relations, on the other hand, is defined as "the process of maintaining mutually beneficial, reciprocal relationships between an organization devoted to particular cultural groups or cultural heritage and the organization's publics" (Johnson & Sink 2013, 356). In this definition, the identity is tied to the organization rather than connected to the publics, as in Sha's (2006) or Gibson's approach (2002). Publics may align with, or differ from, the organization's cultural orientation. Communicators employed by culture-specific museums are likely to enact this form of public relations. Ethnic public relations fits with a family of terms used elsewhere in

communication research, especially in the companion field of journalism, where ethnic media is an inclusive term to designate culture-oriented media, such as the Black press or Hispanic media. The terms ethnic museum, ethnic public relations, and ethnic media also pair with ethnic tourism, encompassing leisure activities related to specific cultural groups.

Sha's concept is embedded in the situational theory of publics (e.g., Grunig & Repper 1992), whereas Johnson and Sink's standpoint draws from a post-positivist concern for public relations' societal functions. Nevertheless, Sha asserted that the concept of race in regard to public relations theories and practices was missing from public relations scholarship (2006). This was a significant call to action, regardless of whether a study is underpinned by intercultural or ethnic public relations.

As Figure 1 shows, museum communication programming makes societal contributions, in addition to achieving desirable museum outcomes such as increasing attendance, volunteers, donations, or the like (as described in Figure 2).

FIGURE 1. Museum Ethnic and Intercultural Public Relations: Functions Supporting Society

For the Cultural Groups

> Preserve and express cultural identity
> Preserve and express language
> Communicate counternarratives
> Communicate visual counterstereotypes
> Boost ethnic or racial pride
> Boost self-identification with cultural group

For Non-Group Members

> Provide culture-specific information
> Communicate to improve cross-cultural empathy
> Communicate to reduce prejudice
> Communicate to increase positive attitudes
> Communicate Americanness of diversity and/or immigration experiences
> Communicate role of diversity in democracy

FIGURE 2. Museum Public Relations: Examples of Outcomes Supporting Organizational Goals

Build the perceived reputation of the museum

Reinforce the identity and brand of the museum

Build relationships with individuals in the community and outside the geographic area in order to:

> Increase attendance for collection and special exhibits .
>
> Increase attendance at museum events
>
> Increase café/restaurant revenues
>
> Increase store (physical and online) revenues
>
> Increase individual donations
>
> Attract a high-quality workforce
>
> Attract high-quality volunteers

Build relationships with leaders in government, corporations, foundations, and other nonprofit organizations in order to:

> Increase donations (foundations, corporations) and sponsorships
>
> Attract suitable nonprofit organization or government partners for mutual endeavors
>
> Gain favorable decisions related to zoning, transportation, roads, infrastructure, and other government policies or mandates affecting the museum
>
> Achieve favorable tax and accounting policies at the local, state, and federal levels

Overview

What follows is a description of the structure of the book. Part I (Chapters 1 through 4) provides an overview on the main concepts that could be manifest in a variety of public relations strategies and tactics. Chapters 2 and 3 are largely informed by interviews with communicators at culture-specific museums because of their special insights on topics such as identities and counterstereotypes. Part II (Chapters 5 through 9) focuses on specific strategies and tactics, informed by museum professional interviews as well as content analyses of museum communication such as social media and

websites. Part III, the book's final chapter, summarizes the findings and applies them to the future of identity-related communication in museums.

Chapter 1 reviews the literature on museum public relations, along with public relations and cultural identity. It demonstrates that there is little research to date on the topic of museum public relations, especially related to race and ethnicity, or how public relations can support museums' organizational and societal roles. Museum studies, however, has broached identity and social responsibility, although the focus has been on museum curation and education programs rather than on public relations. Nevertheless, recent public relations research features identity-related concepts that can be explored and extended in the context of museum public relations. In addition, the call for investigating public relations' societal consequences is clear.

Chapter 2 describes forms of cultural identities and how museum practitioners conceive them. It includes a model of the types of identities in ethnic public relations and intercultural public relations. These include pan-ethnic identities, hybrid identities, immigrant cohort identities, generational identities, language-based identities, and more. Using examples furnished by museum practitioners, it asserts that public relations professionals must understand such identities, along with classic demographic, psychographic, and geographic definitions of target publics. This understanding helps improve intercultural communication competence among museum practitioners. Helpful tips regarding bilingual and multilingual public relations tactics and budgeting for them are also included.

Chapter 3 discusses how museum public relations practitioners can disrupt age-old ethnic and racial stereotypes through production of counternarratives and counterstereotypes in museum communication programming. It also illustrates how museum communication professionals can boost the attractiveness of various cultures relevant to their institutions. Insights from ethnic museum interviewees show how museums can bolster the social roles in their communities, while also helping practitioners avoid culture-related snafus or crises.

Chapter 4 is an overview of ethnic aesthetics and the relevance in branding museums or specific museum exhibits and programs. The chapter introduces how the cultural intermediary role of public relations is enacted

when practitioners take the lead in aesthetic production. For both mainstream museums and ethnic museums, it models the relationship between organizational promotion (of institutions or particular exhibits) and cultural aesthetics. Based on visual communication research, Chapter 4 offers fundamentals about how to link cultural visuals to museum programming, and how to reach culture-specific audiences with visuals that will attract, rather than offend.

Chapter 5 discusses strategic planning and evaluation. Now that practitioners have considered issues such as identities, counterstereotypes, and ethnic aesthetics, along with fundamentals about various communication strategies, how does one create a plan and determine its success? Importantly, how does a practitioner create a plan that is targeted to organizational goals, along with societal goals, so that they are integrated? A model of a strategic plan modified from Broom (2009) is set forth. An original taxonomy of one-way, two-way, and networked communication strategies and tactics also is provided, along with a rubric for making decisions about tactics. A fourth diagram presents a classification system for museum evaluation of communication programs.

Chapter 6 concentrates on multimodal concepts related to websites. An analysis of 224 museum websites shows how institutions employ one-way communication and interactive communication components, along with elements of visual dynamism and multimedia dynamism. Examples are included. Evaluating organizational websites is another point of discussion.

Chapter 7 scrutinizes social media with a content analysis of 227 museums, reviewing the types of platforms and sample uses. Social media's potential for creating dialogue with local community members and far-flung virtual communities is described, including examples from practitioners. This chapter relies on public relations concepts of interactivity and engagement. It also challenges the inconsistent terminology used by technology platforms such as Facebook and Twitter. Best practices and evaluation metrics are also suggested.

Chapter 8 addresses how museums can work with ethnic media and general market media to build their reputations and brands, along with promoting events and exhibits. Foundations are drawn from theoretical concepts such as agenda building and information subsidy. This chapter

includes interview data from museum professionals. The second section of this chapter is a content analysis of 224 museums' online newsrooms, relying on the concept of the information subsidy. Best practices in media relations and digital newsrooms are described.

Chapter 9 discusses engaging communities with museum events and controlled tools (also called "owned media"). This chapter features interview data from museum professionals and examples collected from multiple institutions. Printed tactics such as newsletters, brochures, banners, and the like are described, along with outreach through email campaigns and other tools.

Chapter 10 summarizes the other chapters and discusses the future of identity-centered communication in museums—bridging to an integrated society.

CHAPTER 2

Communicating Identity in Public Relations

Culture-Centered Museum Practitioners Speak

THE PURPOSE OF THIS chapter is to illuminate ideas about identity expressed by professionals who work for culture-specific museums in the United States. Although some chapters in this book encompass both ethnic and mainstream museums, Chapter 2 is devoted to museums whose missions are connected to particular cultures, recognizing that communicators who work for that genre of institutions have special insights about culture and race.

The chapter describes how museum practitioners use communication programming to convey cultural identity, identities that are manifest on the personal level (target publics) as well as at the organizational level (culture-specific organizational identities). A model of the theoretical concepts and concrete PR practice constructs is included (Figure 3). The study's findings are derived from an analysis of in-depth interviews with twenty-two communication professionals in museums and cultural centers whose missions serve a range of racial and cultural groups. In-person interviews were conducted in the four top immigration gateway cities in the United

States; locales that feature a wide variety of ethnic museums. Appendix A describes the methodology and participants.

Identity and Culture-Specific Museums

Reflecting European immigration patterns to the United States, some culture-centric museums were founded in the nineteenth century to be community assets for the migrants, such as the Vesterheim National Norwegian American Museum and Heritage Center founded in 1877. A few, such as Virginia's Hampton University Museum founded in 1868, served minority groups such as African Americans. Other ethnic institutions followed in the early twentieth century, such as the American Swedish Historical Museum in 1929 and the Polish Museum of America in 1935.

However, during the Civil Rights Movement, a new cohort of African American museums were formed, with Chicago's DuSable Museum of African American History (1961) and the Charles Wright Museum of African American History in Detroit (1965) leading the way (Burns 2013; Cooks 2006, 2011; Fleming 1994; Ruffins 1998; Zulu 2014). Similarly, although some museums related to different European, Asian and Latino cultures began in the late nineteenth and early twentieth centuries, many were founded in the 1960s and 1970s. A large cluster of institutions were opened during the 1960–1980 period when cultural groups became more vocal about their exclusion from mainstream museums (Atwater & Herndon 2003; Berger 1992; Davalos 2001; Davis 2013; Johnson & Carneiro 2014; Lin 1998a; Lin 1998b; Loukaitou-Sideris & Grodach 2004; Ruffins 1997; Vargas 2010).

This set of museums manifested immigration trends but also the ethnic consciousness inspired by the period's activism, as well as advocates' goals to build cultural assets that would advance civil and immigrant rights struggles.

As scholars turned a lens toward this genre of museums, the term ethnic museum was employed (Hilden 2000; Loukaitou-Sideris & Grodach 2004; Ruffins 1997; Sze 2010; Tamura 2009). However, Davalos (2001) contested the term ethnic museum because it "othered" the institutions while suggesting that the Caucasian-oriented organizations were not ethnically based. Nevertheless, it is employed here as a museum category interchangeably with culture-specific and other synonyms to denote the genre, recognizing

the limitations of the terms. Thus, these museums are delineated in this book as "For-profit, non-profit, or public organizations devoted to a particular cultural heritage, race, or ethnicity" (Johnson & Carneiro 2014, 358). Although some ethnic organizations primarily communicate with publics who self-define as members of that cultural group (e.g., Hispanic Public Relations Association), culture-centered museums generally not only communicate with the cultural constituency for whom they were founded, but with non-group members, as well. This is because identity-related cultural education is usually part of the organization's mission. The museums highlight the ethnic or racial group's culture and history and convey the group's aesthetic expressions. Thus, the challenge of communicating identity is complex.

As does the American Alliance of Museums or the Association of African American Museums professional associations, this text differentiates between institutions whose primary mission relates to a specific culture versus museums that do not. Note that currently the American Alliance of Museums has a category labeled "ethnically, culturally, tribally specific." This category is separate from the history, art, and "general or multidisciplinary" categories (along with types not considered in this text such as aquariums or transportation museums). Throughout this book, examples will be drawn from general market (mainstream) museums and culture-oriented museums, including African American and American Indian organizations.

Intercultural Communication and Identity

Oetzel described ethnic identity as a category avowed by oneself or ascribed by society based on an individual's cultural heritage that is initiated and maintained through interactions with others (2009). This is similar to other scholars mentioned in Chapter 1 who privilege communication's function in reinforcing identity (Chen & Collier 2012; Chen & Starosta 2005). As communication experts for organizations, public relations professionals center on this societal role.

Social identity theorists conceptualize identity at the individual level and at the group level, with a person's self-concept based on a cognitive assessment of his or her group membership and the emotional significance

ascribed to the membership (Tajfel & Turner 1979). Kim (2006) cautioned that ethnic identity research suffers from being fixed and oversimplified, making an argument for a focus on *interethnic* identity instead. She cited the significant growth in mixed-ethnicity and mixed-race marriages in the United States since the 1960s, along with ethnic identity measures, which showed variation among individuals in identification intensity. According to Kim (2006), since the 1960s, about four-fifths of Italian Americans, half of American Jews, one-third of Latinos, half of Asians, and seventy percent of Native Americans married outside of their "officially designated categories." The number of children born to African American and White mixed-race marriages quintupled between 1968 and 1988 (289–290).

To signify a departure from the idea of static identity, others have used the term *hybridity*, defined as the encounter between two cultures that creates a "third space" (Bhabha 1994). This term does not necessarily suggest intermarriage, as Kim noted (2006). For example, a Brazilian in the United States may self-conceptualize as neither Brazilian nor American but as Brazilian American. A third phrase used in this text is *pan-ethnic*. This signifies the combination of specific cultures that have similar geographic, language, and/or cultural origins. For instance, Hispanic may be used in the United States to refer to residents originating from countries where Spanish is the main language, such as Chile and Costa Rica. Asian may combine diverse groups such as those originating from Vietnam and Taiwan. As noted in Chapter 1, according to research, most ethnic identification is situational, fluid, and layered, rather than fixed and contained within the boundaries of one culture (Orbe & Roberts 2012; Straubaar 2008; Turner, Oakes, Haslam, & McGarty 1994).

Communicating Identity

This chapter describes the techniques museum communicators used to convey racial or other cultural identities and the challenges they faced. It illustrates various forms of identities. As Figure 3 shows, a number of concepts are employed to signal identities. These have relevance for culture-specific museums along with mainstream museums engaged in public outreach.

Given the museum types, it was natural that the professionals interviewed were preoccupied with identity issues and displayed thoughtful consideration of how perceptions of identity affected their communication programming. One identity topic was how the cultural group was defined; in other words, who "belonged." This included specific, pan-ethnic, interethnic, and hybrid identities. The second identity focus among interviewees was the challenge of how cultural identity differed among generations (older versus younger) or among different waves of immigrants. A third theme was language and identity, and a fourth was the importance of diverse employees in helping to manage an organization's sensitivities to language and culture. A fifth theme was the interesting balance between cultural and organizational identities.

FIGURE 3. Ethnic Public Relations and Intercultural Public Relations: Organizations and Publics

Intercultural Public Relations
> Defined by Publics
> Intercultural Emphasis
> Culture Peripheral to Organizational Identity

Ethnic Public Relations
> Defined by Organization
> Intra- and Intercultural Emphasis
> Culture Central to Organizational Identity

Identities of Museum Publics
> Specific Identity
> Pan-ethnic/Pan-racial Identity
> Hybrid/Interethnic Identity
> Immigrant Cohort Identity
> Generational Identity
> Language Identity
> Cultural Gender Role Identity
> Originating Cultural/Nation-state Identity

Specific Identities and Pan-Ethnic Identities

One fundamental question when defining their stakeholders was what cultural groups the museum represented. Complicating this was that some organizational mission statements focused on education about other nations (e.g., China Institute) and others emphasized preserving and presenting a culture as enacted by its members in the United States (e.g., Museum of Chinese in America). Communicators noted that museum audiences self-identified with specific cultures, even though they could be classified by the museum or others as pan-ethnic for the purposes of promoting an exhibit or other museum program. Armenians in the United States, for example, might self-identify as Armenian American, but their art or history could be encompassed within the mission of an Asia-oriented museum.

In communicating identity, practitioners tended to take their cues from the name and mission statement of their museums. For instance, El Museo del Barrio in New York City transitioned from a Puerto Rican-centric institution to one that celebrated a broader Latino focus.

La Plaza de Cultura y Artes (Los Angeles) had a similar evolution. According to an employee, "When we first opened there was this specific focus on the Mexican and Mexican American experience. [But then] we started embracing the term Latino, and that has definitely shifted in the sense that we used the starting point of the Mexican and Mexican American identity to further expand and explore topics that deal with the Afro-Mexican experience, the Central American experience."

Often, the solution was to link identity communication with exhibits and events. For example, a public relations representative for an Asian museum said they highlighted specific cultures depending on the exhibits and events. Similarly, a professional at a Latino-centric organization agreed that their programming directed their communication: "If you've made the decision for the Mexican dancer, that's going to feature Mexican identity" (versus a Peruvian musician or Puerto Rican artist where those identities would be highlighted).

Hybrid and Interethnic Identities

In addition to specific and pan-ethnic identities, other topics were hybridity (Bhabha 1994) and interethnic identity (Kim 2006). Museum communicators discussed the fluidity of cultural identity, emphasizing that focusing on specific

identities may not be meaningful in the twenty-first century. At an Africa-related museum, one public relations professional said, "People could be part Jewish or part Asian or Asian and Jewish or whatever it might be." Another practitioner from a Japanese museum remarked, "It's becoming more and more difficult to define ourselves with a single ethnicity or ancestry. . . . In many ways I think that it is wonderful in terms of an ethnic organization like ours because it simply means that more and more people may feel that this little slice of them that is of Japanese ancestry is meaningful and important. They want to learn more about it and celebrate it." And referring to Swedish Americans, another executive said that many locals "have married others of different ethnic backgrounds, so the community as a whole is changing just within our own membership."

Reflecting this societal reality, respondents organized many creative programs that celebrated mixed heritages. For instance, a Latino organization featured a tango concert whose composer was Jewish, and to supplement the program, a local expert presented a pre-concert talk, "Jewish Life and Tango in Argentina." Attending were audience members from the city's Jewish community along with local Latinos/as. In a different city, a Swedish museum hosted a locally based Swedish choir with a music event that musically mapped Syrian refugees' emigration to Sweden through music, poetry, and narratives. A violinist from Aleppo presented Syrian, Greek, and Swedish folk songs. This event highlighted the ever-changing global immigration story, juxtaposing nineteenth- and twentieth-century Swedish immigration to the United States with twenty-first-century Syrian immigration to Sweden.

Another museum practitioner noted that the traditional metaphor for the organization had been that it created a bridge between East and West. "Maybe the bridge is an old-fashioned idea that doesn't really go with the globalized hybrid multi-movement in society," she reflected. Thus, the organization's traditional identity was challenged by the trends among its contemporary audiences.

Generation to Generation:
Attracting and Informing Older and Younger Attendees
In addition to identity definitions and distinctions, professionals were preoccupied with communicating with different cohorts of immigrants, and

different generations of museum goers. They also felt the pressures of pleasing these diverse subgroups with their special events and various modes of communication. First, museum communicators were attuned to various cohorts of immigrants and how that affected not only the museum's neighborhoods but what these stakeholders wanted from the organization. In one California organization's early years, it primarily served Central Americans who emigrated to the United States for political reasons. But Latinos who had moved to their area more recently had relocated for economic reasons. Among the 37.6 percent of Latinos/Hispanics in the state, as designated by the US Census in 2010, almost 31 percent had Mexican origins, versus 3 percent with Central American origins and 3 percent from South America, Caribbean nations, Spain, or elsewhere (US Census Bureau 2018). Thus, the institution needed to conceive of its mission more broadly.

In a different type of example, an Italian museum professional noted that it was hard for Italians when they first immigrated to the United States, when "they were degraded" and "they were mocked." But because twenty-first-century Italian Americans are generally viewed positively, this allowed for a shift in the institution's messaging. Likewise, one of the oldest ethnic museums represented in the interviews was challenged by serving traditional Polonia (the Polish diaspora) who fled political partition or wars to emigrate to the United States, while at the same time attracting recent immigrants who tended to be highly skilled professionals. The organization found that creating different exhibits or events for each group was a useful strategy.

Second, museum practitioners struggled with trying to please different age groups of cultural group members, even if everyone had been born in the United States. Along with others, this was manifest in large African American museums. Traditional supporters and members of African American museums founded in the Civil Rights Movement continued to want social justice issues addressed, noted one museum professional. They wanted to see exhibits and programs that featured Black leaders recognized as history's heroes. However, he believed that Millennials were more interested in new African American artists or other contemporary topics. As one professional said, if the museum only relied on traditional supporters, "it's not going to help us get younger people into the museum, it's not going to help us get younger donors, it's not going to help us get more relevant with the social

media/digital media side of what's happening. And it's not unique to ethnic museums; it's an issue with everyone."

One solution used by some museums grappling with generational divides and different interests was to form separate boards or committees of Millennials, while maintaining their traditional boards and historic bases. Another tactic was to institute board term limits. For example, one museum used term limits to ensure that the board turned over—not necessarily limited to reasons related to age, but also to garner a variety of perspectives and professional experiences that could assist the museum. Although board terms are not traditionally under the auspices of public relations decision-making, museum communicators counsel directors on such topics.

In summary, museum professionals confronted occasional criticism or suggestions from museum audiences about identity issues related to generations of ethnic groups or periods of immigration. However, they engaged in creative solutions to recognize and forge relations with the various generations and cohorts of immigrants who were their stakeholders.

Language and Identity

One of the biggest barriers that communicators faced was language. Many practitioners, especially from museums with small budgets and staffs, said that they wished they could produce more multilingual tools. These ranged from websites, newsletters, and visitor guides used to promote the overall museum, to communication tools employed to publicize specific exhibits and events. Budgets and the importance of a diverse museum workforce were two topics discussed in relation to language.

Some curators had the resources to print exhibit signage in multiple languages. For instance, one Chinese museum in a market with a large percentage of Latinos presented its permanent exhibit signage in Spanish and English. A Swedish museum noted that almost all Swedish tourists and Swedish Americans speak English, but they offered museum tours in English or Swedish. Although not technically necessary because of bilingual fluency, they had observed that offering the Swedish tours increased enjoyment for visitors because the tours were in the native language and enhanced the perception of having had a Swedish experience. Next, the museum hoped to add Spanish because many local residents were Latino. Elsewhere, a

Japanese museum had signage in English, Spanish, and Japanese, and featured audio tours in five languages, including English, Spanish, Japanese, Korean, and Mandarin.

However, when it came to the public relations budgets for multilingual communication, these language resources were not always available. After all, while curatorial language use in exhibits was permanent or semi-permanent, languages used in public relations tools such as flyers or podcasts were more transitory. As one practitioner noted, "It's finding the resources to do the translations, being able to pay for those. And depending on the nature of the exhibition [determining] how to effectively integrate multiple languages."

Flexibility was critical, and shorter-term, exhibit-specific approaches were often a solution. An Asian museum representative said that when funds were available, they shifted language use depending on particular exhibits and whom they expected to attract. For example, in promoting a Chinese artist they produced some communication tools in English and Mandarin, but for a Pakistan-themed event, promotional material languages were in English and Urdu.

One Japanese museum benefitted from the organizational luxury of a Japanese press officer. The public relations practitioner emphasized that this professional did not directly translate English-language materials. Rather, the expert in Japanese media converted the publicity materials in a manner that was appropriate for Japanese cultural norms along with language. He noted that journalism in Japan and among Japanese American ethnic media differed from mainstream US journalism: "The press releases are very, very different in terms of style and formality." This, however, was an exception among interviewees because most museums did not have such specialized staff resources.

However, several professionals said that they did not translate materials for international home country media or US ethnic media because media personnel gladly translated the news. In other cases, the medium itself was in English, despite catering to an ethnic audience. For instance, in the United States, *The Hmong Times* and *Latina Style* are in English.

Migration patterns also affected use of languages, especially what forms of Spanish and Chinese to use because of their local popularity. For instance, practitioners knew that terminology in Spanish could differ depending on

whether a stakeholder's heritage was Chilean, Nicaraguan, Venezuelan, or another native culture. One organizational communicator mentioned that if she used a Spanish word that was more typical in Mexico but not elsewhere, "there are people that get back to us and [tell me] I'd like you to change this." She said that she would post the correction so that audiences felt free to keep an open dialog with the organization. "They can email us anytime and they do, they often do." This was a good example of true engagement with museum publics, where the public relations representative demonstrated respect for constituents and showed she was listening.

As experts noted, a museum's Chinese-speaking public might prefer traditional Mandarin, simplified Chinese, or Cantonese. And although the People's Republic of China adopted simplified Chinese in the mid-twentieth century in order to improve literacy, this did not affect Taiwan, Macao, or Hong Kong. According to interviewees, traditionally immigrants who moved to San Francisco spoke Cantonese, so this tended to be used by organizations there. In New York, organizations' audiences had different preferences. Also, museums sometimes blended forms of language in interesting ways. For example, the pictographic Chinese used by the Museum of Chinese in America (New York) in its logo is an ancient form of Chinese, sometimes called oracle bone script, but the museum's website and other materials convey a clean, up-to-date look. This befits the contemporary architecture of the museum, designed by the Chinese American architect Maya Lin (known for designing the Vietnam Veterans Memorial in Washington, DC).

One method that museums successfully used when facing language conundrums was to establish policies (aka best practices) for language use that demonstrate respect for native languages, even when budgets did not permit full translations. For instance, a Chinese organization set clear standards about language use in promotional tools. It required that exhibition names and artists' names be bilingual in both Chinese and English, even when an entire article could not be. Likewise, for community events, the date, time, place, and event titles were in Chinese and English. Newsletter content was 30/70. Similarly, a Japan-related organization published its annual report primarily in English, but with a short section in Japanese. These were excellent solutions that other museums with budget challenges could employ to reach out to multilingual visitors, without depleting

public relations budgets. Such policies also allow clear communication with museum audiences when they have questions or concerns about language use, decreasing perceptions that choices are made haphazardly or with favoritism to some groups. The language policies can also streamline budget requests internally if management has agreed to a policy that promotes best practices in linguistic strategies.

Role of a Diverse Organizational Workforce

Many practitioners highlighted the helpfulness of their museum's diverse staff in assisting them with cultural and language sensitivities. For instance, a Latino museum practitioner said that their staff's heritage originated from many Latin American countries where Spanish differed. When vocabulary terms varied among countries, he would discuss it with colleagues and reach consensus. And an African museum representative mentioned that for communication effectiveness it was helpful that "we're a diverse team as far as ethnicity goes."

A museum practitioner with top-notch communication experience, but who was not of Japanese heritage, noted, "I try to be very respectful of the language and learn how to pronounce things correctly, and that's something that some of my colleagues have complimented me on and thanked me for. It's not my heritage; it's not my language; but we use Japanese terms and terminology for a lot of things, and as a professional I feel that it's important to do that as accurately as possible."

A communicator at another institution also remarked on how a diverse staff assisted with other cultural issues besides language. He said, "We have a mix of staff, some are Japanese, some are from the U.S., some are from all over the world. . . . Then within those there are some that are liberally minded, conservatively minded, like let's not offend the emperor by using purple. Others are saying, we need to push this. We have these conversations internally."

These comments supported the public relations concept of requisite variety mentioned in Chapter 1, which asserts that staff diversity leads to higher-quality public relations programming (Grunig, Grunig, & Ehling 1992; Hon & Brunner 2000). In other words, in addition to communication practitioners advocating for diverse staffing because it is ethical, it is

also a good management decision because variety inside organizations can improve strategic outcomes. This study's interviewees were vocal about those advantages.

Organizational Identities and Museum Stakeholders

In addition to the institution's workforce, another organizational issue was the museum's identity and how it resonated with the cultural identity and expectations of museum audiences. Challenges that practitioners faced in portraying the museum's identity vis-á-vis the ethnic group were the expectations of the museum's audiences versus the mission of the organization. For some museums, the founding mission of the organization—what the museum was supposed to be doing—did not align with twenty-first-century expectations from the community or other stakeholders. Public relations professionals had to adhere to organizational missions, just as the curators did, but at the same time communicators experienced pressures from stakeholders more directly because of their boundary-spanning roles and attentiveness to public opinion. All the interviewees showed a clear understanding of their communities' demographics.

For instance, the Museum of Latin American Art (MOLAA) in Southern California was created to hold a body of work by Latin American artists that had been collected by the museum's founder. It was not until a change in the organization's mission statement in 2014, years after the founder's death in 2009, that MOLAA's mission was expanded to include Latino/a artists. It held its first Chicano art exhibit in 2015. This shift was important in the Southern California market, where 48 percent of the population in Los Angeles County and 34 percent in Orange County is Latino/a, according to the 2010 census (US Census Bureau 2018).

Broadening such museum purposes expanded opportunities for museum communicators to diversify the types of events they planned, thereby reaching wider groups. However, extensions of museum missions are decisions of the boards of directors, and while public relations can provide counsel on the advantages of a shift, their programs must follow management's lead.

Along with overcoming identity misalignments, organizational identities could also be too understated. One museum professional felt that a disadvantage for his organization was that they historically had promoted

exhibits, rather than use the museum's brand as a central focus. This risked an emphasis on transactional exchanges with publics rather than long-term sustained relationships with the organization. However, this is a possible outcome when museums adopt a marketing approach—"increasing customer traffic"—rather than a holistic public relations orientation. It can also be a downside of a very broad mission. An exhibit orientation in communication could also affect the link between the museum's cultural identity and the primary audience's cultural identity, decreasing the power of identity-centered or counterstereotypical messages. Thus, the museum's organizational identity in this case needed bolstering in order to build more long-term relationships with the museum's publics. Luckily for the organization, the museum professional was savvy about steps that had to be taken.

A third organizational identity issue was confusion about various museums' US roots. According to interviewees, because of some institution's names, occasionally stakeholders assumed the museums were funded by foreign political entities instead of by their American benefactors. Rather than being identified as nonprofits focused on cultural education, community members or tourists assumed these organizations were outposts of foreign governments. Consistent messages were required to reinforce the organization's true role and the largesse of US founders, donors, or members.

In short, ethnic museum public relations experts displayed significant sensitivity to cultural designations and language issues, felt budget shortfalls regarding language keenly, praised diverse organizational teams' importance, and used "best practices" solutions to guide language-related decision making. They also grappled with balancing the desires of cultural sub-groups, whom they differentiated by immigrant cohorts as well as by age. In some cases, organizational branding was complicated by confusion regarding the cultural parameters and the relationship of the organization to "originating" nation-states.

Conclusions

Practitioners at culture-specific museums were on the vanguard of planning programs that celebrated (1) specific and pan-ethnic identities; (2) interethnic and hybrid identities; and (3) generational identities. Language usage

also intersected with these identities. Scholars have found that global citizens self-identify in multiple ways (Kim 2006; Orbe & Roberts 2012) and they often consume media from numerous sources and countries to duplicate these various identities (Straubaar 2008). However, professionals in this study not only recognized the complexity, but used it as an organizational advantage to reach a variety of audiences.

Coping with language and cultural sensitivities was a strategic reality for communicators. When materials were not fully translated, practitioners primarily dealt with language as (1) a gesture of respect toward the culture; and (2) an identity signifier. Language elements—such as names of programs, or headlines on flyers—functioned as symbolic communication about cultures (Gans 2009) even when most members of the group spoke English. This was suitable for digital platforms where attention spans are short, and for museum goers that view themselves as global citizens but may not speak multiple languages. As discussed in Chapter 3, these elements also had other benefits.

Communicating Counterstereotypes and Cultural Attractiveness

Furthering Public Relations' Societal Role

THE PURPOSE OF THIS chapter is to discuss how museum professionals use communication programming to convey counterstereotypes and emphasize attractiveness of various cultures. The chapter concludes with a diagram that demonstrates how public relations tactics can disrupt age-old characteristics of stereotypes (Figure 4) with the goals of benefitting the organizations and society.

The study's insights are derived from an analysis of interviews with communication professionals in museums whose missions serve a range of racial and cultural groups. See Appendix A for Methodology. Before describing the practitioners' views, a brief review of the communication literature about counterstereotypes and cultural attractiveness is presented. Although this chapter reflects only the perspectives of practitioners at US ethnic museums, their observations are instructive for practitioners at a variety of art, history, or culture museums.

Communication and Counterstereotypes

Stereotypes are "collective abstractions of persons or groups asserting that members lack individuality and conform to a pattern or type" (Johnson 1999, 417). Classic writings about stereotyping capture the key characteristics— such as being fixed impressions—and describe how they function as cognitive shorthand, or schemata, that serve psychological functions for societal members (Carter 1962; Entman & Rojecki 2000). Carter (1962) defined stereotyping behavior as a process measured by "the increased homogeneity of image elements" (80), describing another stereotyping characteristic where ascribed traits tend to interrelate. To use the example of Norwegians, a group that a US president singled out in remarks as desirable immigrants, Norwegians would be stereotyped if all were labeled as White, industrious, and serious—fixed, correlated attributes that do not allow opportunity for individual variation from the group or change over time. The settings in which cultural group members are portrayed, and the artifacts accompanying them, may also be an element of stereotyping. Examples include showing Mexican Americans in rural settings wearing sombreros, or always portraying Asian Americans in offices with computers (Paek & Shah 2003).

Decades of studies have described the preponderance of media stereotypes, harkening back to early twentieth-century portrayals in newsreels and films (Berg 2002; Bogle 2002; Johnson 1999; Orbe & Strother 1996), and extending all the way to contemporary media and digital media (e.g., Dixon & Linz 2000; Entman & Rojecki 2000; Lester 1996; Nakamura 2002; 2007). Scholars have documented the negative effects of stereotypes on self-images of ethnic or racial group members (Branscombe & Wann 1994; Stroman 1986). Media research has also shown the negative consequences on non-cultural group members' beliefs about other racial or ethnic group communities (Dixon & Azocar 2007). Adverse results related to public policy are another outcome of stereotype exposure (Fujioka 2005; Tan, Fujioka, & Tan 2000), gesturing beyond individuals and groups to society at large.

One haven from general market media stereotypes has been ethnic media, but they have been found to engage in some stereotyping, as well, such as primarily featuring thin, light-skinned women or few representatives of indigenous groups (Correa 2010; Johnson, David, & Huey-Ohlsson

2003). Tribal organizations' websites have self-stereotyped (Cuillier & Ross 2007) and non-governmental organizations advocating for minority rights such as the Roma have not performed better (Schneeweiss 2015). Given the decades of research about stereotypes, it is worth noting that there are far fewer studies about counterstereotypes (e.g., Goldman 2012; Holt 2013; Ramasubramanian 2007; 2011). However, Ramasubramanian (2011) demonstrated that exposure to counterstereotypes can affect attitudes toward a racial group, signaling counterstereotypes' importance. She found they could reduce the activation of stereotypes, especially when aided by media literacy training (2007), and even generate support for affirmative action (2011).

In short, combatting these negative individual or societal effects observed by media scholars, or embracing counterstereotypes as some media outlets have done, are goals that public relations professionals can implement in the communication that they produce for organizations. The present study investigates the techniques museum communicators used to present counterstereotypes of the cultural groups that the museums highlighted in their missions, collections, and/or exhibits. In addition, it addresses the challenges museum communicators faced when attempting to overcome stereotypes.

Cultural Attractiveness

To attract visitors, members, volunteers, or donors, museums must communicate the appeal of their organization and its programs, as do other organizations. However, because of their missions, communicators often must relay the attractiveness of one or more cultures. This is far more complex than conveying the appeal of an iPhone® or a bottle of Coca-Cola®. Although nation-branding research has discussed communicating the allure of national cultures (Anholt 2012; Aronczyk 2013; De Moya & Jain 2013), less attention has been paid to promoting the desirability of various domestic cultures. One area of work in this vein is the cultural tourism literature. For instance, one study elaborated on how indigenous sites strived to enhance the attractiveness of a culture (e.g., Kelly-Holmes & Pietikäinen 2014). And in a study about exporting cultural attractiveness, Grantham (2009) described the role of the Irish pub in making Irish culture attractive outside

of Ireland, while within Ireland, "authentic" Irish citizens are drinking espressos in pubs are more likely run by Koreans or Latvians. But there are few other studies about organizational attempts to communicate cultural appeal. This limited research about cultural appeal inspired discussion with museum communicators regarding the methods they employed to convey cultural attractiveness. The following describes their ideas.

Communicating Counterstereotypes

Four sub-themes emerged from the conversations about stereotypes and counterstereotypes: cultural self-stereotyping, visual stereotypes, finding a balance between traditional and contemporary representations, and the role of cultural heroes. Avoiding cultural self-stereotyping is the first topic.

Overcoming Self-Stereotyping

Although the mission of a culture-specific museum is to educate museum-goers so that stereotypes are reduced, public relations professionals remarked on the challenges of overcoming self-stereotyping within the cultural group as well as stereotyping by others. For instance, an organization devoted to Chinese Americans struggled with its use of the color red. Although some members of the community considered red to be a traditional lucky color (as research in Chapter 4 relates), a museum interviewee also was concerned that it drew on an age-old identifier of "Chinese-ness," rather than representations of contemporary Chinese Americans. In addition to color, typefaces were another consideration. For example, one practitioner noted that their staff did not want to use the typefaces one tends to see on Chinese restaurant menus in the United States. The museum purposefully chose contemporary typefaces for its materials.

An Italian museum faced similar challenges from graphic designers and other subcontractors with whom she worked. One executive said their contracted communication producers often wanted to use visual tropes such as red and green from the Italian flag, or food imagery such as pasta when preparing museum materials. She also mentioned Italian stereotypes in US films as typical ones they attempted to overcome in museum communication, especially the "Mafioso" one perpetuated by

The Godfather and similar movies. Similarly, a Greek museum public relations professional working with videographers on a project said she had to keep taking out "those standard cultural Greek images" such as dancers in traditional garb, "in favor of this is what modern Greeks look like and act like."

Although in Burns's history of African American museums (2013) she discussed some of the gender issues faced by museums when they were first founded, only two of the 22 museum professionals mentioned gender. For example, at an Italian museum, a practitioner noted that they consciously put women in the visuals so that there was not a plethora of male faces, because "of the male dominance of the culture," and because of the important social history function of those images: "women's immigration is another untold story."

Regarding self-stereotypes, Asian American organizations were particularly concerned about Orientalizing their cultures (e.g., Said 2003). An experienced public relations professional at a Japanese museum noted that "something we as a museum either tacitly or sometimes directly deal with is the exotification of Japan." He noted that one way the museum overcame this concern was by bringing forth the historical and cultural aspects of topics that lend themselves to exotification, such as kimonos. He noted, "There are some very deep cultural issues having to deal with gender, having to deal with sex and age. The way that we address those is through panel discussions and bringing the experts in the field to talk about that." In other words, programming that interviewees organized to accompany exhibits allowed stakeholders to confront the issues thoughtfully. In addition, these discussions set the tone for media coverage, to ward off media stereotyping that otherwise might occur.

Public relations professionals also keenly felt the responsibility of working for institutions that they regarded as vital to their ethnic and racial communities—locally and nationally. Regarding overcoming perceived heterogeneity of cultures, a Black museum practitioner said, "The all things to Black people becomes a challenge when you're the only one [African American museum in the city] or the largest in existence. How do you represent the range of all of these different cultural voices within the Black diaspora; the Black experience?"

Thus, practitioners demonstrated sensitivity to cultural and gender stereotypes in their remarks. Even when they were not concerned with self-stereotyping, practitioners discussed other communication decisions related to stereotypes, including their visual portrayals of people, artifacts, architecture, and art. The next section summarizes the issues from those reflections.

Visual Stereotypes

Although culture was a dominant message, practitioners had organizational goals as well as diversity goals in mind when choosing photos of people. For instance, many said that they focused on ensuring important donors or volunteers were featured in photos of museum events, rather than just concentrating on picturing ethnic and racial variation. Their visual shorthand often centered on ensuring the main visual message was clear, such as "art class" or "genealogy program," rather than on communicating the cultural backgrounds of those portrayed in the photographs.

A communication expert at a Latino museum said that one technique for avoiding stereotypes was using more artwork in the visuals, rather than always employing, for example, "imagery of children for our public programs." He sought out new books from South America and throughout Latin America as sources of inspiration regarding cultural expressiveness. In doing so, he said, his "color palette has exploded."

Museum professionals recognized that the cultures their organizations represented—whether the original nation-state or the diaspora communities in the United States and beyond—were ever-changing. Thus, a typical challenge for communicators was demonstrating the traditions of a culture without making it seem outdated. This was particularly a hurdle for ethnic museums whose largest immigration cohorts occurred in the nineteenth and twentieth centuries.

Many interviewees discussed the aspiration to create more modern looks when presenting historic images on websites, social media, or other promotional materials. For instance, one professional noted, "If we show things that are traditional, then we need to cast it in a contemporary light—we need to then have a photograph that reads contemporary." Another said that when creating visuals, "you have to mix and match and you have to create a new visual reference for the old photograph." And further, she noted, "If

you present in a sepia tone with the right green and white, it's kind of, okay, we are stuck in the past."

Architectural tropes have been found to be visual shorthand for referencing culture (Aiello & Thurlow 2006). However, architecture was used as counterstereotypical images, too, when the architecture of the museum itself was contemporary. A Greek museum that employed sleek building images in its promotional materials—rather than historic architecture such as the Greek Parthenon—enacted another mode of updating the cultural reference. Referencing architectural visuals' role in stereotypes, a Chinese museum professional said, "It was new for me knowing that the pagodas were actually for nationalist identity, because to us it just seems like self-Orientalizing."

Time and Traditions

A related temporal challenge of communicators, especially when promoting innovative exhibits or when designing museum events, was nudging museum audiences forward in time. One professional used a communication metaphor, saying changing an organization's audiences' perceptions was like "trying to shift a conversation that is getting stuck in one thread."

For instance, a Chinese organization noted the hurdles in attaining audience understanding of innovative programming. A professional said, "Sometimes it's a challenge to get people to understand [an event she organized because] it's not what people expect. You get a lot of people who want to come to something a little bit more traditional. We have a spring festival for Chinese New Year . . . it's something we have done since 1973." Several ethnic museum communicators said they continued these traditional events but provided a counterbalance with newer types of programs that attracted different audiences, such as Millennials or Generation Z consumers. Examples of up-to-date events included a museum fashion show where a contemporary Ukrainian designer and historic costumes were featured. Another was a Corazón del Barrio event on Valentine's Day that featured music, dancing, love poems, and an arts workshop.

While historic exhibits could capture a culture in a particular era, museum practitioners were conscious that in order to attract contemporary audiences, they had to find creative ways of communicating such historic

messages in newsletters, flyers, and the like. They did not have the luxury of extensive museum spaces, as did the curators, to communicate complexity. Choosing art or artifacts to accompany publicity presented similar barriers. For example, expectations that Polish identity would be represented with "old" art from the "old" country were violated when newer expressions from artists of the cultural group (e.g., Polish American artists or twenty-first-century Polish artists) were featured.

Heroes and Professionals

One technique for providing counternarratives to stereotypes is to feature members of the cultural group who are examples of success stories (Burns 2013). Although most of the museums in this study featured many notable professionals and celebrities in their exhibits, cultural heroes or accomplished persons received fewer mentions in the interviews about public relations. In short, this was not a counterstereotyping technique that communicators frequently employed, unless it was exhibit-specific publicity. However, interviewees mentioned a few examples such as US Swedish American astronaut Buzz Aldrin, Mexican American baseball player Fernando Valenzuela, Italian American baseball player Joe DiMaggio, Chinese activist and artist Ai Weiwei, Latina activist and labor leader Dolores Huerta, Latino actor and comedian Cheech Marin, and Latino geneticist Carlos Bustamante. African American "firsts" mentioned included DuSable Museum founder Margaret Burroughs, former Los Angeles Mayor Tom Bradley, and former San Francisco Mayor and California Assembly Speaker Willie L. Brown, Jr. Professionals and heroes/heroines who were still alive and able to participate in museum programming were celebrated as role models. Museum communicators publicized their participation in museum events and conveyed respect for the cultural group paragons.

This was the most typical communication about heroes in public relations, but it was limited by the availabilies of notables who had relationships with the museums. However, signifying the importance of portraying a diverse set of distinguished personages, a communication expert at an African American museum shared one of the challenges of what he called the "Sidney Poitier syndrome." This connoted the situation where a few heroes or heroines had to bear "the burden of trying to be all things to all Black

people." Thus, public relations practitioners demonstrated they understood the pros and cons of working with cultural heroes in programming. It also suggests the necessity of encouraging more notables to be involved with the museum, an endeavor that could be recommended by the public relations staff with invitations issued by museum directors or board members. Of course, a risk of close attachments with notables is that if a celebrity associated with the institution suffers a reputation crisis, it could negatively impact the museum's brand. Recently museums have grappled with public opinion about some of their donors, either because of the donor's personal indiscretions or crimes, or due to public attitudes regarding products made by companies associated with the benefactors. Thus, as they do for all their organization partners, museums must vet such relationships.

In summary, the sub-themes in discussions about the role of public relations in creating counterstereotypes were overcoming cultural self-stereotyping in their own communication tools; demonstrating sensitivity to visual stereotypes; balancing traditional and contemporary messages and representations; and using cultural heroes in museum communication. Although interviewees reflected on communication at culture-specific institutions, these issues face professionals at other genres of museums, too.

Importantly, museum professionals bolstered organizational identities concurrent with cultural identities. This suggested that one does not need to abandon an organization's objectives such as increasing attendance to also fulfill pro-social objectives—at least in the nonprofit sector. The next theme, and a preoccupation of all the culture-specific museum practitioners, was how they communicated appealing cultural identities in twenty-first-century platforms to members and non-members of the cultural group(s) they represented.

Cultural Attractiveness and Identity Tidbits

Of course, cultures are complex and always evolving, further complicating the task of inspiring potential museum visitors to learn more about them. Thus, one of the challenges for ethnic museum communicators was to tease out the most attractive elements of cultures and contrive mini-symbols of their heritage that could be conveyed succinctly in social or digital media, or in a quick pitch

to urban media representatives. I termed these "identity tidbits." This was an easier challenge for those with cultures that are well known in the United States, and that have come to be considered appealing, despite earlier discrimination.

For instance, one professional explained that contemporary Japanese cultural genres such as anime or manga were pleasing to young audiences, while traditional Japanese arts and textiles were appreciated by older stakeholders. He noted, "We're fortunate because Japan has a pretty good reputation of [being] cool." At the same time, others recognize "Kabuki, block prints, and kimonos." "We're for everybody whether you have an interest in Japan or not. One of our secondary missions is to cultivate a life-long interest in Japan." He expertly deployed these symbols, depending on the demographics of the public he sought to reach. Of course, there is both uplift and irony in this appreciation of Japanese aesthetics, given the internment of Japanese Americans in US concentration camps during World War II just seven decades ago.

Practitioners from two Italian museums in the study also remarked that their culture also is now considered desirable, which makes their job somewhat easier. One said, "We are not afraid of losing our identity because the Italian culture is much appreciated and a lot of people here in [city name] want to preserve that." She also said, "Music, food, traditions, history—these are the main attractions." Thus, she noted, events were important for the museum. Another Italian museum professional said about one of their events, "We attract both Italo-philes and Italian Americans. . . . Everyone loves Italian food, Italian wine." Again, this genuine American love of Italian culture is a sharp departure from early twentieth-century prejudice against immigrants from Mediterranean countries such as Italy, and Italians' internment in the United States during World War II, just like the confinement of the Japanese. This is a positive reminder to public relations professionals that their work can help to improve the images of cultural groups who are currently stigmatized.

Capturing delightful aspects of the culture was part of boosting cultural attractiveness. Facing the reality that stereotypes are oversimplified forms of communication, practitioners substituted new forms of visual and narrative shorthand to create alternative, positive prototypes and impressions, rather than lean on tired stereotypes. One professional at the forefront of new promotional ideas noted, "There are concepts and ideas and words in

Japanese that are fun to say and fun to know. So, we try to try to use them in our social media or even in our program titles." Through the attempts of another professional, Swedish words were made equally enticing. For instance, capitalizing on the US coffee mania, a Swedish museum introduced *fika* breaks, which are mid-morning coffee breaks in Sweden, perhaps accompanied by a ginger snap (cookie). According to a professional, "In this area of [city name], everybody at this point now knows what a *fika* break is." She noted that "you introduce new concepts" from the traditional culture but they are adapted by residents to suit their lifestyles (perhaps by eating an American doughnut instead of a Swedish cookie with the coffee). Thus, diffusion of cultures was orchestrated in entertaining mechanisms that allowed non-members of the culture to experience it in a nonthreatening way. In addition, for third- or fourth-generation immigrants who had lost touch with their ancestors' cultures, these were low-stake forms of cultural immersion.

In addition to language nuggets, professionals took advantage of symbolic icons. To reach non-Greeks, a Greek museum said, "What we've found most often is that mythology is the hook." Correspondingly, a Scandinavian museum found that connections to Viking imagery had high appeal, "people like Vikings; you know it is still a mystery about the Vikings."

Seasonal festivals were other popular ways to convey the culture, but often adapted to suit US expectations. A Ukrainian museum hosted a pre-Lent Mardi Gras, drawing on a tradition from pre-Christian Ukrainian history that celebrated spring. However, they geared this to young museum members and non-members, versus their strategy of hosting more traditional events for older community members who represented earlier immigrant cohorts. Similarly, a Swedish museum capitalized on St. Lucia Day in December or the Swedish mid-summer festival to blend Swedish traditions with US culture. So, for instance, at the Swedish *midsommar* festival they maintained the tradition of maypole flowers, but the flowers were local American flowers rather than traditional Swedish flowers.

In the Ukraine, the eve of St. Andrew's Day was traditionally a celebration with fortune-telling and match-making activities. Rather than hold the celebration on the traditional feast day (per church calendars), the museum organized it in conjunction with US Valentine's Day celebrations. This allowed the museum to diffuse a charming tradition by making it more

compatible with US cultural norms, while also updating and secularizing it for broader consumption.

However, creating attractive cultural tidbits was more difficult for professionals representing cultures that are smaller or less understood. Another challenge in highlighting ethnic attractiveness was grappling with shifts in public opinion about the nation-state associated with the culture. For instance, current foreign relations between China and the United States might influence public opinion, and therefore attractiveness perceptions, of the entire culture. On the other hand, political repression against a culture, such as the Russian Federation's invasion of Crimea in 2014, increased interest in Ukrainian culture and may have spurred cultural empathy among potential museum goers.

Nevertheless, symbolic ethnicity (Gans 2009) has its downfalls. An interviewee noted that although promoting a culturally attractive ethnicity can be an advantage, it can also more easily lend itself to stereotypes and self-stereotyping. She bemoaned that "Italians are somewhere between Prada and the Ferrarri, and spaghetti and meatballs."

FIGURE 4. Public Relations Tactics in Creating Counterstereotypes and Boosting Cultural Attractiveness

Characteristics of Stereotypes

> Fixed, long-lived identities
> Apply to all group members
> Attributes are related
> Traditional settings and artifacts
> Cognitive shorthand

Counterstereotype Tactics

> Communicate past and present counternarratives
> Communicate visual variety
> Communicate diverse cultural heroes/heroines
> Disrupt attribute groupings
> Communicate contemporary artifacts and diverse settings
> Convey positive identity tidbits

Discussion and Conclusions

Counterstereotypes

One of the criticisms of traditional media stereotypes is that they create limited, static types (Berg 2002; Bogle 2002; Entman & Rojecki 2000). Despite periodic pressures on media to curtail stereotypes, and regardless of ethnic media's efforts, stereotypes remain ubiquitous in US traditional and digital media. As this chapter has shown, in their efforts to overcome pervasive societal stereotypes and educate audiences about dynamic cultures, museum professionals created innovative counterstereotypes. They employed techniques ranging from capturing the aesthetic color palettes of countries of origin to featuring modern architectural elements. The practitioners worked to create vivid images, even when the message centered on an historic theme. As the museum studies literature has documented, cultural achievers are part of museum collections (Burns 2013). However, communicators did not make such heroes a major component of their public relations messages unless there were living professionals who participated in museum events that they organized (donor events, lectures, etc.). Practitioners at both ethnic and non-ethnic institutions can seize on this idea, expand organizational storytelling about cultural heroes and heroines, and continue to build relationships with local notables.

Cultural Attractiveness and Cultural Tidbits

When language phrases or cultural icons like Vikings are employed as sources of delight, they encapsulate and even miniaturize Gans's concept of symbolic ethnicity. On one hand this adds positivity to communication tools. On the other hand, this approach risks creating stereotypes of a different sort because of their reductive quality. However, these new forms of cognitive shorthand accept the realities of twenty-first-century communication platforms and work to disrupt negative stereotypes. After all, most contemporary forms of public communication do not allow for complex messaging, as other chapters describe in more detail.

In addition, one could critique such symbolic use of language or cultural icons if it merely commodifies culture in service to a museum's goals such as building attendance. Nevertheless, responsibility to organization and

society can co-exist, as our interviewees conveyed. Museum professionals were ever-cognizant of attendance, donations, and the like, but embedded those goals in a larger responsibility to cultural groups and society. Findings also suggest that organizations involved with immigrant groups who are relatively recent arrivals can incorporate these techniques in working to reduce prejudice against them.

Implications for Public Relations Practice

The findings gesture toward the potential that public relations practitioners in culture-specific or mainstream museums have to diffuse positive images of diverse groups. Such appealing representations are a step toward reducing prejudice. And as Blythe (1947) said, reducing prejudice also contributes to democracy.

Second, the interviews have pinpointed a technique that communicators use, creating cultural tidbits, to capture mini-elements of a culture for the hyper-media environment and short attention span of audiences. This symbolic technique has not been addressed in the branding literature, but it is a means of boosting cultural attractiveness and another avenue for disseminating counterstereotypes. Stereotypes are over-simplified negative features suggesting a culture, and the cultural tidbits are over-simplified positive features. While the most authentic counternarratives deal with the complexities of identities, twenty-first-century communication platforms often don't allow it.

Visual Intercultural Communication

Incorporating Cultural Aesthetics in Public Relations

IN ADDITION TO OVERTLY countering stereotypes, public relations practitioners employ cultural aesthetics to convey respect for cultures. They also use culturally resonant visuals to reach ethnic group members they wish to cultivate. In addition, museums may wish to transmit culture-specific expressions in their visual branding and promotion. In ethnic museums, cultural aesthetics are typically incorporated into the organizations' institutional brands. In mainstream museums, cultural styles can be embedded in promotions for special exhibits or programs.

This chapter discusses the role of public relations professionals as cultural intermediaries, a term borrowed from Bourdieu (1984). Various cultures and their visual aesthetics are then discussed, as is the concept of cultural style. The chapter also describes applying these ideas in museum communication, including in the design and selection of visual elements. As cultural intermediaries, public relations practitioners demonstrate intercultural communication competence through appropriate cultural aesthetics usage, just as they do by employing language correctly.

Public Relations Practitioners as Cultural Intermediaries

Some scholars have deemed that public relations professionals serve as cultural intermediaries (Bourdieu 1984; Curtin & Gaither 2007; Hodges 2006; Johnson & Sink 2013; L'Etang 2012; Nixon & du Gay 2002). In this vein of work, a preoccupation is with practitioners' societal roles as purveyors of culture. According to Curtin (2011), "Public relations practitioners, as cultural intermediaries, create and circulate identities they believe will enhance consumption of organizational messages" (374). For instance, in her research about American Indians in the early 1900s, Curtin found that a marketer of the American West, the Harvey Company, empowered Native tribe members socially and financially through the company's promotion of their cultural identities. A different non-US example described how public relations cultural intermediaries shaped Australia Day for more than seventeen decades. Researchers determined that public relations was "an adaptive practice" and that "changing cultural values . . . shaped Australia Day PR, with significant evolution in the identity, images and messages promoted" (Macnamara & Crawford 2013, 305).

Edwards (2006, 2009) also noted that public relations professionals engage in tactics that create representations cementing particular values as legitimate, in part because communicators are unconsciously affected by societal relations. As Macnamara and Crawford declared, "PR practices are developed *in* society; not simply imposed *on* society" (2013, 305; emphasis in original). Summing it up, public relations professionals are "culture-workers" (L'Etang 2012, 167) and "social agents within cultures" (Hodges 2006, 83). They must understand intercultural communication in domestic settings and in global relations.

Attesting to public relations practitioners' responsibilities as cultural intermediaries has tended to be the prerogative of critical/cultural scholars in public relations. This work brought forth the importance of societal responsibility in public relations but generally has not explicated the concept's pragmatic use in professional circles, with a couple of exceptions (Curtin 2011; Macnamara & Crawford 2013). However, envisioning the roles of public relations professionals as cultural intermediaries has the potential for wide utility among post-positive theorists along with practitioners.

As Dozier and Lauzen (2000) insisted, critical theory informs traditional empirical public relations scholarship, and forces the scholar to "consider the aggregate impact of public relations practices" (18). The goal of this chapter is to create a bridge from the lofty cultural intermediary concept and research on cultural aesthetics to on-the-ground intercultural communication practices. Figure 5 exhibits some of the job functions of cultural intermediaries in mainstream museums, and Figure 6 displays roles for them in culture-centric institutions.

Cultural Aesthetics in Public Relations

Although it is vital knowledge for cultural intermediaries, there is little public relations research about ethnic aesthetics. Aesthetics is described by marketers as the sensory experiences associated with an organization or brand (e.g., Schmitt & Simonson 1997). Thus, in this chapter cultural or ethnic aesthetics is defined as the communication of sensory experiences associated with particular cultures. Aesthetics concerns itself with "sensuous knowledge," not logic (Schmitt & Simonson 1997, 8). Although museums may be concerned with ethnic aesthetics to boost brand value, just like for-profit companies, another reason is to demonstrate to audiences the museum's admiration for other cultures. In time, research suggests, this will lead to trustworthy relationship cultivation, improved institutional reputations, and loyal publics. For ethnic museums, it will also improve brand recognition because of the cognitive linkages between the museum and the ethnic group. As Schmitt and Simonson noted, an organization can provide value by satisfying the experiential desires of their audiences—their aesthetic requirements. Museums are certainly experts at satisfying their clients' aesthetic needs. This chapter advocates extending this skill to public relations practices in cultural group communication.

Thus, when employed in strategic communication (rather than in artistic endeavors), cultural aesthetics are a form of intercultural visual communication. This idea extends the linguistic concept of code-switching, defined as fluctuating from one language to another, either by replacing one phrase in a sentence with that of another language or changing languages between sentences. Just as one might add "un abrazo" on an English-language email

FIGURE 5. Mainstream Museum Public Relations Practitioners as Cultural Intermediaries

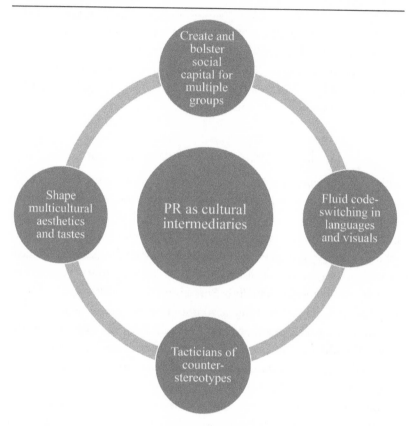

to a Mexican friend, or say "skål" when clinking glasses with a Norwegian colleague, one can also engage in visual code-switching, using symbols, colors, or alternative signifiers to show admiration of and delight in others' cultures. Intercultural communication competence is defined as communicating in a manner that is culturally appropriate, sensitive, and effective (Chen & Starosta 2005; Oetzel 2009). Museum communicators who function as cultural intermediaries aim for high levels of intercultural communication competence, including the ability to code-switch in language as well as in visuals. This

FIGURE 6. Culture-Specific Museum Public Relations Practitioners as Cultural Intermediaries

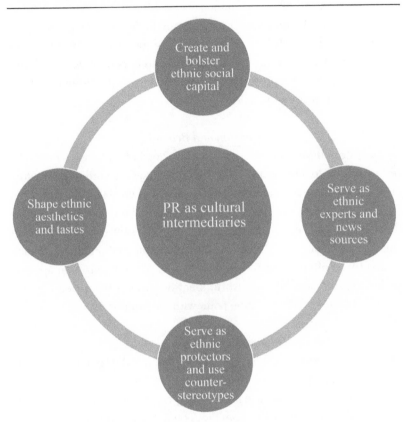

fulfills the ideals of two-way symmetric relationship building with museum publics. The next sections delineate scholars' views regarding aesthetics.

Cultural Aesthetics and the Notion of Style

Some scholars distinguish between cultural aesthetics and cultural styles, but most use the terms interchangeably, as this book does. As one summarized, "Styles consist of shared formal motifs, patterns, or traits" (Leuthold 1998

19). Marketing experts have defined style as a "distinctive quality or form, a manner of expression" (Schmitt & Simonson 1997, 84). For museums, style can boost awareness of an organization or an exhibit and create an emotional association with the museum or its program. Style has been described as superficial and a "foolish enslavement to fashion," but it also can be an authentic signature (Heller 2014, 122). Researchers have explained how styles emerge to (1) express, (2) convey belonging, (3) differentiate from others, and (4) resist domination.

Expression and Belonging

Investigators have focused on style as an aesthetic expression of self-representation to other groups (e.g., Leuthold 1998). According to Pasztory (1989), "The basic function of an ethnic style is to create a coherent visual form that functions as a badge of identity within the group; by projecting the image of a self, ethnic style immediately implies the existence of others who do not belong" (18). Pasztory also noted that continuous affirmation of identity is often required. Of course, this conceptualization appears to discount the possibility of hybrid identities, unless the mixed heritage becomes another differentiation point with its own distinct style.

Differentiation and Resistance

Therefore, an aesthetic of belonging means that one does not, then, affiliate with another group. Aesthetics can separate. Pasztory (1989) said that ethnic styles exist to create difference because they emerge vis-á-vis cultures being juxtaposed with others with whom they compete. She used the example of Scottish tartans that were said to have been invented by an industrialist as (incorrectly) representative of ancient clan symbols. She asserted that the reason for the tartans' popularity was that "for various economic and political reasons Scotland needed an ideology and visual indicators of ethnic identity so much that even the spurious would do" (35). Pasztory emphasized that groups who are isolated are not known for ethnic styles; it is those who are adjacent to others who need to create such styles to gain visual power in the marketplace (1989).

Hebdige (1979) and others in the cultural studies discipline conceptualized style—particularly those of subcultures—as a way of expressing

culture without directly confronting hegemonic culture. Struggles between groups were expressed in the most mundane way of superficial appearances, he said. However, others might argue that the aesthetics of groups such as the Black Panthers intended to do just that—confront mainstream society's stereotypes of unempowered African Americans.

Reflecting this, Leuthold (1998) wrote, "Ethnic styles emerged for the creation of difference in conditions of cultural interaction but also competition and hostility" (59). He noted that aesthetics can be newly invented or represent long-term cultural expression. In the United States, most of us would agree that we see combinations. Although Bourdieu (1984) focused more on elites than did Hebdige, he similarly observed that societal groups who are dominated have their own aesthetic values, albeit because of need. Thus, one driving force for expressions of aesthetics could be cultural oppression by another group.

But expressions are not fixed. DiMaggio and Fernández (2010) reminded readers that cultural forms change as they traverse boundaries, retaining elements of host countries while adapting to new styles or what is available in the new place, perhaps assembling completely new hybrid expressions. This is critical for cultural intermediaries to observe, so that in their quest to demonstrate expertise in ethnic aesthetics they do not present fixed stereotypes instead, as described in Chapter 3.

Mostly rooted in the arts or humanities, the academic literature tends to be separated by cultural origins into Native American/American Indian aesthetics, Black aesthetics, and Latino aesthetics, although there have been publications that attend to Blackness in Latin America (Moreno 2006; Patton 2015). Less is available in English about Asian American and Arab American visual cultural expression beyond art, with some exceptions (e.g., Jamal 2010; Ling 1999). Each of the next sections starts with an overview of some aesthetic traditions and ends with specifics about colors, imagery, and typefaces to be used or avoided in strategic communication. The main goal is to increase practitioners' sensitivity and thoughtfulness about how to incorporate cultural expressions in museum communication. A secondary aim is to highlight a few traditions in aesthetic movements to provide background for experts' suggestions while recognizing the limitations of the examples. Nevertheless, public relations practitioners should not regard the

advice as fixed counsel, as circumstances will govern appropriate usage in museum communication.

Black Cultural Expression and the African American Aesthetic

Aesthetic Movements

A touchstone work in Black expression was Gayle's work on the Harlem Renaissance (1971), aka The New Negro Movement. African American intellectuals involved in the movement at the time believed that projecting the arts (including literature and music) was a means of conveying positive images of Black Americans. Central was the group's desire to "control its own image. Renaissance writers, intellectuals, and artists were charged with articulating a racial identity that not only plumbed indigenous black experience but simultaneously assumed a positive face for white society" (Watson 1995, 92). Similarly, Driskell (1995) noted the importance in the early 1930s and 1940s movement of producing "new images of themselves that were void of negative references" (6–7).

Some common elements in the Harlem Renaissance included portrayals of Black heroes, folk traditions, and Africa as a "source of race pride" (Watson 1995, 9). Scholars said that Black style included elements like the rhythm of jazz or poetry (Gay 1987; Watson 1995), but others observed that middle-class African Americans may have differentiated themselves from those expressions because they were thought to be connected with a different subgroup (Harris 2003).

Like the Harlem Renaissance, the Black Arts Movement that started in the 1960s also was interested in ensuring that cultural production was directed and managed by African American-owned producers (Ongiri 2010). An undertaking strong on visual icons was the Black Panther Party originating in 1966. Ongiri (2010) argued that although the Black Panthers failed in political achievements, they succeeded in affecting popular culture. She said that the Panthers focused on lower socioeconomic representations of African Americans as "authentic" Blackness and noted that their visuals were recalled long after anyone remembered their ten-point political platform. Ongiri also emphasized that the Black Arts Movement and Black Panther Party focused

on the urban aesthetic, versus the Southern "folklife" that was central to earlier African American aesthetics but that also generated stereotypes.

Of course, today elements of the African American aesthetic differ by subgroup, by region, and among the artists and cultural dignitaries who create it. However, many scholars agree that contemporary cultural expressions continue to draw from the early or mid-twentieth-century movements, such as in gestures toward the ancestral arts of Africa and respect for ancestors (Driskell 1995). African origins and spiritual traditions of Africa have now expanded to pan-African experiences (Morrison 1995) and other visuals (Johnson & Pettiway 2017). Other aesthetic movements from which cultural intermediaries may draw inspiration include Afro-Cubanismo and Negritude in the French-speaking Caribbean and African nations.

Color Palettes and Imagery

The Black aesthetic typically encompasses bold expressiveness as opposed to understated expression, which is more prevalent in Japanese American style, for instance. Other characteristics of Black expression are dramatic and participatory speech, often emotional (whether through soulfulness or flamboyance) with expansive style (Gay 1987). "So much of cultural life within the Black community is stimulated by a strong inclination toward dramatic flair, creative impulse, and purposeful action" (Gay & Baber 1987, 347). Museum communicators can observe these norms by viewing Black media, art, and fashion, and incorporating some style elements into their own organizational designs.

Typical colors in the Black aesthetic are warm earth tones, saturated greens, golds, or rusts. In one study, African American women respondents said that deep earth tones were best for communication with them rather than "European colors" such as feminine pastels (Springston & Champion 2004). In regard to images, Lipton (2002) reminded readers that one can't simply add kente cloth and assume a design will appeal to African Americans—individual variation and regional differences mean there are few symbols that tie groups together. One could add variation by age and economic status as reasons for dissimilar preferences, too. On the other hand, Black respondents in Springston and Champion's (2004) study recommended that practitioners use kente cloth designs; they signaled

cultural awareness to them. Thus, public relations practitioners should solicit feedback before incorporating such design elements into museum visual communication.

Lipton (2002) also weighed in about typefaces, cautioning communicators against overuse of Lithos and Mistral typefaces, which are perceived as stereotypically African. He recommended Geo and Kabel because they are angular and stylized; he also noted the use of Lubalin Graph. Inclusion of African Americans in photographs is another fundamental of visual communication. For example, in their study of users' perceptions of brochures, Springston and Champion (2004) found that Black women said that they wanted to see other African Americans in the materials. In fact, research has documented that this is more important to African Americans than to other audiences (e.g., Appiah, Knobloch-Westerwick, & Alter 2013). Next, Latino aesthetics are highlighted, which share some similarities with Black cultural style, along with distinct differences.

Latino Cultural Expression

Aesthetic Movements

Latin American immigration patterns to different US regions in various decades help explain the research on Latino aesthetics. Style inspirations range from the Chicano movements in the Southwest to Caribbean-inspired artistry on the East Coast, and there are distinct visual languages (Lipton 2002). Of course, this section on cultural expression also recognizes that many Hispanics in the Southwest were native to the area when the United States took the territory from Mexico in the mid-nineteenth century. Thus, not all aesthetic trends were imported. This section briefly reviews a few aesthetic movements related to Latino expression.

In an investigation of Mexican American and Chicano art between 1945 and 1980, scholars noted that post–World War II Mexican American artists in Los Angeles were more isolated than those who participated in the Chicano movement later in the 1960s (Noriega, Romo, & Tompkins Rivas 2011). In Los Angeles, Chicano artists often had "professional" jobs such as in television, film, or animation; thus, many did not rely solely on their fine art to generate income (Noriega & Rivas 2011). These artists combined

Mexican heritage with American art, with dominant forms including public art (murals) and graphic art. Just as African Americans drew on African heritage, Latino artists in early West Coast movements drew on symbols from Mexico's mestizaje, pre-Colombian gods such as from the Mayan or Aztec civilizations symbolizing "cosmological power" (2011, 35), or Spanish Catholicism and colonialism. Frequent symbols were Olmec heads and the feathered serpent deity from Aztec culture. In the mural images of the 1960s and 1970s, heroes such as Zapata and César Chávez were portrayed along with images of Quetzalcóatl or the Virgin of Guadalupe. Artists constructed "La Raza Cósmica, the cosmic race, a philosophical concept derived from the mestizo hybrid of the New World" (Vargas 2010, 13).

Cárdenas (2010) observed that Chicano art in the 1960s took elements from traditional Mexican culture plus the Beat and Dadaist movements—a politicized aesthetic that embraced the working class. Artistic production served as a tool for organizing protests for better working conditions and against the Vietnam War. Thus, some Latin iconography also featured rebellion elements (such as the Young Lords Puerto Rican American activist movement), similar to those of the Black Panther Party of the same time period.

Vargas discussed the popularity of Chicano printmaking, especially in protest art, characterized by bright colors and flat designs (woodcuts, silkscreens, lithographs). Posters were also used to make announcements; they were "portable art for an eager Chicano audience" (Vargas 2010, 36). Although Chicano art in the 1960s and 1970s was primarily politically motivated, later eras feature a wide variety. Symbols were the home, family, church, street culture, class, and women's struggles (Vargas 2010, 4). It was colorful work that derived elements from pre-Columbian, indigenous, or contemporary styles.

Color Palettes

As glances at US Latino museum collections or websites convey, Latino style is often expressed with explosive colors. For example, the bold, bright colors of Mexican votive paintings (retablos) are described by Durand and Massey as contributing to this look (2010). Lipton said vibrant "fiesta" colors are an acceptable "stereotype" (2002), as did participants in Johnson and Sink's research (2015), although regional variations in color preferences exist.

Renderings in ocean colors may be more appropriate when communicating with Latinos hailing from places near the water.

Southwestern and Tropical Imagery

Perhaps because of the influence of mural and poster traditions, flat graphic looks often reflect the Latino style of the Southwestern states. In terms of graphic imagery, Lipton (2002) recommended pre-Columbian masks, murals, and tiles because of their widespread use throughout Latin America. (Tiles are also reflective of Iberian Peninsula styles.) In addition to symbols mentioned earlier, other typical ones are sun or solar images, terracotta images, hearts, or papel picado, the colorful patterned paper cut-outs.

Conversely, many immigrants on the East Coast have origins in Cuba, Puerto Rico, and elsewhere in Latin America. The Caribbean has always been a place of porous borders with a history of centuries of migration. For example, Herrera (2011) discussed Cuba's complicated identities mixing European, Asian, African, and indigenous Taíno cultures, including Creole cultures dating to the fifteenth century. Imagery associated with Cuba included symbols of the island and the tropical geography such as the palm tree, the guajira, and the guajiro (female and male peasants). Symbols from Afro-Cuban religions like Santería and Palo Monte were also employed to convey images divergent from the Southwest.

In summary, both Black aesthetics and Latino aesthetics incorporated symbols and histories of birthplace cultures in Africa, the Caribbean, and Latin America. They also employed images of cultural heroes such as Martin Luther King or César Chávez. However, they differed in other iconography and color schemes.

Indigenous Cultural Expression

Unlike US Latino and Black expression, American Indian aesthetics movements are less studied and knowledge tends to be tribe-specific. This may be partly due to the small numbers of Native populations remaining in the United States or attributed to the isolation of some tribes. Thus, the next section briefly reviews aesthetic movements and concentrates on scholarship about imagery, color, and design.

Aesthetic Movements and Impulses

The Red Power movement of 1969–1970 and its members' occupation of Alcatraz in San Francisco is probably the most known activist impulse that spurred American Indian visual expression outside of Native communities (Martínez 2015; Rosenthal 2018). This was followed by the American Indian Movement of the 1970s, when Native aesthetics became more diverse. However, scholars have identified earlier expressive movements that are less known than the post-1960s era. For instance, Martínez (2015) recognized the 1920s and 1930s as early years of Indian art. He said this had followed three other stages of indigenous American art, when work was transformed from items to trade, to collectibles, to artifacts and art. For example, in New Mexico the San Ildefonso Watercolor Movement of the early twentieth century was one such development. Beginning in 1935, Oklahoma's Bacone School of art was another early undertaking (Martínez 2015). Later, in 1992, the five-hundredth anniversary of the "discovery" of America brought forth a new Native aesthetic movement "producing scores of work that addressed genocide, land loss, and the ongoing assault on Indigenous sovereignty" (Morris & Anthes 2017, 6).

Color Palettes and Imagery

Meyer (2001) said that "there is no cohesive pan-Indian culture" (31). However, authors agree that religion and nature are recurring themes in Native aesthetics (e.g., Ballengee-Morris 2008). For example, in his analyses of American Indian-produced film and video, Leuthold (1998) found that religion, myths, and nature were central. He noted that many Native American clans linked identities to plants or animals. Other researchers have further found that visions and dreams are a source of inspiration for Indian expression (Meyer 2001). Of course, Native traditions vary depending on tribes, clans, and locations. For instance, the Plains Indian narrative tradition created on buffalo robes and the winter count's visual tribal histories differed from the aesthetic expressions of many Southwestern US tribes, who featured more abstract renditions and included myths and symbols in their visual communication (Leuthold 1998). Images of nature such as lightning, mountains, animals, a full moon, or rivers may be infused with meaning, and they should not be employed indiscriminately.

Along with tribal identities, Indian belonging often related to place (Ballengee-Morris 2008). In fact, scholars remarked that traditional Native arts are frequently connected with land (Ballangee-Morris 2008; Leuthold 1998). For example, clay pots or using natural dyes in weaving are exemplars of land-related indigenous art. Land has been a primary source of intercultural conflict since the Whites in power forced American Indians off their territories, just as land appropriation has been a political issue throughout much of Latin America (Kay 2007).

Public relations practitioners incorporate Native aesthetics to show esteem for indigenous peoples. Another objective for museum communicators is to demonstrate respect for Native American's role in Americanness overall. However, practitioners must balance representing "style" without it leading to commodification such as "Indian chic" (Kelly & Kennedy 2016; Rosenthal 2018). One concern about employing Native images in museum communication is the risk of cultural appropriation, defined as "the borrowing or taking of a valued cultural item," including intellectual property and cultural expressions (Kelly & Kennedy 2016, 5). In particular, portrayals of objects pertinent to religious rituals or funerals are highly sensitive, and visual sovereignty is a concern (Blalock, Lopez, & Figari 2015; Thackara 2019). Practitioners should be overly cautious that they do not misuse sacred objects, for instance via photography. In public relations, native aesthetics must be conveyed carefully, by relying on the museum's cultural experts or consulting tribal leaders.

Asian American Cultural Expression

Next, immigrant Americans who are often combined into one pan-ethnic descriptor are discussed. As a descriptor, "pan-Asian American" lumps together an enormous number of US cultures. The largest populations in the United States have roots in China, Korea, Vietnam, Japan, the Philippines, Thailand, and India.

Aesthetic Traditions and Cultural Values

Because of the high financial status of many Asian Americans in the United States relative to other ethnic groups, Asian Americans are a frequent target

of marketers. Regardless of finances, they may be an important public to museums as residents in their communities, as tourists visiting from elsewhere, or as members of the organizations' far-flung virtual networks. However, aesthetic differences among those with East Asian and Southeast Asian heritages can be vast, making a pan-Asian designation problematic, as interviewees pointed out in Chapter 2. Communicators must be cognizant of distinctions. For instance, US census data designate Indian Americans as the wealthiest group. Conversely, Hmong Americans, who first arrived as Vietnam War refugees, have not made similar economic progress as a culture, although naturally there is individual variation from each group statistic. As with Black Americans, American Indians, and Latino/as, values and aesthetics vary by Asian subgroups. However, some pan-Asian values described in research include education, proper behavior, respect for elders and tradition, practicality, and self-effacement (Lipton 2002). Flamboyance is generally not an ideal among Asian Americans. Ideas about luck or lucky symbols may also be norms in some Asian cultures.

Cultural Palettes and Imagery

Research has centered on the symbolism of numbers and colors in Asian cultures, along with design elements and images. One intercultural communication research area relates to colors with negative connotations, such as those associated with funerals, versus colors with positive associations, such as colors typical in weddings. Western-trained communicators cannot assume similarities with European cultures. For example, white is associated with funerals in some countries such as India, Japan, or Korea—not with brides (Chen & Starosta 2005; Jandt 2018). Red may be connoted with luck, as in China, but writing a Korean person's name in red may signify death (Lipton 2002). Indian American style is often expressed in bright warm colors such as warm yellows, oranges, or reds, whereas the Japanese American aesthetic is more likely to be unassuming, pale "tea" colors. In short, subtle symbolisms may vary by specific cultures (Lipton 2002).

Even and odd numbers may have significance and certain numbers are considered unlucky, such as the number four to Americans of Chinese, Korean, or Japanese ancestry (Lipton 2002). Americans of many ethnicities working in office buildings without a thirteenth floor will understand such

beliefs. Lipton also asserted that concepts from feng shui could be applied to visual communication that desires to attract Asian groups, including yin and yang, plus the five elements of wood, fire, earth, metal, and water (2002). In summary, despite some pan-Asian values and visual norms, communicators must remember that the best communication choices highlight specific cultural norms when communicating largely to one group, rather than attempt to rely on imagery that appeals to pan-Asians overall.

Arab American Cultural Expression

As in other cultures discussed here, the dilemma of representing a pan-Arab aesthetic is that many visual traditions are associated with national identities and do not apply to a broader group (Leaman 2011). In addition, Arab and Islamic identities are often conflated. As Leaman remarked, "The identification of the Arab with the Islamic is also a problem, and not just because there are many Arabs who are not Muslims. Non-Muslim Arabs have made a huge contribution to what we now call Arab culture, and indeed non-Arab Muslims have had a significant impact on Islam as a whole" (114). Blair and Bloom (2003) define Islamic art as "the visual culture of a place and time when the people (or at least their leaders) espoused a particular religion" (153). They point out that the concept of Islamic art usually does not include Indonesia or India, despite the number of Muslims living in those countries. There is a long tradition of Islamic art, although Leaman (2011) said it was positioned in the courts of the Ottoman Empire, Persia, and Mughal India, rather than reflecting a style of everyday contemporary people. Perhaps civilizations such as those that preceded Islam are good sources of inspiration for contemporary visual portrayals if the aesthetics can be updated.

According to Jamal (2010), one challenge for US audiences viewing Arab American aesthetics is that it is difficult to separate cultural and political symbolism. Scholars point to the distinguished tradition of letters in Arab art and calligraphy (Blair & Bloom 2003; Leaman 2011), suggesting their centrality in Islamic or Arab style. However, Arabic script can suggest political meaning to some viewers, even when public relations practitioners employ it as a nod toward the revered artistic tradition of calligraphy. For

instance, Maasri (2012) explained how Hizbullah effectively used script in political art supporting their movement in Lebanon. Museum communicators employing Arabic script must also remember that it reads right to left, so the direction of images should be consonant.

Besides calligraphy, Arab Americans concentrate on "intertwined symbols of cultural traditions, class and religious experiences, and homeland identities" (Jamal 2010, 75). Traditional portrayals include embroidered robes, headscarves, and jewelry, along with agricultural symbols that express pride in the land (Jamal 2010). Gardens are another style element (Blair & Bloom 2003; Leaman 2011).

Aiello and Thurlow (2006) warned that architectural snippets can present generic descriptors rather than symbolize specific cultures, but one aesthetic tradition that unites the diverse Arab World is architecture. According to Blair and Bloom, "Architecture is undeniably the most important medium of Islamic art" (2003, 167). The horseshoe arch is emblematic of Arab style, as is the minaret or mihrab. In addition to architecture and calligraphy, Blair and Bloom added inlaid metal ware, knotted carpets, ceramics, enameled glass, and brocaded textiles as emblematic of Arab aesthetics. These traditions are excellent inspirations for graphic design styles, such as relying on geometric patterns or architectural image elements to convey Arab aesthetics. Generally human figures are avoided in Islamic art so public relations practitioners should choose other representations.

European American Cultural Expression

Finally, one last group must be addressed. Lipton (2002) noted the diversity in European American cultures, funneling down to differences among cities and neighborhoods. For instance, although one would find Romanians, Ukrainians, and Russians in New York and California, Poles will more likely be in Illinois and New York, and Ukrainians will also be found in Illinois. Most Americans of Western European ancestry can be reached with general market designs, according to experts. However, as with other groups, scholars caution that communicators avoid stereotypical visuals such as ethnic costumes unless it is communication about an event where dancers or attendees will wear traditional dress, as interviewees recommended in

Chapter 3. Art from originating countries may be appropriate signals of aesthetic appreciation, but some art such as German Expressionism or French Impressionism may be perceived as "owned" by all. Discrimination should be used in employing flags or flag colors, national seals, or sports team logos in public relations tools (Steiner & Haas 1995). Misuse occasionally creates para-crises, such as when a seemingly innocent symbol is being used by a separatist group or nationalist political party unbeknownst to the US public relations practitioner. Some European-related ethnic museums in the United States have existed for a century; these organizations are superb aesthetic resources for other communicators working in mainstream museum genres.

Cultural Aesthetics and Best Practices in Visual Communication

How can we absorb the literature on cultural aesthetics and apply it to museum communication practices? Professional graphic designers holding degrees in the discipline will be aware of design sensitivities and inappropriate uses, but museum public relations professionals often have little design training. There are also present-day ethical dilemmas and sensitivities. For instance, although everyone may understand that German "blackletter" typeface is associated with the Nazis (e.g., Heller 2014), are other uses of the typeface suitable to suggest evil?

Public relations practitioners also work with visual experts on organizational logos, a key element of branding. Heller (2014) described logos as "the direct descendant of burgher crests, coats of arms, signets, trade and factory marks, emblems of free professions, and symbols for professional guilds and associations" (189). Logos must reduce an idea to its simplest and most attractive form, be memorable, and be applicable to uses from museum lawn monument signs to stationery and websites. But a logo for a specific museum exhibit or event series should adhere to cultural norms and concerns, just as the findings about color, typefaces, and imagery showed.

Steiner and Haas (1995) suggested several ways of signaling other cultures in one's design such as redeploying an icon or image; employing a typeface, words, or language characters that represent a culture; using an ethnic symbol; or juxtaposing images to suggest a different idea than

expressed by the original images. Further, they described the challenges of choosing typefaces when translating materials into multiple languages, because not all fonts work for Cyrillic, Arabic, or Chinese, for example. Layouts are also affected by languages, depending on whether they are normally read in flush left and ragged right such as in English or Russian; flush right and ragged left such as in Arabic, or flush top and ragged bottom as in Chinese (208).

Of course, a challenge not deliberated by scholars cited here is recognition of mixed race and hybrid cultures, as described in Chapter 2. However, visual communication can account for blended identities and emerging ones by implementing visual styles in new ways, too.

Cultural Aesthetics and Public Relations Practices

According to Hyland (2006), traditionally *brand* referred to the logo or mark that identified an organization but has expanded to the idea of *total identity*—visual management of all an organization's activities that can even extend to sounds and smells. Although this chapter has focused on visual expression, Schmitt and Simonson (1997) noted that organizations can create sound identities, too. Typically thought of as advertising music, the concept evolved to include the types of sounds used in a museum's digital media, or even within the museum itself. Of course, curators use sound effectively in museum exhibits. For example, the "sound brand" of the National Museum of African American History and Culture on the building's lower two levels is based on the voices of luminaries such as Martin Luther King. Conversely, upstairs in the culture gallery the oral aesthetic is more dependent on music excerpts from notable African American performers. Other museums could employ this technique in their non-exhibit communication, such as on their websites or podcasts. Native American "site-singing" where artists or performers sing to places (Morris & Anthes 2017) is such a possibility for incorporating sound into a Native museum's brand. A brainstorming session among communicators, curators, museum educators, and other institutional professionals could explore possibilities.

The chapter has provided background to enable public relations practitioners to incorporate elements of cultural aesthetics into their visual

communication. The goal was to impart knowledge that could improve their intercultural communication competence. For academics, it laid forth how the role of cultural intermediary extended into making specific choices within communication programming in order to establish intercultural communication competence. Studies on cultural aesthetics and styles are positioned as elements of visual code-switching.

The chapters in the next unit discuss other ways to develop relationships with diverse publics via public relations planning, program implementation, and evaluation.

PART TWO

MUSEUM PUBLIC RELATIONS PLANNING, IMPLEMENTATION, AND EVALUATION

CHAPTER 5

Public Relations Planning and Evaluation

RESEARCH IS IMPORTANT IN all phases of a public relations program. Formative research helps an organization set its goals and target its publics. Summative research assists in determining whether the communications programming met its goals and objectives. And while a program is underway, research is used to monitor and provide feedback if modifications are needed midstream. Since the mid-twentieth century, practitioners have conceptualized the four stages of public relations activities as research, planning, implementation, and evaluation. This process is considered to be circular, not linear, because evaluation findings then feed information back into the research stage of the next public relations plan or campaign.

The purpose of this chapter is threefold: to lay out a short review of the public relations planning process; to present a new model of public relations strategies and tactics; and to share observations from museum professionals about communication program evaluation. Planning is central to this text because without strategic planning, museums will be challenged to reach a diverse set of constituencies and achieve their missions.

Depending on the public relations office or practitioner, a strategic plan is broken into various elements which are combined or divided in various ways. This text recommends a modified version of the model used by Broom and others (e.g., Broom 2009), as displayed in Figure 7. Of course, many

museums already have a plan format that they prefer, so elements may be organized differently from the rubric discussed in this chapter.

FIGURE 7. Public Relations Planning Process

Problem Statement
Situation Analysis
 Background
 Internal Organizational Strengths and Weaknesses
 External Opportunities and Threats
Program Goal
Target Publics and Descriptors
Objectives by Publics
Message Strategies by Public
Action and Communication Strategies and Tactics
Implementation (staff, budgets, schedules)
Evaluation (ongoing and summative)

Note: Concepts modified from Broom 2009.

Problem Statement, Situation Analysis, and Goal

The public relations plan starts with a brief problem statement based on a research-rich organizational review and situation analysis, including a SWOT analysis (internal strengths, internal weaknesses, external opportunities, external threats). More about research is discussed later in this chapter. A short behavior-oriented goal statement encompassing the entire program is written to direct the ultimate outcome the museum desires, informed by the realities of the present situation as described by the situation analysis.

Publics, Message Strategies, Objectives

Then, practitioners define target publics, including descriptors such as demographics, psychographics, geographics, and identities. Although the terms are used interchangeably in this book, Grunig (2009) differentiated publics from audiences, and this text concurs with the spirit of his remarks.

As he described, audiences are persuaded for the sole benefit of meeting organizational goals. This fits with a marketing orientation toward communication. On the other hand, publics are groups who have mutually beneficial relationships with organizations. This is the public relations discipline's conceptualization of the assemblages with whom practitioners communicate.

US census data and other publicly available surveys assist in describing demographics, enhanced by the museum's own primary research as available. For instance, local or state tourism agency data or commerce department statistics can be mined for relevant information about prospective tourist publics. A museum's zip code analyses of members, donor rosters, or attendee lists can delineate the geographic ranges of current museum patrons. Similarly, some social media metrics illuminate geographic distribution. Communicators can then target the geographic gaps to reach others in their community or region. As other chapters describe, mainstream museum communicators also can learn from their counterparts at culture-centered museums about how to reach diverse museum audiences.

Objectives, which are mini-goal statements, are set for each public, as are message strategies. Whereas a program goal statement declares the end-behavior desired (such as "attain 75,000 attendees through December 31, 2021"), objectives can include behavioral, cognitive, or affective measures. Examples range from building awareness and knowledge about a collection or an event to changing attitudes about a topic or the museum itself.

Most important, objectives must be time-oriented (achieved by a certain date), specific, and measurable. Those adhering to the SMART acronym popular among some communicators would add reasonable and achievable (Specific-Measurable-Achievable-Reasonable-Timely). The gist of this advice is that a museum's objectives should be segmented by public and divided into manageable desired outcomes which are mutually beneficial to the target public and the institution.

Message strategies are the key points that the museum wishes to convey to a particular group. Message strategies are not the exact words that appear in a blog post or a brochure; they are the main thoughts an organization wants its public to have about the museum or a program. The intention of including message strategies in a plan is to gain agreement from everyone involved in the plan's success about what the organization is trying to say to its stakeholders (see Figure 8 for examples).

FIGURE 8. Sample Objectives and Message Strategies by Public

Public One: Urban Working Professionals

OBJECTIVE 1: By May 31, build knowledge about museum's Thursday Night summer concert series among 15% of working professionals who reside in the city.

OBJECTIVE 2: By May 31, increase favorable perceptions of the museum's programming for urban workers by 12%.

OBJECTIVE 3: By September 1, increase attendance over last summer's attendance at the summer concert series by 10%.

MESSAGE STRATEGY 1: The museum is a convenient location for pleasurable after-work activities.

MESSAGE STRATEGY 2: The museum is an affordable venue for after-work activities.

Public Two: Suburban Seniors

OBJECTIVE 1: By June 30, increase top-of-mind awareness about the museum to 15% of county residents 60 years or older.

OBJECTIVE 2: By June 30, increase the number of county residents 60 or older who are knowledgeable about the museum's need for volunteers.

OBJECTIVE 3: Increase museum volunteers who are seniors from 15 to 22 by December 31.

MESSAGE STRATEGY 1: Volunteering at the museum is an enjoyable means of meeting others in the community.

MESSAGE STRATEGY 2: Museum volunteering is a good method of supporting local arts and culture.

These sections are the foundation for the public relations plan. Next, practitioners choose suitable action and communication strategies and tactics that they will implement. Substantial space in this book is devoted to action and communication strategies, to which museum communicators devote most of their daily efforts. Detailed discussions of particular action and communication tactics are in the chapters that follow. For that reason,

following the general overview below, the rest of the chapter concentrates on public relations evaluation.

Action and Communication Strategies and Tactics

Strategies refer to the overall implementation approaches, such as deciding to rely on media relations or social media to publicize an upcoming exhibit. Tactics are specific elements within the broader strategy. For instance, tactics within a traditional media relations strategy might include inviting the local arts reporter to meet with a historian or curator, distributing a press release, or circulating a media listing. If the main strategy is relying on social media, tactics could be posting on Twitter once every day or uploading new photos to Instagram after each exhibit opening.

Action strategies may be under the auspices of a public relations department—the most common is the special event, as discussed in Chapter 10. But action strategies may also create changes in the museum that the public relations practitioner recommends to management but over which the public relations function does not have control. These could be severe, such as not accepting donations from a particular company or excluding from a planned lecture series a speaker deemed as racist. More typical are suggested action strategies that arise in the planning process, such as the public relations office recommending longer opening hours for a blockbuster exhibit or advising that the museum lease extra wheelchairs to have on hand for a history program anticipated to attract seniors. Other possibilities might be advocating for discounted admission at a youth-oriented event or offering more child-oriented food in the museum café on weekends.

In all these cases, the decisions are not typically the prerogatives of the communication office. As the previous examples suggest, decisions might be authorized by a museum's restaurant manager, a facilities chief, or even the board of directors. Sometimes the organization must implement an action strategy in its goal to be an ethical community citizen and to have two-way symmetric relationships with its publics; other times, it is simply a practical organizational change. In summary, though, action strategies

are included in public relations plans with the knowledge that some recommendations are decisions where the public relations practitioner has input, but not full authority.

Communication Strategies and Tactics

Many public relations professionals separate communication strategies and tactics into four types: earned, owned, paid, and shared. *Earned* refers to publicity gained through media relations. As Chapter 8 discusses, the advantages are the perceived third-person endorsement of traditional media and their reach, but the disadvantages are lack of control over the content and the placement of the message. *Owned* media are tools where the content is controlled by the organization. In communication tactics such as brochures, newsletters, or websites, museums develop the wording and select the images used in their communication, then place the messages as they see fit. Chapters 6 and 9 expand on these options. The third type of strategy is *paid* advertising. Small museums seldom choose this because of budget constraints. However, as with owned media, when a museum pays for advertising it chooses the words and visuals to represent exactly what the institution wants to say. With the exception of some challenges with digital advertising where advertisements have been displayed juxtaposed against unfavorable content, the organization also has input into placement—where and when advertisements will appear. The fourth is *shared* media on social platforms, the topic of Chapter 7. With these networked forms of communication, museums benefit in reach and affordability, but after the initial post the institution has no control over its distribution or the ensuing reactions that will accompany it.

Although "earned, owned, paid, and shared" are handy media-centric divisions for overall planning, another way to think about selection of strategies and tactics is displayed on Figure 9. This configuration separates one-way, two-way, and networked communication strategies. It then delineates examples of tactics within each broad category, such as two-way

communication divided into direct interpersonal contact activities or mediated communication. This allows a practitioner to link foundational public relations theory (e.g., Grunig & Hunt 1984) with communication implementation, rather than divorce theory from practice.

As a third diagram (Figure 10) describes in more detail, there are many other criteria a communicator considers when choosing communication tactics. For most museums, cost and the suitability for the target audience are paramount. As interviewees noted in Chapter 7, despite potential cost savings, some museums could not migrate to online newsletters completely because they had older constituents who preferred print copies. Consequently, the practitioners produced print versions for these groups, testimonials to how well the professionals understood their stakeholders. A third consideration is desired outcome. For instance, media listings, posters, or street banners are effective at stimulating awareness but building knowledge about an upcoming exhibit requires in-depth information available in a newsletter or newspaper article. Further, changing attitude or opinion may require interpersonal communication of some type—such as a lecture or an open house. One would rarely change an attitude about a museum exhibit's value merely by seeing a street pole banner or flyer. In summary, communication tools vary in their abilities to reach specific market segments and achieve various objectives.

Evaluation Overview

For decades, scholars have been concerned about the lack of evaluation in public relations practice (Broom & Dozier 1990; Gregory & Watson 2008; Pieczka 2000; Watson 2012). However, it is necessary for organization managements to monitor the value of their staff functions and invaluable for practitioners in order to continually improve their public relations programming. Broom's touchstone model of the three levels of public relations evaluation is a helpful taxonomy for considering measurement of program preparation, implementation, and impact (2009, 358; see also Broom & Dozier 1990, 70 and 87).

FIGURE 9. Public Relations Tactics

ONE-WAY COMMUNICATION

One-Way Media: Working with Traditional Media ("Earned" media)

Newspapers and Magazines (print or computer-mediated)

Tools include news releases, feature releases, media advisories ("alerts"), tip sheets, fact sheets, press kits, "listsicles," query letters/emails/calls to solicit coverage (pitch letters), requests for editorial board meetings, op-ed page columns, letters to the editor, listings, photos/captions or infographics. Satellite media tours, news conferences. May include two-way elements, e.g., blogs, news reader responses on news websites.

Radio and Television (broadcast or computer-mediated)

Tools include news releases, feature releases, video news releases, audio news releases, media advisories, tip sheets, fact sheets, press kits, query letters/emails/calls to solicit coverage (pitch letters) or talk show appearances, community calendar items, announcer info (radio), unedited footage or actualities (B-roll), public service announcements, infographics. Satellite media tours, news conferences. Possible two-way elements.

One-Way Media ("Paid" media)

Paid advertising.

One-Way Controlled Tools ("Owned" media)

Print Tools

Letters, fliers, stuffers (inserts), brochures, invitations, organizational newsletters/magazines, booklets, annual reports, other reports, position papers (white papers), organization books or catalogs, signs, banners, posters. "Direct mail" may have variety of forms.

Non-print Tools

> One-way multimedia, one-way electronic bulletin boards, websites without interactive elements, organizational videos, podcasts, videocasts, live-streaming audio or video, email programs (e-blasts), other.

Other Tools

> Premiums (giveaways, freebies, merchandise), non-electronic bulletin boards, brochure racks, exhibits (may include print and non-print elements). Set-ups for "selfie" photography.

TWO-WAY COMMUNICATION: ORGANIZATION-CENTRIC

Two-Way Direct Contact

> Individual or group meetings, speeches, speaker's bureaus, open houses, tours, conferences, receptions, parties, other special events, including "guerilla marketing" events.

Two-Way Mediated Communication

> Telephone hotlines, telephone conferences, video conferences, websites with interactive elements, other.

TWO-WAY COMMUNICATION: NON-ORGANIZATION-CENTRIC

Two-Way Mediated Communication

> Citizen media (grassroots media) such as blogs, e-zines, etc. Media produced by other organizations such as research institutes or arts organizations to which one can contribute.

MULTI-WAY NETWORKED COMMUNICATION (SHARED)

> Social media and other platforms such as YouTube, Facebook, Twitter, Instagram, Flickr, Pinterest, Tumblr, Vimeo, etc. Review sites such as Tripadvisor and Yelp. "Free" posts and paid advertising.

FIGURE 10. Sample Considerations for Choosing Communication Tactics

1. Cost
2. Target public
 - a. Geographic locations
 - b. Age cohort (senior citizens, middle-school students, college students, etc.)
 - c. Education level and income
 - d. Psychographics
 - e. Cultural identity
 - f. Other identities/memberships
3. Desired reach
4. Desired outcomes
 - a. Awareness
 - b. Knowledge
 - c. Attitude change
 - d. Emotional response
 - e. Relationship outcome
 - f. Behavior
5. Preferred level of organizational control over message, placement, distribution
 - a. Controlled tactics (owned or paid media)
 - b. Uncontrolled media (earned and shared media)
6. Two-way feedback loop desired?
7. Multi-way input and feedback desired?
8. Levels of participation/involvement by publics
9. Levels of information seeking or entertainment seeking by publics

Many practitioners do not advance beyond measuring their communication implementation with diagnostics of where messages were placed and the potential reach of their messages. Nonprofits attribute infrequent evaluation to lack of resources, but the dearth of attention to evaluation is true in the corporate sector as well (Gregory & Watson 2008). However, in the evaluation impact stage professionals use survey data and behavioral

metrics to determine knowledge gain, opinion and attitude change, and behaviors influenced by a public relations program. These methods illuminate the links between forms of communication and outcomes sought after by museums. Hon and Grunig's (1999) set of survey measures for evaluating key relationship concepts (trust, credibility, etc.) is another useful tool readily available free to practitioners on the Institute of Public Relations website.

Broom's evaluation model (2009) also called for measuring repeated or sustained behaviors, along with social and cultural changes. These elements are aligned with concepts outlined in the diffusion of innovations theory (Rogers 2003) and relate to long-term goals for museums. Examples at the organizational level are long-time memberships and donations, where satisfied museum patrons renew year after year without questioning their commitment to the institution or the value of the relationship. At the societal level, examples are building long-term understanding of a specific culture (pertinent to an ethnic museum), or of arts and culture more broadly. Another such goal would be making sustainable inputs into the innovativeness of the community where a museum is located. As noted elsewhere, museums help to create vibrant workforces and communities. Obviously, measurement of long-term societal outcomes is more complex than determining attainment of short- or long-term organizational goals and objectives.

Gregory and Watson (2008) discussed international practitioners' desire to have a "magic" one-item measure of public relations evaluation, such as return on investment (ROI). If this is a metric used by museum management, public relations officers can sum the cost of salaries and other communication expenditures and divide it by the portion of the museum's revenues for which communicators can take credit. As in all public relations settings, such formulas are complicated, because unlike in a laboratory, the practitioner cannot claim that all evaluation metrics were the result of his or her communication programming. For instance, a communicator may credit a newsletter item for growing museum café sales in the following quarter, but the increase may have been due to an enthusiastic docent who recommended the restaurant on her tours.

Practitioners use a variety of software platforms and vendors to help them track communication outputs and exposure. For example, Burrellesluce.com,

Business Wire, Meltwater Platform, and Cision assist with traditional media and social media monitoring of message exposure. Practitioners may use dashboard systems such as Hootsuite for social media set-up, scheduling, and monitoring traffic or museum mentions. There are also web analytic services, blog services with analytics, and email campaign organizers and evaluators. Some of these are expensive, so practitioners should investigate their usefulness and affordability and inquire about nonprofit organization discounts. Programs available from Internet platforms such as Google Analytics, Facebook Insights, Instagram Insights, and TWEETDECK® are other possibilities.

Faced with the dilemma of needing to measure social media, international public relations organizations such as the Public Relations Society of America, the Global Alliance for Public Relations and Communication Management, the International Association of Business Communicators, and other associations held an industry summit to develop measurement standards (Conclave 2013). The results of their work are freely available on the Internet. Six priority evaluation areas identified by practitioner representatives were (1) content and sourcing, (2) reach and impressions, (3) engagement and conversation, (4) opinion and advocacy, (5) influence, and (6) impact and value. It should be noted that some of the terminology in the Conclave document differs from more commonly used jargon in public relations research.

What are examples of evaluation in museum communication? Interviewees at twenty-two museums in this study grappled with this topic, as research has shown public relations experts do in every type of workplace (Watson 2012). Themes in the interviews ranged from employing traditional measures of specific tactics, to developing creative ways of measuring tactics, to determining effects of communication programs on museum goals. The following section offers observations from museum professionals.

Measuring Communication Preparation and Implementation
Thinking about the implementation stage of Broom's model (2009), practitioners said they tracked media clippings and broadcast coverage to gauge effectiveness of media relations and publicity efforts. They used various social media analytics, online advertising analytics, and website statistics to

tabulate numbers of message recipients on their digital and social platforms. These forms of evaluation helped practitioners gauge the reach and potential number of impressions a message could be seen or heard. The data also allowed them to compare the effectiveness of communication channels— what worked best in what situation? As all nonprofits have limited staff and financial resources, this was valuable feedback. It ensured that museum communicators would not waste time in the future employing ineffective tactics.

Evaluating Communication Programs in Ethnic Museums

However, as one practitioner noted, the "big question is trying to make the link between the communication tactics you are using and the behavior" of museum publics. Every museum expressed the challenge of measuring which communication tactics best drove museum inquiries, visits, or other desired behaviors. Many organizations used guest books or simple types of surveys, such as at the ticket counter, to find out "how visitors heard about us." Several said that visitor surveys were imperfect because "they don't always complete the forms." However, pragmatic museum professionals extracted the available information they were able to garner, even from incomplete surveys.

Practitioners also employed marketing techniques such as promotions where museum visitors had to submit something to get a discount. One professional had a "kid's page" in her newsletter where she featured a coupon for free admission and a cookie to help her track the connection between readership and turnout. Another used different codes to track discounts, finding, for instance, that the museum had more responses from food and wine blog coverage than they did from ethnic blog items. That interviewee was also amazed to find that a small listing in an auto club magazine generated many calls to the museum, unlike some paid advertising elsewhere that did not produce desired outcomes.

Overall, most communicators checked attendance figures to determine the impact of major communication tactics. For instance, a California professional said that after a particular press release was used by local media, attendance on the following Saturday was five times the normal Saturday attendance. She also examined gift shop sales as another measure of effectiveness, especially because she cooperated with other museums in

FIGURE 11. Public Relations Measurement for Museums and Examples

PREPARATION

Research, message strategies, and tactics appropriate for publics and objectives

Quality of communication or event produced

IMPLEMENTATION

Distribution

Number of events organized

Number of news/feature releases issued, social media items posted, controlled tools mailed, etc.

Placement

Number of items used in media, blogs, partner publications, digital media, etc.

Potential Reach

Possible exposure to message (media circulation or ratings, traffic averages for outdoor advertising, event RSVPs, number of employees/members on partner organization lists, etc.)

Reach

Number of individuals who read traditional, digital, or social media items, attended events, heard podcasts, etc.

SHORT-TERM OUTCOMES: COGNITIVE AND AFFECTIVE

Increased awareness, knowledge, favorable attitude

Heightened emotional connection (sentiment analysis)

SHORT-TERM OUTCOMES: BEHAVIORAL

Increased attendance

Increased memberships

Increased donations and sponsorships

Increased gift shop and restaurant purchases

Increased volunteers

Increased community partnerships (non-sponsors)

LONG-TERM OUTCOMES: ORGANIZATION-PUBLIC RELATIONSHIPS

 Control Mutuality (empowered to influence each other)

 Trust (integrity, dependability, competence)

 Satisfaction

 Commitment

 Exchange Relationships (transactions that provide mutual benefit)

 Communal Relationships (genuine concern for each other)

COMMUNITY/SOCIETAL OUTCOMES

 Increased understanding of cultures and cross-cultural empathy, reduced prejudice

 Improved innovativeness of workforce

 Enhanced urban brand as a creative and/or historic city

 Increased local tourism

 Increased community support for arts and culture

Note: Concepts adapted from Broom 2009; Hon & Grunig 1999.

distributing media features about museum shops as unique shopping destinations. Another California practitioner said that after a social media video promotion, an event attracted 3,500 visitors in one day, one of the largest events to date for the relatively small museum. In short, regular museum attendance data, event turnout, and museum store and café receipts were straightforward gauges of likely communication impact on an organization. Although they were not mentioned in interviews, tallies of new donations, new memberships, or volunteer sign-ups are similar behavioral indicators. A challenge for professionals was devising a simple system to compare public relations tactics against desired outcomes in cross-lagged time periods (communication tactic in Time One, sought-after behavior in Time Two), recognizing limitations in isolating the communication effects from all the other possible influences on behaviors.

Despite these successes, interviewees did not mention measuring relationship concepts such as trust (see Hon and Grunig 1999), nor were there any discussions of trying to demonstrate to museum management the overall

return on investment of communication expenditures. In addition, when discussing evaluation, several interviewees mentioned that they perceived "word of mouth" was important but said that they did not know how to measure it accurately. All in all, though, contrary to other research studies cited earlier, the interview findings demonstrated that practitioners were employing measurement techniques when possible and were certainly cognizant of evaluation's necessity. Donors and grant-making foundations are also interested in evaluation metrics, so museums able to provide data about accomplishments may have an edge in future development endeavors. Thus, public relations practitioners must work with their colleagues to install cost-effective, straightforward evaluation techniques to benefit all the departments in their museums.

In summary, planning and evaluation are the framework for public relations programming, even though practitioners spend most of their time in implementation: producing communication tools or events. This chapter has presented reflections about evaluation from museum practitioners. Second, it displayed a planning framework modified from others in the public relations literature (Figure 7). Third, sample message strategies and objectives are displayed (Figure 8). Fourth, a comprehensive taxonomy of strategies and tactics is explicated (Figure 9), along with criteria to help public relations professionals select pertinent tactics (Figure 10). Finally, a categorization of evaluation approaches tailored for museums is offered (Figure 11). To conclude, museum practitioners employ professional planning and communication techniques as outlined here to boost their chances of extending the museum's mission to broader publics, thereby accomplishing institutional and societal goals.

CHAPTER 6

Museum Websites and Multimodal Communication

THERE IS A PLETHORA of research on increasing the effectiveness of websites. Websites help meet museums' strategic objectives such as increasing attendance, donations, memberships, and volunteering. They communicate an attractive brand and institutional expertise. They also aid in achieving relationship objectives with target publics once interactive components are employed. These relationships are further enhanced when target audiences view the websites as a reliable, convenient spot available 24–7 to find information. (Although museum curators and educators also use websites for goals such as expanding access to collections, this text does not address such topics.) And finally, museum websites contribute to the institutions' societal goals such as improving the cultural environment of their communities.

The purpose of this chapter is to convey the state of US museum website communication and to suggest best practices for museum professionals. The main preoccupations of research about museum websites have been the quality of information and appearance, usability and navigation features, and ability to foster relationships with target publics. Findings about these ideas in the academic literature were derived from content analyses, surveys, experiments, or usability studies. In her recommendations to website

producers, Kabassi (2017) recommends some of these methodologies for practitioner evaluation of their organizational websites, too, with Pallas and Economides (2008) stressing that evaluation of a website's functionality must continue throughout its lifetime.

A challenge for museum practitioners interested in gaining advice from scholarly research is the vast number of taxonomies and terms used, sometimes describing different concepts. Following are highlights of research about museum websites useful to communication scholars or museum professionals.

Website Features and Interactivity

As in social media studies, interactivity is a key concept in website research. For instance, in one study Capriotti and his colleagues (2016) studied two types of interactivity. One was presentation interactivity, concerned with the website resources used to present information. The other was relationship interactivity, which dealt with technologies used to interact with museum website visitors. Although their research investigated the websites of the top 100 most visited museums in the world, they found low levels of interactive tools employed (Capriotti, Carretón, & Castillo 2016). Overall, museums relied on graphic resources, although in their study American museums were more apt to use audiovisuals than institutions in other global regions. On a positive note, the authors observed that museums were adding resources to boost visitor interaction, even though the techniques had not yet been maximized (Capriotti, Carretón, & Castillo 2016).

Looking just at 120 museums in the Catalonian region of Spain, another study of websites found that audio and video features were present in 10-15 percent of the sites. Interactive tools such as blogs, social networks, and the like also were seldom employed, although email was offered by 84.2 percent of institutions. In short, museums were not using "interactive, multidirectional and symmetrical communication" (Capriotti & Pardo Kuklinski 2012, 624). Another Spanish study in a medium-sized city found that just 70 percent of the museums had websites and relied more on traditional media and controlled tools than digital strategies to reach prospective visitors and other publics (Capriotti 2010).

Research on museum websites in five countries similarly found low usage of Web 2.0 technologies (López, Margapoti, Maragliano, & Bove 2010). However, scholars combined curation and educational features with those that fostered symmetric communication and relationship building, without a formal classification system. Thus, the work is less useful to communication researchers or practitioners as a guiding schematic. On the other hand, Pallas and Economides (2008) presented a comprehensive model of museum website evaluation guidelines, consisting of six major categories: content, presentation, usability, e-services, technical ability, and interactivity/feedback. Although they included aesthetics and content criteria such as accuracy of information, their main concerns were technical aspects of websites. Notably, none of the aforementioned investigations mentioned considerations for outreach to diverse audiences such as the culture-specific aesthetic traditions described in Chapter 4.

Website Content, Aesthetics, and Identities

Moving from technologies to appearance, one taxonomy of website aesthetics delineated a long list of judging criteria, from balance and coherence to color and text fonts (Moshagen & Thielsch 2010). Similarly concerned with visuals, Pierroux and Skjulstad (2011) emphasized a website's role in communicating a museum's public image, achieved through the identity and branding visible on the site. Other scholars have scrutinized how looks matter to museums' strategic aims. For example, an experiment by Pallud and Straub (2014) affirmed the relationship between aesthetically pleasing websites and desired behaviors from respondents. As they said, visitors who have had a good experience with a museum website are "more likely to visit the museum in person" (367).

Finally, a series of studies about African American and ethnic museum digital communication (Johnson & Carneiro 2014; Carneiro & Johnson 2015; Johnson & Pettiway 2017) studied how cultural identities were portrayed in aesthetics (layouts, color palettes, font styles), logos, slogans, types of visuals, and the languages used. The authors found that these elements contributed to presenting ethnic or racial identities online, central to culture-centric museums' branding.

Dynamism

As discussed in the chapter on social media, one consideration for practitioners producing website content is the balance between one-way communication and two-way communication, described as informational and interactive content in Chapter 8. This chapter expands on interactivity concepts for websites and adds other content considerations. Two other concepts related to website research and production are visual dynamism and multimedia dynamism. Visual dynamism is defined as the "force and energy aspect of credibility" (Martin & Johnson 2010, 165). Its meaning in this text differs from studies where dynamism is defined as timeliness of content (e.g., Capriotti & Pardo Kuklinski 2012). Many museums create visual dynamism with photo slideshows or videos on their homepages. Multimedia dynamism also includes sound, such as when websites feature podcasts or slideshows with narration. For example, a study of visual dynamism and multimodal dynamism in African and African American museums found that although these culture-specific museums expertly used visual dynamism to stimulate viewers, they were woefully short of multimodal features such as video, music, or narration (Johnson & Pettiway 2017). This was a disappointment given the oral traditions of many Black cultures.

As Johnson and Martin (2014) found in their website study, however, the most visually dynamic websites may be less favored by website users if the aspects that make it dynamic also create navigation impediments. In short, dynamism must be balanced with usability. Usability is the website's ease of use, which includes three central elements in most research. One is the ability to access the website and the second is its loading speed. Navigation is a third dimension of usability, which can include everything from the presence of logical cues and clear mapping, to page size and scrolling mechanisms. The ability of disabled users to access the website is another consideration. Section 508 of the Rehabilitation Act of 1973 applies only to federal websites, but the Americans with Disability Act encourages organizations to "communicate effectively." The US General Services Administration (2020) website is a resource on this topic. Obviously, usability problems reduce a museum's ability to use its website to pursue new stakeholders and further relationships with existing ones.

Observations by Museum Practitioners

Next, this chapter presents a few reflections from museum practitioners and then describes the results of a quantitative content analysis of museum websites. Examples of some websites that illustrated key concepts are highlighted. Interviews with museum practitioners affirmed the importance of a website in reaching target publics. They described it as the "go-to" vehicle for current information about the museum. According to one Los Angeles practitioner, "The website is the most accurate, up-to-date point of information." Often constrained by small budgets and staffs that limited their communication aspirations, the professionals could readily critique their organizational websites' strengths and weaknesses. For instance, in discussing the color palette and design features perceived as strengths, one clarified, "It's inviting in certain ways. The brown color signifies sort of the land, this very human sentiment." However, in considering weaknesses, another practitioner said he wanted to do more to optimize searches for the museum' site (SEO) and improve website analytics to better evaluate its effectiveness. A third commented on usability: "We want to develop our website more. I think we want to make it more user friendly, more accessible, just easier to navigate."

Content Analysis of US Museum Websites

For a broader look at museum websites, 224 US museum websites were examined to tally content that was informational or interactive. The content analysis also measured whether common strategic goals of museum communication departments were pursued in website features. For each variable, comparisons were conducted among the five museum genres in the study: mainstream art, mainstream history, American Indian, African American, and other ethnic museums. (See Appendix B for the methodology of the website content analysis.)

Informational and Interactive Features

As museum public relations professionals had noted, the informational aspects of websites were important to museum goers and their staffs. In

addition to rarely changing information such as location, opening hours, and admission fees, a popular feature was the online newsletter, with 60.3 percent of museums having one. Newsletters were often on art museum sites but rarely on American Indian museum homepages (X^2 = 80.704, 4 df, p < .05). Of course, as discussed in Chapter 9, many museums also distributed hard-copy newsletters or emailed digital versions. Blogs on the websites fulfilled a similar role to online newsletters, except with information nuggets that sometimes were less comprehensive than newsletter articles. Blogs were available via 37.5 percent of museum websites, with art museums most likely and African American institutions least likely to have them (X^2 = 32.794, 4 df, p < .05).

TABLE 1. Percentage of US Museums Featuring Website Functions

Function	Total	Art	History	Other Cultures	African American	American Indian
Email/Contact us	85.7	85.7	85.0	81.0	80.5	95.6
User sign-up	69.2	94.6	65.0	64.3	63.4	51.1
Search	62.9	86.8	75.0	59.5	53.7	35.6
Interactive calendar	47.3	60.7	40.0	57.1	51.2	24.4
RSS	2.2	1.8	2.5	0	4.9	2.2
User controls	1.4	0	7.5	0	0	0
Surveys or polls	0.4	1.8	0	0	0	0
Online newsletter	60.3	92.9	70.0	64.3	61.0	6.7
Blog	37.5	66.1	42.5	26.2	14.6	28.9
Donate	84.4	80.4	82.5	95.2	95.1	71.1
Become member	82.6	96.4	82.5	88.1	82.9	60.0
Volunteer	61.2	71.4	72.5	52.4	61.0	46.7
Mobile app	14.3	35.7	10.0	9.5	7.3	2.2
	n=224	n=56	n=40	n=42	n=41	n=45

Interactive website elements also varied greatly, as Table 1 displays. User sign-up availability was visible on 69.2 percent of the museum homepages and search functions were available on 62.9 percent. Sign-up features had significant variation among the five museum types (X^2 = 25.366, 4 df, p < .05), as did search boxes (X^2 = 31.598, 4 df, p < .05). Interactive calendars were on 47.3 percent of websites; they also displayed statistically significant differences by museum genre (X^2 = 16.212, 4 df, p < .05). These differed in sophistication but were useful tools for locals planning impromptu museum excursions or tourists organizing future museum visits.

RSS Feeds were on 2.5 percent of the websites, and the ability to email or contact the museum was observed on 85.7 percent; neither portrayed significant differences by genre. Although feedback from constituents is valuable, at the time of coding, art museums were the only institutions to feature homepage surveys or polls, and rarely at 1.8 percent of all the organizations in the study. In the other four museum genres website visitors were not asked their opinions, although it is possible that social media and emails were used for this two-way communication.

Similarly, user controls such as increasing type size or color contrast for visually impaired patrons were seldom included. History museums were the only category to feature these at 7.5 percent (X^2 = 13.837, 4 df, p < .05). However, the Hispanic Society of America's homepage noted at the bottom that users could "download homepage screen software for visually impaired users." Although this book concentrates on cultural diversity, inclusiveness that extends to museum patrons of various abilities is commendable.

Meeting Strategic Objectives

Indeed, even the most modest websites excelled by including revenue-generating features such as icons that website viewers could click to donate or join the museum. Overall, 84.4 percent had donation icons and 82.6 percent had membership ones. Among all categories, ethnic museums and African American institutions had the largest percentage of readily apparent

"donate" buttons, and art museums were best at soliciting members from the homepage. As Table 1 shows, there was variety among the museum genres on these items, with statistically significant differences regarding donation (X^2 = 14.149, 4 df, p < .05) and membership features (X^2 = 24.317, 4 df, p < .05). Seeking volunteers was another strategic goal apparent on websites, with 61.2 percent of the 224 museums featuring an icon promoting volunteer sign-up. Art and history museums solicited volunteers most in this manner (X^2 = 9.994, 4df, p < .05).

Mobile Platforms

Some museum interviewees discussed the importance of mobile platforms, especially for people of color, given statistics about mobile usage. Supporting these experts' comments, a Pew Research study on the demographics of cell phone ownership found that 98 percent of African Americans and 97 percent of Latinos owned mobile devices, compared to 94 percent of White Americans (Smith 2018). Pew also noted that cell phone penetration differed by age, education, and income, with younger, more educated and financially successful Americans more likely to own a cellular device. And a more recent Pew Research report emphasized the importance of mobile phones to lower-income Americans, finding in early 2019 that "26% of adults living in households earning less than $30,000 a year are 'smartphone-dependent' internet users—meaning that they own a smartphone but do not have broadband internet at home" (Anderson & Kumar 2019). In short, research delineates the importance of cell phones in American life.

Despite these trends, just 14.3 percent of museums overall offered the ability to access their website via a mobile interface. There were statistically significant differences among museum genres, as apparent with 2.2 percent of Native museums and 35.7 percent of mainstream art museums boasting the feature (X^2 = 29.352, 4 df, p < .05) at the time of coding. Clearly, US museums are evolving toward increased mobile capabilities, although some have made more progress than others. Notable was the New Hampshire Historical Society Museum's promotion of its new mobile application on its homepage, boasting an "Audio Tour and Activities for Kids." Museums interested in expanding relationships with lower-income Americans and residents of color have discerned the applicability of mobile usage research to their target publics.

Visual Quality and Multimedia Dynamism

The majority of the 224 museum homepages analyzed were visually rich, with 95.1 percent displaying photos and 78.6 percent highlighting other types of visuals such as illustrations, graphics, historic maps, replicas of artwork, and the like, as Table 2 shows. These varied by museum category. For instance, 100 percent of art and history museum homepages included photos, with fewer at the other genres of organizations (X^2 = 13.392, 4 df, p < .05). Other non-photo images were most likely to be found on art or African American museum homepages (X^2 = 37.662, 4 df, p < .05). Photos of a variety of attendees or volunteers were visual signals in most museums that individuals of all types were welcome.

TABLE 2. Percentage of US Museum Homepages with Visual or Multimodal Dynamism

Feature	Total	Art	History	Other Cultures	African American	American Indian
Photographs	95.1	100.0	100.0	85.7	92.7	95.6
Other images	78.6	92.9	70.0	88.1	90.2	48.9
Rotating Images	67.0	73.2	77.5	59.5	70.7	53.3
Video	13.8	12.5	15.0	16.7	14.6	11.1
Other sound	1.8	1.8	0.0	2.4	2.4	2.2
Animation	0.4	0.0	0.0	0.0	0.0	2.2
	n=224	n=56	n=40	n=42	n=41	n=45

Few website homepages were completely static. Visual dynamism was typically achieved through image slideshows, found in 67 percent of homepages. Museums in this group usually featured slideshows at the top of the homepages, communicating their most important brand features or current programs. However, some museums used rotating photos in more than one place on the homepage. For instance, the Polish Museum of America (Chicago) boasted four levels of slideshows on its homepage. Other museums such as the African American Museum (Dallas), the Western Heritage Museum (Montana), and the Willamette Heritage Center (Oregon) cleverly displayed sponsor or museum

partner logos in rotations at the bottom of homepages. These features not only honored the partners with special visual recognition, but the movement created a sense of magnitude regarding the number of sponsorships!

It was noteworthy that in some image slideshows, museums augmented visual expressiveness by panning in, out, or sideways on still images—meaning that visual interest was created within each shot as well as by the photo changes. This was two-factor dynamism at work. Examples were the Baltimore Museum of Art and the Art Institute of Chicago. A few such as the Museum of History & Industry (Seattle), the Nelson-Atkins Museum of Art (Kansas City), and the Portland Museum of Art (Maine) used a series of short motion videos in the rotation cycles, again enhancing the dynamism of the slideshows. And although most museums focused on image dynamism, the Museum at Warm Springs (Oregon) had rotating type blocks with Native phrases and their translations from the confederated tribes that the museum represented. This was an effective technique for reinforcing that the brand identity included several differentiated tribes while also creating visual dynamism.

Additionally, 13.8 percent of museums had videos on their homepages. The Florence Griswold Museum of Art's eye-catching drone video "flying" over the museum was a captivating method for drawing viewers into the website. The Museum of Mississippi History's dramatic opening video was another such example. Alternately, the Museo Italo (San Francisco) homepage featured a fully produced eight-minute video with many elements, including interviews. Noteworthy were subtitles accompanying footage of the interviewees who spoke Italian. This video was a website highlight that also could be repurposed at donor dinners, community events, or other venues. However, some museums also took advantage of simpler videos that added dynamism without the expense of a full edited production. For instance, the Japan Society's homepage had a brief video promo about its current exhibit that played music over still photos without narration or "true" moving images. It added dynamism but was a tactic that could easily be updated with different slides when a new exhibit was ready to be promoted.

Other compelling interfaces were museum homepages that applied parallax scrolling, where large background photos scrolled differently from those in the foreground, creating depth to an otherwise flat appearance.

Examples were the Honolulu Museum of Art and the Huntington Museum of Art (West Virginia). Just 1.8 percent of homepages included a sound element other than videos or the features noted previously, although other sections of the websites may have highlighted podcasts or sound (such as in the digital newsrooms). One, the Speed Art Museum (Louisville), hosted a podcast on its homepage. And the River Road African American Museum (Louisiana) featured a two-minute audio production over a still photo, with music and narration by actor Louis Gossett Jr. This was an excellent device for adding dynamism to the website while at the same time highlighting a celebrity's relationship with the museum.

Finally, one museum used animation to communicate its main message. The Wounded Knee Museum (South Dakota) homepage opened with seven teepees (representing the Seven Council Fires of tribes) and a moon that rose up on the homepage as if it were the sky. Sounds were "natural" nature sounds such as water and animals rather than narration, suitable for conveying the Native values that Chapter 4 related. The teepees were clever navigation devices, allowing viewers to click on "exhibits," "museum store," "for descendants," "for educators," and so on.

Although they were not included in the codesheet at the outset of the data collection, two other dynamic elements appeared on museum websites. One was Augmented Reality at the DuSable Museum, whose homepage said it was the "First Chicago museum with a fully functioning AR experience. Download the app and immerse in the augmented Harold Washington story." Also, live-streaming events was another way to add dynamism to websites. The National Civil Rights Museum at the Lorraine Motel (Memphis) said it live-streamed events from its website (when applicable).

Graphic Design and Quality Images

Although the chapter has devoted considerable space to website dynamism and interactivity, if a museum does not have the technical knowhow or budget for sophisticated features, most important of all is clean design and high-quality elements. A homepage with a few superior images and plenty of open space is more appealing than one cluttered with a plethora of text boxes and many poor-quality, small images. For example, museums who had high-impact homepages without motion features included the Iroquois

Museum, Hammonds House, Museum of Danish America, Gibbs Museum of Art, Arkansas Arts Center, Des Moines Art Center, and the Los Angeles County Museum of Art. These met the ideal of a credible, attractive website without incorporating multimodal dynamism. In summary, key concepts in the museum website content analysis were types of features, how website features tied to strategic objectives, visual quality and dynamism, and ability to be accessed on various platforms.

Photography

Photography is a challenge for some practitioners, as many public relations professionals are primarily trained as writers. Although social media platforms have lower aesthetic standards suitable for transitory images, websites require more compelling visuals because of their perceived organizational brand identity and "information of record" status. If viewed on a mobile phone the website images may be small, but on a computer the image resonance is important because the viewer sees it full-size. Public relations professionals may also make distinctions between small photos displayed lower on the website and the high-quality photographs that run at the top of the homepage boosting the brand, its exhibits, and museum programs. Lower-quality "snapshots" may be appropriate for certain uses as determined by practitioner's objectives and aesthetic standards. In short, professionals must balance the authenticity and visual credibility of the "selfie" or "snapshot"—particularly of diverse museum visitors or patrons engaged in activities—with high-quality images that convey museum excellence and expertise. As one study reminded, "Museums are supposed to be beautiful places; thus, by transference, visitors will also expect their websites to be beautiful" (Pallud & Straub 2014, 362).

Photography options include hiring a professional photographer, using museum communication staff to shoot photos, or buying stock photos. Occasionally an expert is required, such as an architectural photographer who will shoot museum building shots that will be used in multiple communication tools over many years. Sometimes local professionals are willing to negotiate custom photography for a reduced fee and photo credit or consider photography an in-kind donation to the institution. For example,

the Baltimore Indian Museum and the Sequoyah Birthplace Museum in Tennessee prominently credited photographers on their homepage images. Certainly, these local photographers benefitted from the extra visibility and the association with respected museum brands.

When a museum practitioner desires quality photography but lacks a budget for custom shots, stock photography is a solution. Although free stock photos run the risk of showing up in other organizations' communication, they furnish professional quality at a lower price than a custom shoot. Some stock vendors offer free photos, and occasionally commercial companies provide nonprofit discounts. Other options could include stock videos, illustrations, or other graphic resources. Sources at this writing include Getty Images, iStock by Getty Images, Adobe Stock, Shutterstock, Pexels, Pixabay, Burst, Freepic, Unsplash, and Twenty20, but there are many others. There are also companies specializing in photography genres such as food photos. If a museum is featuring a food event, there may not be anyone in-house who can shoot a high-quality food close-up that could be used in a website promotion for the current event or employed in future food-related promotions. Another contemporary specialty is photography related to types of diversity. For instance, two companies that provide images of people with disabilities are PhotoAbility and Disabilityimages.com. Eye for ebony and CreateHERstock are two that concentrate on photos of African Americans, while NativeStock specializes in American Indian portrayals. As always, professionals should research options and costs.

Website Analytics

As with email and social media platforms, there are some free services that display website metrics along with commercial companies available to assist practitioners. Some of these analyze multiple platforms such as websites and social media. However, many measures promoted by the firms merely gauge implementation, not whether the website content is linked to cognitive, affective, or behavioral outcomes. Typical implementation metrics are reach (possible views), impressions (website hits), day/time accessed, and geographic descriptors of website users. Other measures

can show practitioners how the website was reached, such as from a city's tourism site, search engine, or online media site. Most useful are evaluations of click stream analysis that can show communicators not only how long users spent on portions of the website, but which website elements prompted event RSVPs, donations, memberships, or the like. Along with Google Analytics, commercial companies offering various services to practitioners include Adobe Analytics, BrightEdge, Clicktale, Clicky, Drupal (open source content management), or Type Pad (blog service with analytics), to name a few. All use zippy jargon, acronyms, and vague technical descriptors in their marketing, so practitioners must carefully consider what data they need and its value to the organization before entering into any contractual agreements.

Conclusions

In short, design and layout, photo quality, and the amount of written information are considerations for museum homepages. When possible, visual or multimodal dynamism adds interest. The museum website content analysis described in this text found that dynamism and interactivity levels were higher than those reported in earlier studies. This suggests that US museum experts are successfully diffusing new technologies in their communication practices. Also, practitioner interviews made it clear how savvy museum professionals were regarding websites' importance and what they needed to improve, even when staff and budget restrictions curbed their ideals. Figures 12 and 13 can help practitioners move in this direction.

Figure 12 offers practitioners a checklist for homepage visual quality and dynamism elements based on the literature and the present study's findings. Figure 13 displays considerations for improving website interactivity and usability. Although it was not addressed in the interviews or content analysis, given the increased societal concerns about Internet privacy and security, this item was added to the usability matrix. The figures draw from other website research (e.g., Johnson & Martin 2014; Kabassi 2017; López, Margapoti, Maragliano, & Bove 2010; Moshagen

& Thielsch 2010; Pallas & Economides 2008; Pauwels 2012; Searson & Johnson 2010).

All in all, the findings presented in this chapter are useful to public relations scholars interested in Web 2.0 technologies and museum communication research. Additionally, the conclusions from the interviews and content analyses, along with the two rubrics about visual elements, interactivity, and usability will increase museum public relations experts' aptitude for improving their websites. For museums, websites remain central communication tools in information distribution, reputation enhancement, and relationship building with stakeholders.

FIGURE 12. Website Visual Quality and Dynamism

Visual Quality

 Design quality, balance, lack of visual clutter
 Colors suitable for museum's brand image
 Font styles, sizes, colors
 Quality of photography and other graphics

Visual Credibility

 Coherence and structure
 Authenticity and timeliness of images
 Professional icons and infographics
 Working links
 Spelling, grammar, syntax

Visual Dynamism

 Movement between images (slideshow effect)
 Movement within "still" images
 Moving images

Multi-modal Dynamism

 Video, animation
 Music, narration, "live" sound
 Livestreaming

FIGURE 13. Website Interactivity and Usability

INTERACTIVITY

User One-Way Interactivity

> Email address, telephone, physical location
> RSS feed
> Interactive calendar
> FAQs
> Links
> Forms (online reservation forms, membership forms, etc.)
> Roll-over images

Two-Way or Networked Interactivity

> Forums
> Polls/surveys
> Quizzes or mini-games
> Video/audio conferences
> Live-streaming video or audio with chat or comments
> Chat rooms, simulation tools, multiplayer games

USABILITY

> Speed of loading
> Access
>> Mobile options
>> Bilingual/multilingual functions
>> Alternatives for visually impaired users
>> Sign-in requirements
> Navigation
>> Site map
>> Site search bar
>> Logical mapping and directions
>> Page size and scrolling
>> Font adjustment, background adjustment
>> Index or directory
>> Shortcuts
>> Bookmarking
> Security and privacy

CHAPTER 7

Social Media

Interactivity and Engagement

SOCIAL MEDIA ARE INEXPENSIVE forms of digital communication with the potential to reach large networked audiences. Nonprofit organizations were early adopters of social media because the low costs drove implementation, even though nonprofits often lacked the large staffs needed to maximize social platform communication. However, prior studies have found that social media usage has been spotty among museums. After discussing previous research and some key concepts, experiences with social media and views of ethnic museum practitioners will be shared. Following their remarks are the results of an analysis of social media use by 227 US museums, including mainstream history and art museums, plus American Indian, African American, and other culture-centric institutions.

Two concepts used in discussions of social media are interactivity and engagement. As the summary of earlier research shows, these are separate concepts that even the technology specialists who market network platforms sometimes conflate or misuse. The following reviews studies applicable to public relations social media research and practice.

Interactivity and Engagement

Researchers have studied the concept of interactivity on digital platforms for decades, even before the advent of social media. An early definition still useful today described interactivity as "the extent to which users can participate in modifying the form and content of a mediated environment in real time" (Steuer 1992, 84). Throughout public relations and media research, the two main approaches have been analyzing the technical aspects of interactivity or describing interactive elements of messages, although terminology has differed. Some studies described these research types as *functional* and *contingency*, with functional interactivity explicating the interface's capabilities, and contingency interactivity noting the interactivity that resides in the message (Guillory & Sundar 2014; Saffer, Sommerfeldt, & Taylor 2013). Other scholars called them *modality interactivity* (found in the medium) and *message interactivity* (Oh & Sundar 2015). The key components of the technological focus are user control and reciprocal communication. Regardless of which concepts are incorporated into public relations research, the two ideas are helpful for practitioners to consider as they plan social media tactics.

A popular term among communicators is *engagement*. Communication research has defined user engagement as a condition where users are "completely absorbed in operating a new media technology . . . or engrossed in media content" (Oh & Sundar 2015, 215). Devoting cognitive resources in the communication endeavor has been another way to describe engagement. However, engagement is a term loosely used by social media platforms that champion numbers of users or "likes" without realizing that unlike interactivity, engagement requires psychological immersion. In this book the concepts of interactivity and engagement are separate.

Public relations scholars have based their definitions of engagement on the organization-public relationship literature (Broom, Casey, & Ritchey 1997) and rhetoric-based studies of dialogic communication (Kent and Taylor 1998; Taylor & Kent 2014). According to Watkins (2017), authentic engagement means "publics become part of the organization's community" (165). In short, in public relations, engagement is more than two-way

communication. It represents "a commitment to dialogue and relationship building on the part of the organization" (Watkins 2017, 165), and the psychological involvement of individuals communicating with the organizations. In summary, it suggests a true relationship between an organization and an individual, not just a series of interactive communication transactions.

Interactivity and Engagement: Outcomes

What outcomes of interactivity or engagement can museums expect? Significant for museum communication is that higher levels of interactivity in an organization's digital and social media have been found to improve perceptions of organizational reputation (Guillory & Sundar 2014; Lee & Park 2013). Research has also examined sought-after attitudinal and behavioral outcomes, such as loyalty, satisfaction, positive word-of-mouth, intent-to-purchase, actual purchases, or donations (Ingenhoff & Koelling 2010; Lee & Park 2013; Ott, Vafeiadis, Kumble, & Waddell 2016). Interactivity's influence on the societal benefits of organizational communication has not been a focus of prior research, except for citizen engagement research related to e-government (e.g., Haro-de-Rosario, Sáez-Martín, & Caba-Pérez 2018; Yavuz & Welch 2014) or activism public relations (Hon 2015; 2016). However, activism is important to some museums, especially ethnic museums or history museums involved in social campaigns. Thus, it can be assumed that interactivity and engagement could play a role in longer-term museum goals related to community betterment; perhaps this is a subject for future research.

Many studies of digital platforms have shown that organizations have not maximized the interactive aspects of social media (DiStaso, McCorkindale, & Agugliaro 2015; Haro-de-Rosario, Sáez-Martín, & Caba-Pérez 2018; Linville, McGee, & Hicks 2012; Lovejoy & Saxton 2012; Rybalko & Seltzer 2010). Small staffs and budgets are often the reasons. Nevertheless, this has inhibited engagement between organizations and their stakeholders.

A few studies have honed in on social media use by museums (Caerols-Mateo, Viñarás-Abad, & Gonzálvez-Valles 2017; Drotner & Schrøder 2013; Osterman et al. 2012). The Caerols-Mateo et al. research and the Osterman

et al. study found that museums underutilized the interactive functions of social media, just as they underutilized the other technologies employed by museums illustrated in Chapters 6 and 8. In summary, although inter-activity is transaction-oriented, with interactions either in the technologies or in the messages, engagement signifies psychological commitment among museum stakeholders with a promise of action. Research to date shows that whether working for museums or different kinds of organizations, most public relations practitioners have not taken full advantage of the interactive or engagement possibilities of social platforms.

Social Media Use: Culture-Centric Museum Communicators' Perspectives

Interviews with ethnic museum communicators found they used social media similarly, and interviewees described some of the challenges. Topics ranged from cultural sensitivities and language use to staffing and list management. First are looks at social media successes and interviewees' suggestions for best practices.

Organizations who used social media were astounded at its popularity with museum publics. For instance, one practitioner said, "We just started on social media and it's grown." Another remarked that, "We started our Facebook page about five years ago and have over 1,000 followers, which is not bad for a small organization like ours." A third commented, "Even on Twitter, we have been adding more and more followers every day."

Communicators often compared social media advantages and disadvantages to the strategy of working with traditional media. As one expert noted, "With social media we sense that we're able to highlight what we're doing." She emphasized that it was not always possible for the newspapers and broadcast outlets in her large city to cover her institution; thus, social media was a means of relating timely information. Practitioners also differentiated usage by what topics would appeal to legacy media versus topics that were best for social media. As an example of such a contrast, one expert said that she solicited traditional media coverage for an event featuring famed Latina activist Dolores Huerta, whereas she relied on social media for a

family-oriented event honoring the twentieth anniversary of the death of Tejana singer Selena. With the use of special hashtags, "it really exploded." "We had over 3,500 visitors here that day; one of our largest events."

But interviewees also compared each social media outlet to the others, adapting usage depending on museum goals or messages. As a professional said, "Twitter is a different kind of social media for us. It may not be as effective as Facebook, a newsletter, or an email in our situation. I think Twitter should be more engaging [should tweet multiple times a day]. Facebook is more effective than Twitter in our situation."

As always, practitioners considered the demographics of their museums' audiences in selecting a communication channel. For example, one noted the research on social media use by Black Americans. "African Americans are over-index on their use of all of the digital platforms, whether we're talking about the web, social media, smart phone technology—on a percentage basis we're way more active in our usage than any population in general." However, he noted, "There's a certain caution that has to be raised. We've talked a number of times here about the broad demographic range that this museum serves. You know, there are folks who are up in age but nonetheless very dedicated to the institution, very supportive of it. [But] they are less apt to just use digital media to find out what's going on, so we can't just throw all of the traditional means overboard."

In another city where a museum's mission celebrated an Asian culture, a practitioner made the same observation: "Should we emphasize [only] social media for people closer to retirement age?" Of course, the answer to this quandary was to produce multiple forms of communication tools tailored to different publics as Chapter 5 delineates with more examples.

Interviewees enjoyed a variety of successes on social media. For instance, one liked to take a photograph of the first piece installed in a new exhibit, or the first sign in the show, and share it on social media. She found that audiences are interested in such "behind-the-scenes" photos, just as popular television shows have found that audiences are interested in how pastries are made or homes are remodeled.

Communicators also described the role of social media as a listening device rather than employing it simply as a one-way communication or

reputation-building channel. For instance, one expert said social media helped to find out "what's happening with your communities. I think opening that dialogue and seeing what their concerns are" is important. This sometimes helped the museum determine "where we're going to go from here." Another noted that they occasionally tested an idea on social media to see what gained traction. Popular notions might then be translated into organizing an event with that emphasis.

Interestingly, social media relations were not always virtual. A New York museum professional discussed the pleasures of turning an interactive "connection" with a museum aficionado into an engaged museum patron. It was rewarding, she noted, when she made a connection via social media and then met the person at a museum event.

Of course, a challenge of social media, as all forms of communication discussed in this book, is to be appealing without violating a cultural sensitivity. As one savvy professional described, this includes "deep cultural issues having to do with gender, sex, and age." Given the short-hand nature of social media posts, he observed, norms are easier to violate in an abbreviated message than when one can use more words or images to convey a complex thought about an historically rich culture.

As always at culture-focused museums, language was another consideration for ethnic museum communicators. Several interviewees said they constructed bilingual posts on Facebook. A professional at an Italian museum liked to write bilingual posts, or use an Italian word, like *buongiorno*, in an English post. "A lot of people know a little bit of Italian or they're Italian Americans. The nice thing is that sometimes they try to reply in Italian, which is a sort of connection with them."

One interviewee speculated that some social media users have a virtual relationship with the museum (use its resources) but don't tend to visit. Thus, the museum had applied for grants to put more of its catalogue online. "So, we're hoping that over time we'll be able to put the majority of our collections online and see a greater increase in interest in the museum." This was an interesting case of the communication driving curatorial practices, whereas in the majority of cases described in this text, curation steered communication plans and tactics. This trend also points to a future where

museum communicators will have to assign additional resources to communicating with virtual publics, rather than concentrating on in-person visitors, as many do now.

Staffing and Social Media Policies

Although experts were enthusiastic about social media's potential for helping museums reach some of their goals, staffing was the main challenge noted. Museum professionals with many tasks had less time to devote to this medium which they recognized required frequent postings to avoid being stale. As one practitioner said, if you acquire social media followers, the organization then needs a dedicated person to spend time connecting with stakeholders. "Social media really is a big hungry mouth to feed and it's time consuming. And we don't have a dedicated person in social media to feed that hungry mouth." She also noted that the ROI is hard to demonstrate to management (return on the investment of a social media person).

Some museums had the luxury of full-time social media coordinators, and others were able to assign social communication duties to interns or volunteers. A Chicago museum overcame the dilemma by hiring a freelancer to help with social media. However, these solutions came with their own challenges. Interviewees were not asked about whether their museums had social media policies, but it arose in a conversation with one professional. He realized that they needed an organizational policy for Facebook postings so that there was consistency, especially because various staff members posted to the museum's account. Social media policies are recommended for all museums, especially those who do not have museum communication experts in residence dedicated to the job.

Despite the challenges, ultimately the practitioners interviewed embraced networked technologies. As one summarized, "With the democratization of media, with social media and electronic formats, we've had quite a bit more coverage and at a lower cost." Looking to the future, another noted that museum professionals were now questioning "what kind of apps should we be creating for smartphones? What kind of separate messaging

do we need to consider; how many different platforms do we need to communicate?" The preoccupation with keeping up with technological change was a shared concern among many employees. Several mentioned how helpful professional public relations associations or networks with other communication practitioners were in maintaining awareness of trends.

Given these successes and cautionary notes from practitioners, what are some overall patterns of social media use among museums nationwide? A content analysis found mixed uses of social media at 227 museums, as the next section describes. (See Appendix B for methodology.)

Social Media Use in US Museums

The most popular platform used by museums was Facebook at 90.3 percent, followed by Twitter, used by 77.1 percent of museums in the analysis. Next in order of popularity were Instagram, YouTube, and Pinterest. Fewer than 10 percent of museums used Flickr, LinkedIn, or Snapchat, and the blog site Tumblr attracted 7 percent of museums. Noteworthy was how some museums used networked travel sites such as Tripadvisor, Yelp, and Foursquare, although usages ranged from 2.2 percent to 9.3 percent of museums. These were particularly popular with history museums and Native American museums.

A comparison of social media by type of museum revealed statistically significant differences in use of Facebook (X^2 = 16.023, 4 df, p < .05), Twitter (X^2 = 48.186, 4 df, p < .05), Instagram (X^2 = 42.952, 4 df, p < .05), YouTube (X^2 = 11.226, 4 df, p < .05), Pinterest (X^2 = 15.941, 4 df, p < .05), and the blog site Tumblr (X^2 = 11.044, 4 df, p < .05) . There were no statistically significant differences by museum genre in usage of Flickr, LinkedIn, Snapchat, Tripadvisor, Yelp, or Foursquare. This was in part due to the low utilization of these social media and networked travel sites overall. For further details, Table 3 shows usage by percent of museums in each category, along with the totals for all 227 museums in the analysis.

TABLE 3. Percentage of US Museums Using Networked Media

	Total	Art	History	Other Cultures	African American	American Indian
Facebook	90.3	96.4	95.1	95.2	88.4	75.6
Twitter	77.1	94.6	85.4	85.7	76.7	40.0
Instagram	66.5	98.3	73.2	71.4	65.1	28.9
YouTube	42.3	51.8	56.1	42.9	27.9	31.1
Flickr	8.4	8.9	14.6	9.5	2.3	6.7
Pinterest	19.4	33.9	26.8	14.3	7.0	11.1
LinkedIn	3.1	5.4	0.0	4.8	0.0	4.4
Snapchat	1.3	3.6	0.0	0.0	2.3	0.0
Tumblr	7.0	16.1	4.9	7.1	4.7	0.0
Tripadvisor	9.3	5.4	14.6	7.1	2.3	17.8
Yelp	4.8	3.6	4.9	7.1	2.3	6.7
Foursquare	2.2	1.8	2.4	4.8	0.0	2.2
	n=227	n=56	n=41	n=42	n=43	n=45

Social Media Reach and Interactivity

Social media followers and connections are tracked by public relations practitioners because they suggest at least a minimal form of interactivity, although, as noted earlier, these metrics are often mislabeled "engagement." Numbers of Facebook followers ranged from 67 to 1.99 million and "likes" ranged from 64 to 2.05 million. The mean number of followers and "likes" were 47,327 and 44,764, respectively. At the time of data collection, New York's Museum of Modern Art had the most Facebook followers. One museum had three Twitter followers, but the largest had 22.4 million (Chicago History Museum). Another history museum, the Atlanta History Center, was a standout with the most Instagram followers.

Among all museums, the mean number of Twitter followers was 173,262. Readers should note that the means were skewed for Facebook, Twitter,

and Instagram because some very high volumes mathematically increased the "average." Medians—the true central points—for these platforms' followers were 8,236, 1,328, and 1,176 respectively.

Among travel sites, Tripadvisor reviews ranged from 37 to 2,694 with a mean of 61 reviews and Yelp reviews extended from one to 298, with a mean of four reviews per museum. Foursquare ratings ranged from 23 to 1,199 with a mean of six per institution. These travel reviews were highest at the Heard Museum in Phoenix and the Pérez Art Museum Miami. See Table 4 for the ranges, means, and medians of followers and connections on other platforms.

Reach and Interactivity by Museum Genre

Table 5 examines the mean number of followers (reach) by museum type. These statistics are included to provide museums in each genre some general comparisons, recognizing that the numbers change constantly. Although the

TABLE 4. Number of US Museum Followers, Connections, or Reviews: Ranges and Midpoints

Platform	Lowest	Highest	Mean	Median
Facebook	67	1,986,101	47,327	8,236
Facebook likes	64	2,053,843	47,764	8,209
Twitter	3	22,400,000	173,262	1,328
Instagram	70	23,600,000	291,499	1,176
Pinterest	12	660,000	3,196	0
Flickr	1	1,200	11	0
LinkedIn	162	47,047	235	0
Tripadvisor reviews	37	2,694	61	0
Yelp reviews	1	298	4	0
Foursquare reviews	23	1,199	6	0

n=227

Note: Among the museums analyzed in this study, Snapchat had no followers at the time of data collection.

numbers of followers varied widely at the time of data collection, the only statistically significant differences by museum genre were among Facebook followers (F = 4.994, 4 df, p < .05), Facebook "likes" (F = 4.784, 4 df, p < .05), and Instagram users (F = 3.049, p < .05). Art museums as a group had the most Facebook followers and "likes," but history museums overall had the most Twitter followers. The low volume of Twitter followers among African American museums was a surprise, given the research showing that as a group, African Americans are robust participants in that platform (e.g., Brock 2012; Cabosky 2016). Means were included for researchers because the number of followers, connections, and reviewers are ratio data. However, a museum communicator appraising his or her institution's followers vis-á-vis the findings in this study should focus on medians, not means, for a fairer comparison, recognizing that many other factors influence these

TABLE 5. US Museum Average Number of Social Media Followers, Connections, or Reviews

	Art	History	Other Cultures	African American	American Indian
Facebook followers	142,470	14,346	23,134	18,648	8,959
Facebook likes	144,023	14,541	23,409	18,601	8,841
Twitter	243,303	603,248	12,391	8,096	2,304
Instagram	167,495	1,369,969	4,621	9,874	980
YouTube	6,471	146	5,808	147	328
Flickr	35	3.0	2.0	0.3	9.0
Pinterest	12,560	369	52	35	77
LinkedIn	935	0	22	0	0
Tripadvisor reviews	36	56	37	2.0	176
Yelp reviews	5.0	6.0	2.0	0	6.0
Foursquare reviews	21	3.0	1.0	0	2.0
n=227	n=56	n=41	n=42	n=43	n=45

Averages are arithmetic means.

Note: Among the museums analyzed in this study, Snapchat had no followers at the time of data collection.

metrics. For instance, Cabosky (2016) cautioned that even within one age demographic, differences in gender, race, and prior relationship with an organization can affect social media sharing.

Google Plus was discontinued in October 2018. Therefore, the platform was omitted from this analysis, although many museums continued to feature the icon on their sites. Coders also noted other platforms connected to museum websites that were infrequently visible such as Vimeo, which offers live streaming and video hosting, or Reddit, a social news aggregator and discussion site.

Recommendations and Best Practices

Related to interviewees' concerns about staff time for social media, it was not unusual to find broken links for the social networks highlighted on museums' websites. Just because a museum featured a social platform icon did not mean it worked. Other weaknesses were not featuring the social media icons in prominent places on the websites (normally at the top or bottom of the homepage) or using colors for the icons that did not provide enough contrast to be noticeable. Unfortunately, like other technical glitches, these problems impact the perceived credibility of the organization (e.g., Johnson & Martin 2014).

What are the solutions for small organizations? Museums with modest resources maintained the most credibility by concentrating on one or two platforms, paying attention to the demographic profiles of users. Some institutions may wish to consider paying an hourly wage to a local college student or vendor once each month to check website and social media functionality. As described earlier, other museums found solutions by sharing the tasks among staff members or using freelancers.

Measuring Social Media Effectiveness

As museum professionals testified, determining the overall value of social media to the museum's bottom-line strategic goals (return on investment) or its societal impact remained elusive. Services such as Facebook Insights, Instagram Insights, Google Analytics, TweetStats®, or TWEETDECK®

can assist practitioners in evaluating some aspects of their social media campaigns, such as how many users visited a platform, when they viewed it, peak viewing times, locations of users, and other basic data. Hootsuite and other similar commercial services provide a "dashboard" to allow professionals to organize social media, schedule posts in advance of activities, trace mentions, count traffic to one's social media site, and the like. Vendors such as these also provide metrics about organizational response time to constituents' posts. As with other companies mentioned in this text, museums should check pricing, ask for nonprofit organization discounts, and investigate free options before contracting with an external service. Figure 14 presents a rubric to assist communicators in measuring social media effectiveness, following the guidelines in Chapter 5 related to Broom's 2009 model of the stages of the measurement process, and Hon and Grunig's 1999 relationship measures.

Unfortunately for communicators, when Facebook was initiated, "likes" was chosen for the feedback mechanism, relating to emotional (affect) expression. No "agree or disagree" buttons were included, which would have allowed public relations practitioners insight into individual's cognitive perceptions of organizational messages. Thus, although, as noted earlier, "likes" do not meet the definition of engagement, they allow some minimal tracking of feelings toward a museum, known as sentiment analysis among some experts.

One complication about discussing public relations uses of social media is separating it from advertising on social media. Facebook, Twitter, and the other companies use *reach* and *impressions* most often when referring to advertising (total audience versus number of times the advertisement was presented to the audience). Figure 14 concentrates on non-paid social media posts, not advertising. Thus, it is portrayed in a manner consistent with other public relations tools. As an example, if a museum has 1,300 Twitter followers, its reach is 1,300. If 600 individuals view today's post, the museum has garnered 600 impressions. Again, terminology varies from platform to platform, so museum professionals are advised to develop consistent usage in their own measurement schematics in order to reduce confusion among their managements or boards of directors. Despite all the brouhaha about social media analytics, most of the data are limited to measuring communication implementation, not the actual effects of communication.

FIGURE 14. Social Media Evaluation for Museums and Examples

PREPARATION
Appropriateness of message for platform and target public
Quality of message including novelty and "viral" potential

IMPLEMENTATION
Distribution
 Number of channels (Facebook, Instagram, etc.) used for message

Placement
 Number of posts per channel

Potential Reach
 Number of followers

Reach (Interactivity)
 Gross impressions: Actual number of individuals who read the post, "mentions"

SHORT-TERM OUTCOMES (COGNITIVE & AFFECTIVE)
Heightened Emotional Connection
 Likes
 Response posts involving feelings (sentiment analysis)

Increased Awareness, Knowledge, Favorable Attitude

SHORT-TERM OUTCOMES (BEHAVIORAL)
 Increase attendance, memberships, donations, sponsorships, museum gift shop/restaurant purchases, volunteers, community partnerships

LONG-TERM OUTCOMES (RELATIONSHIPS)
 Improved control mutuality, trust, satisfaction, commitment, exchange and communal relationships

Note: Concepts adapted from Broom 2009; Hon & Grunig 1999.

It is up to the practitioner to employ surveys to judge social media's sway over awareness, knowledge, and attitudes of museum stakeholders. And behavior logs (membership sign-ups, attendance receipts, etc.) remain uncomplicated methods for comparing communication implementation against sought-after outcomes to determine effectiveness. In other words, as an example, did a museum's Thursday social media post about a unique museum gift shop item improve its weekend store sales?

As noted in Chapter 5, this requires a quasi-experimental, cross-lagged approach where one compares communication tactics implemented at various times with behavioral metrics occurring after each of those times. Of course, as noted elsewhere, it is not always possible to isolate communication generated by the public relations department from other factors that influence museum patron behavior, including stellar staff or cheerful volunteers. In short, measuring true cognitive outcomes or relationship outcomes that are displayed on Figure 14 requires surveys. Determining behavioral effects require data beyond ballyhooed social media analytics.

Conclusions

To conclude, museum interviewees validated the importance of social media as channels to reach museum publics inexpensively and quickly. They envisioned these networked communication forms as alternatives to the relentless challenges involved in securing traditional media coverage for their programs, as discussed in the media relations chapter (Chapter 8). Museum professionals also testified to the role that social media can play in informal research and program feedback. Some even used social media comments as formative research for new programs.

Further, the content analysis demonstrated that social media in museum public relations is growing, compared to prior research about its lack of use in museums and other kinds of organizations. The findings suggest that US museum professionals continue to gain expertise in using social media for one-way and two-way communication with their publics.

Finally, the evaluation suggestions included in this chapter and Figure 14 are a response to professionals' concerns about how to measure social media programs. As the technologies continue to evolve and more research is conducted, the techniques can be improved.

Media Relations
and Digital Newsrooms

ONE OF THE MOST discussed communication strategies in the ethnic museum interviews was media relations. The first half of this chapter is devoted to the themes explored in the interviews. One device for media relations, the digital newsroom, is discussed in the second half of the chapter. First, media theories that are useful to public relations scholars and practitioners are briefly highlighted, along with definitions.

Theoretical Foundations and Media Relations Research

Regardless of the type of organization, recent media relations research has centered on applicable theories, relationships between journalists and public relations practitioners, the role of organizational sources, effectiveness of various media tactics, and issues related to truth and credibility. Typical theoretical underpinnings of research about media relations have been agenda building (e.g., Curtin 1999) and public relations as a media information subsidy (Gandy 1982). The following discussion highlights findings most relevant to the present research.

Agenda building stems from the decades of media research based on agenda setting theory, originally conceived by McCombs and Shaw (1972)

in the seminal Chapel Hill study. Combining media content analyses with survey research, robust evidence from agenda setting studies demonstrated that media help to set the main topics that are deemed relevant by citizens. The related concept of agenda building refers to media input from others, such as public relations professionals providing news items (DiStasio 2012). Ethical public relations practitioners enact a partnership where journalists can avail themselves of practitioners' expertise in certain topics or industries (Pincus, Rimmer, Rayfield, & Cropp 1993) and organizations can thus contribute to the media agenda.

Another concept also examines public relations and media interactions: information subsidies. Gandy (1982) characterized the public relations discipline as an information subsidy because when public relations professionals help to provide the news, they assist in bankrolling the media business. As a result, the information furnished by practitioners is input in the "production of influence" (31). Researchers have examined how traditional and online media relations have exemplified this concept (Moon & Hyun 2014). In addition, the financial impetus of information subsidies has been linked to agenda building (Berkowitz & Adams 1990; Turk 1985; Zoch & Molleda 2006). Journalists must continually fill a news hole, and public relations professionals must earn media coverage for their organizations. Thus, their relationships are built on professional information exchanges, which Gandy (1982) characterized as an exchange of value.

Certainly, contemporary journalism's financial pressures have enhanced the need to help underwrite news organizations. Given the widespread twenty-first-century layoffs of journalists, the subsidy role is more important now than it was when Gandy first developed the idea. With advertising revenues declining in many media sectors and 1,800 US newspapers closed since 2004 (Abernathy 2018), "free" public relations input to media has financial clout. Indeed, interviews with US, UK, and Australian journalists and public relations professionals found that public relations interviewees recognized "the importance of independent journalism for society" (Macnamara 2014, 743) and their roles in helping to produce news. As the US Department of Labor has forecast a 9 percent decline in reporter jobs from 2016 through 2026 (Bureau of Labor Statistics 2019), future demand

for information subsidies will continue. In summary, "traditional" media are communication channels that public relations professionals cannot ignore. It is also clear that practitioners help journalists do their jobs and that high-quality, ethical relationships between media and public relations workers are mutually beneficial to each other and to society.

Despite this reality, scholars have consistently documented tensions between journalists and practitioners (Cameron, Sallot, & Curtin 1997; DeLorme & Fedler 2003; Macnamara 2014). Nevertheless, Curtin (1999) found that news workers who claimed they did not use public relations materials admitted receptivity to story ideas generated by public relations practitioners. Also, journalists were less skeptical about materials from nonprofit public relations workers (Curtin 1999; Seletzky & Lehman-Wilzig 2010). And finally, because many newspapers have regular culture sections, they need the material contributed by museum public relations workers (Sallot & Johnson 2006; Seletzky & Lehman-Wilzig 2010). These studies suggest that because most museums are nonprofit organizations and generally are considered to be in the cultural sector, journalists are apt to be receptive to museum communicators' ideas and materials.

What communication tactics work best for reaching media, according to research? The press release (aka news or feature release) continues to be used, although its delivery mechanisms have shifted. In research investigations, the strongest predictors of news release usage were news substance, such as importance or usefulness to consumers; journalistic elements such as writing quality and inverted news pyramid style; and the source of the release, including the type of organization (Sallot & Johnson 2006; Seletzky & Lehman-Wilzig 2010; Zoch & Molleda 2006). Localization was another factor (Berkowitz & Adams 1990; Curtin & Rhodenbaugh 2001; Hong 2008). News outside a media outlet's market area is not of interest unless it meets other news determinants such as novelty.

Public relations personnel also provide visuals, which may be more desired by news outlets than in earlier decades. One reason is the 43 percent decline in news organization photographers, videographers, and artists from 2000 through 2012 (Pew Research Center 2013). Another is the growth of visual news.

Media Definitions

US general market media are defined here as English-language "mainstream" journalism outlets including newspapers, magazines, broadcast stations, and digital news platforms such as the *Huffington Post*. Legacy media is another common term, generally signifying traditional elite journalism organizations such as large daily newspapers or networks like CNN. Ethnic media are defined as print, broadcast, or digital news media targeted at one or more racial or cultural groups (Johnson 2010). The term minority media is often used as a synonym, but it is misleading because sometimes an ethnic group is not a population minority, such as Latinos/as in Los Angeles County, where they comprise almost 50 percent of the residents. As a concept, ethnic media can be inclusive of indigenous media or signify media for newcomers—also referred to as diaspora media or immigrant media.

Early twentieth-century research at the Chicago School of ethnic studies focused on the uses of ethnic media by immigrants (Park 1970). However, a new vein of studies began appearing in the 1970s about media devoted to cultural groups such as the African American press (Roshco 1967; Wolseley 1971), Chinese language press (McCue 1975), Filipino American press (Hart 1977), Hispanic media (Gutiérrez 1977; Gutiérrez & Schement 1979), or the Polish American press (Chapinski 1979), in the same time period as new museums devoted to collections centered on cultural groups began to form, as pointed out in Chapter 2. Ethnic media as a term reached popularity in communication studies in the 1980s with landmark studies such as those by Jeffres and Hur (1980; 1981), who connected ethnic media consumers with the broader area of scholarly inquiry, ethnic studies. Archivists also used the term, such as in Buttlar and Wynar's 1996 *Guide to Information Resources in Ethnic Museums, Libraries, and Archival Collections in the United States*. Ethnic media theories and concepts were also central in this research phase, moving scholarship from description to theory (Faber, O'Guinn, & Meyer 1986; Miller 1987; Riggins 1992; Subervi-Vélez 1986).

In this book, ethnic media refer to US-based culture-specific media, although, of course, ethnic media are produced in societies worldwide. International media are distinguished from ethnic media in that they originate in another nation. For example, international media such as London's

Financial Times or Paris's *Le Monde* are distributed in the United States, but their primary audiences are in Great Britain and France.

Reflections on Media Relations

Interviews with professionals at ethnic museums confirmed the importance of media relations, highlighting challenges as well as benefits. They discussed print and broadcast general market media, local and national ethnic media, and, for some museums, if an exhibit or project warranted it, international media. As they discussed media relations tactics, they included digital versions of media (including some outlets that had discontinued print versions), and some museum practitioners treated specialty bloggers similarly, including them on their media lists. Remarking on this targeting of bloggers, one experienced media relations professional said, "We had 65 Latino bloggers here last week, and of course, the social media for the museum just went crazy" following the bloggers' museum visit. Examples such as these demonstrated that communicators continued to adapt their definitions of "media" as journalism institutions changed.

General Market Media as Reputation Enhancers

The main themes that emerged from interviewees' remarks about general market media were journalism's role in enhancing organizational or programming legitimacy, the ability to reach audiences not currently touched by other tactics, and the museums' responsibilities to media in their community roles as thought leaders and influencers. Although newspapers have declined and many media outlets are disparaged in contemporary political rhetoric, not a single interviewee questioned journalism's ability to help museums achieve their goals. In fact, the most pragmatic of interviewees realized that a controversial exhibit or event might increase media attention and ultimately benefit the museum, despite some angst in the interim.

Most noteworthy was the reputation boost that museum professionals said occurred when the museum was covered by legacy media. According to interviewees, such media coverage epitomized that "our shows are important," or "if we get a story it legitimizes what we are doing." As a Chicago

public relations practitioner said, if prospective visitors "saw this was in the *Tribune,*" it was worth attending. Traditional media bestowed value.

Several professionals noted that sometimes the legitimacy conferred on the museum by media expanded to their cultural community as well, especially groups that suffered from negative press due to crime rates, immigration controversies, or the like. As one remarked, uplifting ethnic museum news in local media "presents a positive story. It's an image for our community as well as for our organization."

Reaching external audiences was not the only impetus for soliciting coverage from legacy media. Communicators knew that general market media coverage was appreciated by their executive directors or board members, too. One said that her museum leadership was interested in raising the reputation of the institution, and media were important in that goal. And as another remarked, "Our board members read the *Wall Street Journal* and respect it."

Given the reputation garnish that the legacy media provided, practitioners amplified the traditional news coverage of their institutions by highlighting it in their own organizational media. For instance, many interviewees described how they re-merchandized news coverage on other platforms such as social media or websites. This included reproducing the coverage on their sites or providing links to the news stories.

Media as Audience Expanders

A second reason for media relations activities and distribution of press releases or media advisories was audience building. Despite the growing reliance on websites and social media for conveying information, museum officers noted that traditional mainstream or ethnic media expands awareness to new individuals. For instance, a practitioner affiliated with an Asian organization said that securing traditional media coverage "increases our audience space." Contrasting it with digital media, the same practitioner said, "in order for people to come to our website they have to know about us."

Many said that mainstream media coverage surpassed social media attention in generating museum attendance, especially because it reached those who were not yet connected on social media and did not know about the museum in order to look for its website. For example, one professional

said that although her press releases were rarely picked up by her city's major daily, when covered, the museum received more visitors.

Relationships with local media representatives could impact short-term goals, but also paid off in different ways. For example, a public relations expert said that a long-term relationship with a local television network affiliate resulted in a public service announcement (PSA) that the station produced for the museum. PSAs are spots that broadcasters provide for free to nonprofit organizations because the FCC requires that broadcasters serve their local communities, given that the commercial stations occupy the public airways, as do public broadcasters. Of course, some local stations are more conscientious than others about using their staff resources to fulfill this mission, so not all museums can take advantage of this tactic in the same manner.

Thought Leaders and Cultural Influencers

A third interview theme centered on traditional best practices in media relations but also pointed to communicators' societal roles as cultural intermediaries. Savvy media relations practitioners—some who had been journalists or trained in journalism—knew it was important to help journalists do their job, too. As one noted, "I think about the relationships, it's a value that you bring for them." She continued, "Because I am a source for them, too, so whenever they have questions, they come to me." However, this assistance to media benefited the museums by positioning the institutions as local influencers on cultural topics. As one California professional remarked, "I've really tried to establish [the museum] as a thought leader, where media will come to us to talk about important historical events."

In one example, a Chicago museum expert became a media source when an international event occurred in the European country whose culture was the focus of her museum. In another instance, a New York professional noted that he had been called by journalists in a different metropolitan area reporting about a cultural topic about which his museum had expertise. A third public relations expert observed that the local media recognized the legacy of the museum and revered the museum's founder as a city leader, so it was accorded respect as a community authority.

Ethnic Media Relations and International Media Relations

All the interviewees discussed their important relationships with ethnic media, in addition to their work with local urban media, community media (such as weekly newspapers), and media with national reach. They observed that the thought leader role also was granted to museums by some ethnic media because museums were recognized as influencers in the local racial or ethnic community.

For some museums, ethnic media simply meant local print, broadcast, or digital ethnic outlets. Others worked locally and nationally. For instance, one practitioner at a museum associated with a Scandinavian culture sent press releases to ethnic media across the United States and Canada. Although another professional observed that printed versions of some publications were dwindling, she worked with online ethnic media and a local ethnic media club whose members were journalists identifying with that cultural heritage. A third communicator maintained a strong relationship with a weekly ethnic talk show.

Of course, ethnic media could appeal to pan-ethnic or pan-racial audiences or narrowcast. One professional provided a sophisticated overview of the population segments of African Americans reached by various radio stations in his region. He explained that radio formats such as jazz, R&B (rhythm and blues), and hip hop appealed to different age groups, and he had to be cognizant of that when furnishing information to the stations.

Other practitioners used global approaches to establish relations with media in home countries related to the cultural group and send them translated materials. Not all museums targeted these international media, but sometimes international media asked the public relations practitioners for assistance. For example, a South Korean television network contacted a museum communicator because they wanted to do a program on her museum's conservation of artifacts; this was not a station on her regular media distribution list.

As discussed throughout the book, the preferred channels of communication for audiences was the top-of-mind issue for museum professionals. For some, ethnic media were key. One said that among new arrivals of the cultural group associated with her museum, "for immigrants, newspapers are still the way they get news; that's something that we always have to keep

reminding ourselves." A museum practitioner in a separate city working with a different cultural heritage concurred; "hard-copy newspapers are still very much appreciated by these communities." Some interviewees evaluated their efforts with ethnic media as more successful than relations with legacy media, but one emphasized that she had gained "equal support from ethnic and general market media."

Media Relations Challenges

Practitioners bemoaned the state of US media and its effects on public relations practice. A former journalist remarked, "The media has shrunk. They don't have time to get out" and cover events or exhibits. Along with grappling with the overall decline of newspapers was the challenge of working with the reporters who covered the museum beats. If the city dailies had arts and culture reporters, there was a lot of competition for their time. And this extended to reporters covering other types of museum programming, such as the culture-related performances that many museums offered. As one public relations manager noted, "The performing arts media is very, very small, but very competitive."

Communicators coordinated with regular news or feature journalists in addition to beat reporters. However, an obstacle was that even when a media outlet planned to cover an event at the museum, a crisis elsewhere might sidetrack them. Decreases in reporters overall exacerbated these scenarios. As a Californian joked, in the Los Angeles media market, "Entertainment news takes up 50 percent, and crime takes up 40 percent." Solutions mentioned by numerous Southern California museums were various cooperative initiatives involving multiple museums, which then created larger-scale events or promotions that warranted journalists' notice. This was an example of how public relations experts leveraged community partnerships to improve media coverage.

Along with metro desk reporters, community dailies, and various arts and culture reporters, other specialized forms of journalism noted by practitioners were travel publications. These were more pertinent to some museums than others. Still other communicators targeted food and wine writers or bloggers for some of their events. These examples pointed to the importance of diversifying media contacts beyond arts reporters or the

city desk. Of course, developing relationships with journalists in multiple beats and publications required more effort. Some museums simply did not have the staff to do it.

A practitioner who had been a journalist for a major daily newspaper described a textbook-perfect approach to media relations, but one that obviously took considerable time. "What I like to do is meet with my contacts periodically. We have lunch or I talk to them about what's coming up; just to get their feedback as to what they might be interested in." Then, she noted, although the same news release is sent to the general media list, she can tailor coverage to "some aspect of our activities that they're more interested in." Another lamented that such an approach, which she also preferred, was tough. "I am a department of one, so it can be difficult at times to really give personal attention to journalists who will potentially write a story about what we're doing here." Similarly, another noted, "Our media relations is not as effective as I would like it to be. I'm not able to carve out as much time as I would like to focus specifically on the media relations piece."

Besides time, a second challenge was being innovative in media relations. "We have to create something unique and timely that will break through that media membrane," said one professional. Another said that to appeal to legacy media, the exhibit or program must have wide appeal beyond a culture-specific topic. As a different interviewee remarked, "When we talk about topics that expand [beyond the cultural group], we're able to generate some coverage." According to another, "It's harder for me to get an interview with mainstream media if it's not something they find absolutely feature worthy." Communicators had to clarify this reality for museum executives when organizational leaders wondered why an exhibit or program of high interest to some stakeholders did not generate universal media appeal. As one emphasized, "General market media cover *unique* events and exhibits." That said, many culture-centered museums excelled at creating media-worthy events, as Chapter 9 depicts.

As discussed further elsewhere, it was relatively easy for museum professionals to track digital platform attention via online analytics, but far more challenging to determine the effectiveness of various general market media tactics. Even survey responses fell short when practitioners attempted

to correlate specific media tactics with sought-after behaviors from target publics. As one interviewee summarized, "They saw it in the *New York Times*, but was it a listing, a review, or an advertisement?"

Chapter 2 illustrated that language selection was often a dilemma for public relations professionals. However, none of the interview participants expressed that language was a problem when working with ethnic media. Sometimes the media outlet was bilingual or in English, rather than in the native culture's language. In other cases where the language was not English, practitioners maintained such good relations with the ethnic medium that the publication, broadcaster, or digital news platform was often willing to translate the museum's news. A third solution for a few museums was relying on bilingual resources and distributing news in more than one language. These examples described how the museums and the ethnic media outlets worked in tandem to serve their communities.

Interview Conclusions

Media relations helped to implement strategic planning goals of reputation building and audience expansion. But because museums' programs also educated their target publics, even these organization-centered strategies had societal functions, too. Media relations also contributed to the democratic ideals of society when museum experts served as thought leaders. Thinking of society's well-being, an experienced California media relations expert bewailed that culture as a topic does not receive its fair share of coverage in the press. "Culture is not promoted by the media; that's an overall general problem" in society. She felt this did not differ between ethnic or general market media—it was a common problem throughout American media.

Because these interviews were with communicators at culture-centric museums, it is possible that the challenges of mainstream museums' media relations are different. For example, most of the ethnic museums were tested in procuring mainstream media attention. However, this may be less difficult for behemoth museums in urban centers who are regularly covered by arts and culture reporters. Conversely, ethnic media were a natural fit for culture-oriented museums with most institutions having regular ethnic media contact. Large mainstream museums without these specialized media relationships could face hurdles in clarifying for journalists why their exhibits

or events would appeal to ethnic media consumers. Mainstream institutions may need to work harder to establish relationships with ethnic media reporters. Consequently, in order to improve relations with journalists at a plethora of news outlets, some practitioners employ a technology-enabled tool for media relations—the digital newsroom.

Media Relations and Digital Newsrooms

The online pressroom is one form of information subsidy that provides convenience for journalists and reduces labor for public relations practitioners. In discussions about media relations, interviewees were not asked specifically about their digital pressrooms. Thus, this section relies on a content analysis of digital newsrooms that examined the websites of 224 ethnic museums, African American museums, American Indian museums, mainstream art museums and mainstream history museums in the United States. Appendix B describes the procedures involved. As in the prior section, theoretical concepts underpinning the work are agenda building and information subsidy. Before reviewing the analysis results, the following provides background research on digital pressrooms.

Online Pressrooms

The main concepts discussed in the literature regarding online newsrooms or journalists' use of public relations websites have been the quality and quantity of information, usability, navigation, and interactivity. Organizational factors have been another realm of inquiry.

For example, several studies identified organizational size as a variable influencing the complexity of online newsrooms. Some found that the largest corporations offered more features in their online newsrooms, compared to those lower on the Fortune 500 list (Callison 2003; Moon & Hyun 2014). Similar findings applied to pressrooms of large nonprofits versus smaller ones (Yeon, Choi, & Kiousis 2005) and to top-ranked universities rather than lower-ranked institutions (Lee & Merle 2018). In other words, scholars have acknowledged that resources affect an organization's ability to maximize offerings to journalists, just as Gandy (1982) in his work about information

subsidies observed. However, generally studies of digital pressrooms have discovered that even when organizations have large budgets, most are limited to featuring press releases rather than maximizing the tool's potential (González Herrero & Ruiz de Valbuena 2006).

A separate line of inquiry has examined reporters' views. Interviews with journalists have documented their professional priorities and their opinions of online pressrooms (Pettigrew & Reber 2011). For instance, in the Pettigrew and Reber study, business journalists said that they wanted specific contact information for public relations personnel, organizational background information, financial reports, and issues-related viewpoints. In other research, technology journalists declared that public relations websites were time and cost savers, and helpful for obtaining routine information, although they bemoaned the sites' usability flaws (Hachigian & Hallahan 2003). Of course, although some requirements are common across journalism specialties, arts and culture reporters may have needs that differ from media staff on other beats. Thus, it behooves public relations professionals to seek input from their media contacts about individual preferences.

In investigating digital newsrooms, scholars have characterized their elements in different taxonomies. Moon and Hyun (2014) divided features into informational and interactive, and added design as a third component. They found *Fortune 500* company newsrooms that were the most interactive and informational correlated with more media mentions than digital newsrooms with fewer elements. In short, better pressrooms meant better news coverage. Other studies have delineated types of downloadable visuals available. Notably, González Herrero and Ruiz de Valbuena (2006) said that downloadable graphic images are a top reason that journalists visit digital newsrooms.

One research study specifically examined museum newsrooms. In a study of museum online newsrooms in the 100 most visited global museums, Capriotti and González Herrero (2017) observed the frequent use of traditional tools such as text, photographs, and graphics, rather than audio, video, or social media applications. According to these investigators, museums used tools with interactive capabilities mainly for one-way traditional communication.

Museums' Online Pressrooms

Although Macnamara (2014) estimated that more than 200 studies since the early 1900s have examined relationships between public relations professionals and journalists, he and others (e.g., Duke 2002) asserted that new media formats and practices warrant further investigation. Given their declarations and the research described, the study in this text examined the percentage of museum websites with clearly labeled newsrooms and the labels used; available informational media relations materials, including multimedia resources; available interactive media relations materials; navigation; and usability. Features were also compared by museum genre. (See Appendix B for methodology.)

Overall Results

Among the 224 websites studied, 28.1 percent did not feature a designated spot for media use or news. Of those in the study that had a digital news site, museums used various terms to signal that there was a place to serve journalists. These included labels such as *Press* (17.0 percent), *News* (13.4 percent), *Press Room/Pressroom* (12.5 percent), or *News Room/Newsroom* (3.5 percent). In the sample, 25.5 percent of the museums had sections with other names such as *For the Press*, *Media Center*, and *Visit the Newsroom*.

Once reviewing the website sections, it was clear that despite the names, some newsrooms were not targeted at working journalists. Rather, they featured already published news for museum visitors or other stakeholders (20.5 percent) or were places where blogs or social media were highlighted. Thus, among the museums analyzed, just 53.1 percent had true digital newsrooms serving the press. Museums met this criterion if they had at least one release written in news style, text that mentioned the page was for the working press, and/or a public relations contact noted.

Some museums created a hospitable environment for media by highlighting their intent to serve the working press. For instance, at the top of its pressroom page, the Asian Art Museum in San Francisco said, "Welcome working press. Here you can find our latest press releases, request images for publication, join our press list, and view our archive of past releases." More simply, Prince George's African American Museum and Cultural

Center urged media representatives to "Help Us Tell Our Story," a nod to cooperative relations between journalists and public relations practitioners that ultimately benefitted society.

One-Way Communication: Informational Features

Next, pressrooms were checked to determine the materials most often included. Consistent with prior studies, the most frequent element was the news release (53.1 percent). In addition, release archives were found in 47.3 percent of the museum newsrooms. News release archives are helpful for reporters who want to refer to prior museum activities, such as exhibit details or the date of a personnel change. One art museum archive included releases as early as 1994, but 90 percent of institutions with archives featured news after 2005. Some newsrooms had sections labeled press release archives, but it was difficult to find the releases, especially if there was no systematic organizational schematic. The best archives were arranged clearly by date. Some were also divided by topic categories or were searchable. These features improved the usefulness of the archive to journalists.

Factsheets about the museum, or factsheets about specific topics such as exhibits or events, were available in 17.4 percent and 20.1 percent of the museums' newsrooms, respectively. Factsheets could be short or comprehensive, ranging from brief histories of the institutions to lists of statistics. Some pressrooms highlighted "ready-to-go" press materials. For instance, the pressroom of the Tamástslikt Cultural Institute (Oregon) included story ideas in its press kit.

Biographies appeared just 6.3 percent of the time, most prominently in museums where directors were profiled, such as in the newsrooms of the North Carolina Museum of Art and The Studio Museum in Harlem. The Chicago History Museum included the photos and biographies of four staff professionals, noting that "Chicago History Museum curators and historians are available to comment on breaking news and trends in their area of expertise." This was an example of a museum that recognized its duty to assist journalists in writing stories, even when the main topic was not about the museum. This tactic also positioned its experts as Chicago opinion leaders and cultural influencers.

Mission statements were commonly available on other sections of the website, such as on the homepage. That is probably the reason that just 4.5 percent of museums included mission statements in the pressrooms. Another element seldom featured at 3.1 percent was financial information. Given the nonprofit status of most museums, including a financial report and/or a Form 990 (nonprofits' filings with the US Internal Revenue Service) demonstrated transparency. One standout was the Charles H. Wright Museum of African American History in Detroit, which included Form 990s, audited financial statements, and attractive annual reports with reader-friendly financial highlights and charts.

The least common feature in museum pressrooms was a position or policy statement (aka white paper), found in one newsroom (0.4 percent), the Houston Museum of African American Culture. One white paper on their site was "A Cultural Plan for Houston's African American Communities." Another was "A Call for Equity in Houston Cultural Funding." These showed the museum was positioning itself as a local cultural thought leader. Such tactics not only bolstered organizational reputation but demonstrated the institution's service to its Texas community.

Two-Way Communication: Interactive Features

The aforementioned features were one-way communication tactics whose purpose primarily aligned with museum goals of promoting their exhibits and events, although as just noted, they could be stature boosters. However, online pressrooms were also analyzed for their inclusion of two-way communication features that demonstrated responsiveness to journalists' needs. These tools included contact information, news alert components such as Really Simple Syndication (RSS), and search features. A key question was whether the sites included the names of museum PR practitioners, along with their contact information. Just over one-fourth (25.4 percent) of museums boasted this feature. Another 16.1 percent did not name specific personnel but included a general email address or phone number, such as press@lacma. org. One reason for this approach might be that responding to the press was a shared responsibility among several employees. Another possibility was museums' desire to protect the employees' privacy and circumvent negative

online behaviors from non-journalists. A downside to this approach was that journalists without existing public relations relationships could interpret the lack of a specific name as unresponsive to media requirements, or simply decrease media inquiries due to perceived inconvenience.

In addition to contact information, a useful feature was a search function of the site; 4.5 percent had a newsroom search box, although additional museums had search functionality for the main website. Museums that offered reporters the option to sign up for a news alert service or featured an RSS feed totaled 16.1 percent. Table 6 displays each one-way informational communication tactic and interactive feature used by the five museum genres.

TABLE 6. Museum Online Pressrooms: One-Way and Two-Way Communication Tactics (%)

Tactic	Art	History	Other Cultures	African American	American Indian
News release	78.6	62.5	40.5	46.3	31.1
News release archive	78.6	60.0	33.3	23.3	26.7
Mission statement	3.6	12.5	2.4	0.0	4.4
Factsheet museum	30.4	25.0	11.9	9.8	6.7
Factsheet specific topic	35.7	22.5	19.0	9.8	8.9
Biography	12.5	5.0	0.0	9.8	2.2
Financial statement	7.1	0.0	2.4	2.4	2.2
Position statement	0.0	0.0	0.0	2.4	0.0
RSS or news alert	28.6	17.5	11.9	12.2	6.7
Search engine within news	10.7	5.0	0.0	2.4	2.2
Name of PR practitioner w/contact info	46.4	32.5	9.5	12.2	20.0
No name but email/phone	30.4	15.0	14.3	14.6	2.2
Other Features					
Policies guiding media	26.8	22.5	2.4	4.9	6.7
Published news	17.9	25.0	28.6	19.5	13.3
n=224	n=56	n=40	n=40	n=41	n=45

Multimedia Downloads

Including downloadable image files in the pressroom ensures that reporters are not obligated to contact the museum for mundane requests such as building photographs or logos. Equally, public relations professionals can then save time by focusing on other tasks. Visuals are vital in media coverage because they enhance stories and help attract viewers or readers. Although this is a simple feature to include, merely 3.6 percent of museums offered downloadable logos symbolizing the institution, and 3.1 percent had logos for particular events or exhibits. Museum interiors (often highlighting current exhibits) were in 7.6 percent of newsrooms and exteriors in 7.1 percent. Photographs including museum visitors were in 5.8 percent and museum personnel were pictured in 1.3 percent of pressrooms. Although museum newsrooms did not always have explicitly designated downloadable images, some sections appeared to assume that journalists would "right-click" and save the images for media use. Other museums such as the Anacostia Community Museum did not have a separate pressroom section for images but embedded them in digital news releases or press kits.

No newsrooms had charts, graphs, or infographics in a downloadable image section of the site (although they may have accompanied individual press releases). Just 2.2 percent of museums demonstrated multimodal media relations by featuring downloadable videos, and none featured audio downloads. Evidence that there was little overtly commercial content in newsrooms was that only 0.9 percent had a photo related to a museum store or restaurant, and no newsrooms featured logos of these enterprises, although they may have been highlighted on the main museum website. Table 7 displays image availability by museum type.

Of course, some museums have a plethora of materials for reporters, but they do not want them available to the general public, given concerns about artifact copyrights and digital mischief makers. A log-in or registration to access communication tools was required in 6.7 percent of pressrooms, and 16.5 percent featured other mechanisms for image access, such as direct requests. As these materials were not visible to the researcher, it is assumed that this study undercounted tactics available in such restricted modes.

TABLE 7. Museum Online Pressrooms: Downloadable Images and Files (%)

Tactic	Art	History	Other Cultures	African American	American Indian
Logo or graphic for:					
Museum	1.8	10.0	0.0	4.9	2.2
Specific event or exhibit	0.0	5.0	0.0	12.2	0.0
Museum shop, restaurant	0	0	0	0	0
Photo of:					
Museum personnel	1.8	0.0	4.8	0.0	0.0
Museum exterior	5.4	17.5	4.8	9.8	0.0
Museum interior(s)	7.1	20.0	4.8	7.3	0.0
Museum products for sale	0.0	2.5	2.4	0.0	0.0
Museum visitors	7.1	7.5	7.1	7.3	0.0
Others:					
Video files	5.4	0.0	0.0	2.4	2.2
Audio files	0	0	0	0	0
Charts, infographics	0	0	0	0	0
Visuals available:					
by request	37.5	20.0	7.1	4.9	6.7
via log-in	19.6	5.0	2.4	2.4	0.0
All materials available:					
via log-in	21.4	2.5	2.4	4.9	0.0
n=224	n=56	n=40	n=42	n=41	n=45

A final point of interest was whether museum newsrooms had a statement of media policies or photography restrictions, and 13.4 percent included such a policy. For instance, The Denver Art Museum had a comprehensive

set of guidelines in their Film and Photography Policy statement. Given the sensitivity of the use of cameras in museums because of copyright laws, as well as degradation of artifacts due to flash photography, it was surprising that more museums were not clear about photography policies. Often museums appeared to assume that reporters would adhere to professional standards in photography usage and credits without the institution needing to specify policies. For example, in clarifying photo credits for historical photos, the North Dakota Heritage Center and State Museum said, "Please credit State Historical Society of North Dakota." Contemporary concerns about the use of drone photography is another timely matter for policy statements, especially for museums with outdoor sculpture gardens and open-air event facilities (National Press Photographers Association 2017). A RTDNA/Hofstra University survey conducted in 2018 reported that 55 percent of television newsrooms own drones (Papper 2019), so this is another emerging media relations topic for museum personnel to contemplate.

Navigation and Usability

Because journalists have complained about less-than-optimal usability and navigation of media pressrooms, whether the media section of the website was available in "one click" of the homepage, or whether a journalist would be obligated to search through a museum website to find the pressroom, was another inquiry topic. Results showed that most of the newsrooms could be accessed directly from the homepage via an icon or words at the top, side, or bottom of the site (direct click or hover-and-click over a drop-down menu). Only 4 percent required two clicks. In short, if there was a digital newsroom, museums made them easily apparent.

Comparisons among Genres

As described, slightly more than half of the museums had digital newsrooms, and most under-utilized tools except press releases. Because usage of many materials was low, small cell counts did not allow statistical tests of differences among the five museum genres for all the variables. However, findings indicated that 87.5 percent of art museums had a true digital newsroom for working press, compared to 60.0 percent of history museums, 42.9

percent of ethnic museums, 34.1 percent of African American museums, and 31.1 percent of American Indian museums (X^2 = 43.797, 4 df, p < .05). Statistically significant differences emerged in the types of institutions whose pressrooms included the names and contact information for communication practitioners, with 46.4 percent of art, 32.5 percent of history, 20.0 percent of American Indian, 12.2 percent of African American, and 9.5 percent of other culture-specific museums displaying them (X^2 = 24.156, 4 df, p < .05). Sites without names but generic contact information also differed, as Table 6 shows (X^2 = 15.068, 4 df, p < .05).

The most common tactic, the press release, was used by 78.5 percent of art, 62.5 percent of history, 46.3 percent of African American, 40.5 percent of ethnic, and 31.1 percent of American Indian museums (X^2 = 28.186, 4 df, p < .05). Table 6 delineates other genre differences, with statistically significant differences in availability of news release archives (X^2 = 40.876, 4 df, p < .05), exterior photos (X^2 = 10.981, 4 df, p < .05), interior photos (X^2 = 12.979, 4 df, p < .05), museum fact sheets (X^2 = 14.298, 4 df, p < .05), and specific fact sheets (X^2 = 14.933, 4 df, p < .05).

One possible hindrance to ease of use by journalists, but a method for monitoring media relations activities and limiting unauthorized use of materials is the media log-in or registration to use the newsroom. This feature was apparent on 21.4 percent of art museum pages, whereas 4.9 percent of African American museums, 2.4 percent of ethnic museums, 2.5 percent of history museums, and no American Indian museums required log-ins (X^2 = 23.745, 4 df, p < .05). Suggesting the sensitivity to copyright and artwork protection, there were significant differences among museums in mandatory log-ins for images (X^2 = 20.878, 4 df, p < .05), or having to request images (X^2 = 28.103, 4 df, p < .05), as Table 7 describes. Similarly, policies about filming or photography were more common among art institutions at 26.8 percent, compared to 22.5 percent of history, 6.7 percent of American Indian, 4.9 percent of African American, and 2.4 percent of ethnic museums (X^2 = 20.229, 4 df, p < .05). Beyond copyrights, concerns about cultural appropriation of artifact images such as those used in American Indian ceremonies is a valid reason for these policies. Museum communicators probably trust that journalists educated in their profession respect these

issues, but with the growth of journalist substitutes such as bloggers who may lack such credentials, policy statements about visuals are wise additions.

Informational, Interactive, and Multimedia Conclusions

Although not generalizable to all US museums, the content analysis demonstrates that most US art, history, and culture-specific museums are not maximizing their digital resources to foster relationships with journalists. The likely reasons are lack of time, staff, and funds. Nevertheless, many features of online press rooms are cost-effective public relations timesavers, such as including easily available financial reports, biographies, fact sheets, or downloadable photos and logos.

Furnishing financial information was rare in this sample, perhaps because museum professionals work with arts and feature reporters who do not ask about finances. However, displaying such information or providing links to IRS Form 990s demonstrates transparency and helps educate reporters about the institutions' business aspects. If financial information is available elsewhere, such as in website donor sections, it should be linked to pressrooms.

Like businesses, museums establish reputations not based solely on their collections, but on the strength of their managements and programs, too. With journalism's move toward more feature and personality content (Verboord & Janssen 2015), highlighting museum director and curator biographies could take advantage of that trend. In fact, recently museum professionals have been front-page news, such as in the controversy about El Museo del Barrio hiring a curator with expertise in Latin American art instead of in US Latinx art (Moynihan 2019). But positive personnel news, such as the NC Museum of Art hiring its first woman director, can be newsworthy, too. Also, Curtin and Rhodenbaugh (2001) recommended providing tip sheets rather than full-fledged news releases, because studies have shown that reporters prefer narrative control. Museums could expedite this by outlining different angles for reporting on an upcoming exhibit or event. An advantage of this approach is that it could be less labor-intensive to accomplish than writing a full-fledged release.

Shrinking photography, videographer, and design staffs (e.g., Pew Research Center 2013) and forecasts for another 34 percent decline in

newspaper photographers through 2026 (Bureau of Labor Statistics 2019) also suggest that local news organizations need photography, information graphics, or multimedia content in arts and culture reporting. These elements could make the difference between a museum earning coverage or missing out. Television broadcasters and the digital versions of print and broadcast outlets feature video files along with still photos. Museums may already have some of these resources. For example, many history and ethnic museums have been conducting oral histories as part of their collections. Featuring interview snippets from these archives (with appropriate permissions) in newsrooms would meet the audio-visual demands of contemporary media. Inexpensive audio files with excerpts from management's remarks about current museum activities or sound clips from events with speakers or performers are other possibilities.

Although ready-to-use public relations materials are recommended, more incorporation of interactive features is another suggestion. Clear contact information and technological affordances such as RSS feeds and newsroom search features (especially for press release archives) increases convenience for journalists, thereby increasing the probabilities of press coverage for museums and influencing the media agenda.

Finally, Callison encouraged standardizing the names of newsrooms so that reporters would easily find them (2003). This text supports the wisdom of that recommendation. Perhaps the American Alliance of Museums or the Public Relations Society of America could encourage a standard set of names.

Theoretical Contributions: Information Subsidies and Agenda Building

It is somewhat ironic to discuss nonprofit museums being information subsidies to for-profit news organizations. Although newspapers have suffered revenue crises, many broadcast stations and networks remain highly profitable, especially as they have expanded into digital and mobile platforms. Nevertheless, media relations in nonprofits subsidizes news businesses in the exchange relationships that Gandy described (1982).

In communication research, the scarcity of multifeatured pressrooms is typically attributed to organization-specific reasons, such as funding or

staff members' digital skills. In line with this, a survey of arts organizations found that 19 percent of organizations with a budget of $50,000 to $500,000 had a paid employee whose main responsibility was website management and content, versus 74 percent of arts organizations with a budget of $10 million or more (Thomson, Purcell, & Rainie 2013). Of course, "website responsibilities" do not suggest all personnel have media relations expertise. But as many museums in this study had modest-sized staffs, this is a likely reason for underutilization of newsroom features.

However, given the recent research about US news deserts (Abernathy 2018), it is conceivable that some museums have little demand for information from local reporters because media outlets have disappeared from their communities. Abernathy also described the rise of *ghost newspapers*, which have scaled back their reporting of local news. This implies that even when there is a media organization nearby, a museum wanting coverage must take the initiative to get on the media agenda because there are no local journalists available to do it for them.

Although heavily populated states lost numerous newspapers in the past decade and a half, there were disproportionate heavier losses in less populated regions (Abernathy 2018). These were correlated with vital societal factors. For example, Abernathy noted that the average poverty rate was 18 percent in news deserts compared to 13 percent nationwide, and the average percentage of residents with bachelor's degrees was 19 percent in news desert communities compared to 33 percent US-wide. Thus, museums located in communities with few media have a larger burden to society, because arts and culture reporters may not be bolstering local arts education and community innovation as in the past. This responsibility to their community is another impetus for museums seeking more arts and culture media coverage.

Scholars such as Gandy (1982) positioned the information subsidy concept as media-centric, with public relations serving media only for organizational gain. One could also conceptualize public relations as an element in an information ecosystem that is consistent with the social responsibility model of public relations. In other words, rather than deem public relations as merely journalism's underwriter, public relations practitioners and journalists can be equal partners in generating news of interest to their communities for overall societal betterment.

Likewise, traditional agenda building theory is self-serving for public relations because its focus in research has been on how practitioners can meet strategic goals by encouraging media to feature their organizational news. But given findings among practitioners who viewed themselves as partners in providing communities with news (see also Macnamara 2014; Zerfass, Verčič & Wiesenberg 2016), public relations scholars should conceptualize the agenda-building role as less transactional. As with the information subsidiary model, agenda building related to arts and culture coverage can benefit society.

CHAPTER 9

Special Events, Controlled Tools, and Other Tactics

SPECIAL EVENTS ARE ONE of the most popular strategies that museums use to raise funds or involve museum devotees in the organization. This chapter will concentrate on special events and the controlled tools used to attract visitors and keep them abreast of other news. Practitioners' insights about paid tactics will also be provided. However, before discussing ethnic museum interviewees' observations and highlighting a few examples from museum listservs and websites, some of the extant research about special events and controlled tools is summarized.

Prior Research

There has been little attention to special events or controlled tools in the contemporary scholarly public relations literature, perhaps because these long-time strategies are covered well in classic public relations textbooks. Special events are defined as activities planned by organizations, contrasted with "real" events that take place naturally. Public relations practitioners also use the term pseudo-events coined by Boorstin (1964) to refer to events staged solely to gain media coverage. An example was the "die-in" staged by activists at New York's Solomon R. Guggenheim Museum to

protest Sackler family donations to the institution because of the family's association with opioid producer Purdue Pharma (Pollack 2019). The main purpose of the pseudo-event was not outreach to other museum aficionados; it was to spur journalists' attention. However, Broom (2009) contrasted "phony" events whose goal was to "hype self-serving interests" with legitimate ones: "Produced with the public interest foremost, however, special events contribute to clarification of public issues, not to their displacement, distortion, or obfuscation" (331). This chapter's emphasis is on authentic events planned by museums to achieve various organizational objectives and provide stakeholders with worthwhile activities.

Recent communication research has emphasized special events related to sports, politics, tourism (such as travel fairs), environmental/science/health, beauty contests, and religious media activities. Of course, events and pseudo-events are discussed in conjunction with protests and crises. In marketing research, the focus has been on whether corporate sponsorship of community or nonprofit events is worthy, with scholarly perspectives centered on the corporations' benefits rather than the advantages of sponsorships for nonprofits such as museums. Related research has encompassed for-profit or "brand" events, such as for music celebrities interested in improving their visibility. However, although lacking the volume of those studies, some attention has been devoted to arts-related events in museum and nonprofit organization research. Two types of events are fundraisers and activities aimed at increasing museum participation.

Special events are a popular fundraising tactic for museums and others in the nonprofit sector because a nonprofit can "zero in on distinct target markets" (Higgins & Hodgins 2008, 50). In other words, events tend to be segment-specific, although there are some activities that generate wide appeal. There are also tentative links between involvement in events and subsequent contributions, although more research is needed. For instance, a survey of more than 3,000 US taxpayers found that 35 percent of those who contributed to charities said that they would make a larger contribution if they were more involved in a nonprofit, pointing to the correlation between organizational involvement and donations (Fidelity Charitable 2017).

Events are also "tools for direct communication and engagement" (Toledano & Riches 2014, 809). They allow target publics to interact directly

with the organization in ways that are not possible with the mediated strategies discussed in other chapters.

Event Benefits to Participants, Museums, and Communities

When strategizing about special events, museum managements should consider their benefits to participants, the museum, and the community. Research studying motivations of participants has found that participants appreciate learning, entertainment, personal growth, life enrichment, social interaction, and personal involvement with the organization (Hume 2011; Jansen-Verbeke & van Rekom 1996; Loureiro & Ferreira 2018). Some events can be an activity that a family can do together; "learning for fun" (Hume 2011). In addition, Loureiro and Ferreira (2018) described the phenomena of "serious leisure," where some individuals pursue an activity systematically, such as studying pre-Columbian collections in various art museums or visiting history museums with World War II collections. Given all the possible motivations of potential audiences, when promoting events museum communicators must construct message strategies depending on which target publics and their anticipated motivations match an event.

A second benefit accrues to the museum. Advantages include using events to structure alternative means of donating to the museum or prioritizing events to reach audiences who are less likely to visit museum collections on their own. In line with this, many museums structure activities to reduce the stuffy image of institutions. Events have been used to enhance brand identity, build awareness or knowledge, change attitude about the institution (or museums in general), and promote intention to behave in desired ways such as to donate, become a member, or volunteer. In his article on how to measure the effectiveness of events, Jeffries-Fox discusses some of these criteria in Figure 7 (2005, 23).

Further, research has shown that museum events can provide community or societal benefits in addition to offering the intrinsic value of incorporating culture in a community. For example, museums who target tourists may assist in place-branding, furthering the identity of a city (Stylianou-Lambert, Boukas, & Christodoulou-Yerali 2014). As noted elsewhere, many cities are

interested in being branded as culturally vibrant locations to attract workers in the city's creative for-profit industries such as software start-ups or video gaming companies. Museums contribute to urban renewal, aka "the Bilbao effect" (Lazzeretti & Capone 2015), and regularly scheduled events bolster those efforts. Other museums contribute to the perceptions that their cities have historic significance, with events cementing those images. Of course, tourists or local visitors also provide economic support to communities when they participate in museum events because it is common to patronize adjacent businesses in combination with museum outings. As Cohen and colleagues (2003) put it, "Unlike most industries, the arts also leverage significant amounts of event-related spending by their audiences, generating commerce for local businesses" (17–18).

Although events are a popular nonprofit strategy (Hershey & Schnaidt 2019), anyone who has perused the Internal Revenue Service's Form 990s of nonprofit organizations knows that special events can be moneymakers or generate colossal losses. The logical reason for choosing a special event as a strategy is to meet one or more objectives reviewed above rather than simply be the "default" strategy because board members enjoy attending them. After all, special events are replete with negative possibilities, too. Events have up-front costs such as contracted amounts for food or performers that cannot be recouped if attendance goals are not met, or even if the event must be cancelled due to severe weather. Safety of property, artifacts, and participants is paramount, but protection comes with costs. Thus, special event liability insurance (short-term insurance coverage normally purchased to cover the organization and others involved in the event) plus the security costs must be weighed against the expected benefits. Events also require logistical precision and can reflect badly on a museum's brand if logistics do not go as planned, even if out of the control of the museum (such as unexpected traffic nearby). If staffing is mainly handled by volunteers, they must be trained well. And lastly, events require high participation to symbolically look like successes, even when the break-even point on expenses is met by lower attendance.

Finally, even the most creative event at a museum with a stellar brand competes for a patron's leisure time with other arts organizations, sports events, for-profit venues such as commercial theatres, and 24/7 streaming television on a plethora of electronic devices. The Bureau of Labor Statistics

(2016) reported that Americans in 2015 spent an average of five hours each day devoted to leisure and sports, but television occupied nearly three of those hours, and far more for seniors 75 and older. Moreover, younger demographics are captivated by other screens. For instance, two-thirds of Millennial Americans play video games monthly (Nielsen Insights 2019), and some enjoy merely watching others play. The *Washington Post* reported that e-sports consume considerable leisure time, with 100 million gaming enthusiasts watching a 2019 livestreamed video competition as spectators, not gamers (Partin 2020). Consequently, distractions in the home may be the source of more competition for museum visitors than other live events taking place in the community.

Museum Special Events: Types and Examples

Patterns found in the primary research for this book were similar to those unearthed in the prior research just described. Mentioned by interviewees or observed on more than 200 museum websites included education-oriented

FIGURE 15. Event attendees at Museum of Latin American Art's Robert Gumbiner Sculpture Garden & Events Center. Courtesy of Museum of Latin American Art, Long Beach, California.

audience participation events, entertainment-oriented audience participation activities (including children's events), and fundraising events whose main goal was to raise money. Interviewees specifically mentioned the following categories of events their museums offered: (1) tie-ins with a culture-centered holiday such as Day of the Dead or Lunar New Year; (2) tie-ins with a US holiday such as Valentine's Day; (3) formal or informal dinners, food festivals, wine/beer tastings capitalizing on the current American foodie culture; (4) performances including dancers, musicians, plays, or puppet shows; (5) films or film series; (6) lectures and book readings; and (7) auctions (often in conjunction with fundraising dinners). Exhibit openings were the most common events mentioned; museums regularly used them to kick off new shows. Of course, this is not a generalizable taxonomy for all museums, but it summarizes some trends.

A review of email listservs and websites also showed how museums creatively targeted specific publics with different activities. (This does not include ongoing education efforts such as classes, summer camps, and the like normally under the auspices of museum education departments). In fact, many museums used website headings or coding systems (such as icons or colors) to signal to their constituents the suitability for target audiences. For instance, one Latino museum presented a Día del Niño targeting families and separate creative "maker" events for toddlers, teens, and 8–12 year olds. Clearly, a black-tie Gala fundraiser targeted upper-crust museum patrons and a women's awards ceremony had different goals. Examining a Chinese-affiliated institution's emails demonstrated similar diversity in targeting different audiences. Examples included a happy hour for their Young Professional Group, a $500 per ticket gala, and a "vogueing" event (reflecting the highly stylized dance technique associated with music celebrity Madonna). Family events at the Museum of Idaho (Idaho Falls) included an Archeology Day. History buffs would have been interested in the New Mexico History Museum's illustrated lecture on military cemetery design and the American Battle Monuments Commission, established after World War I to honor the American Expeditionary Forces. With a lighter touch, the Mashantucket Pequot Museum and Research Center (Connecticut) held a "Native New Year" clambake and for the June summer solstice, a music activity. Noticeable on websites were other museum events tapping into

popular activities such yoga exercises in a garden or gallery. Further, book clubs were perfect links to museum collections, such as the Delaware Art Museum's DelArt Readers, "a community-led book club passionate about art-inspired literature," and the Honolulu Museum of Art's Book Club, a docent-led group where books were "selected to connect with the museum's galleries and specific works of art."

Partnering with local governments or other organizations, the museums also participated in community events that were not museum-only enterprises, such as a local music festival appealing to younger audiences, a parade viewing party, or a neighborhood dance event (in which museum listserv members were urged to participate). At other times, museums carved out their own events to correspond with city-wide endeavors. For instance, for the past few years the Nelson-Atkins Museum of Art (Kansas City) has hosted a Juneteenth Celebration featuring music, dance, film, poetry, storytelling, weaving demonstrations, and more. Their activities were an element of other Juneteenth observations in Kansas City. Community partnerships were also common. One example was the Museum of Florida History (Tallahassee) that partnered with Mission San Luis to present a six-part speaker series and screening of the PBS documentary *Secrets of Spanish Florida*. On the other hand, The Durham Museum (Omaha) partnered with the Smithsonian Cultural Rescue Initiative to hold a workshop on how to preserve heirlooms damaged in natural disasters, timely given twenty-first-century Nebraska floods and growing climate change concerns.

Some museums also planned events related to advocacy. For instance, one California organization held an information event about Proposition E. This was a 2018 San Francisco ballot measure that reallocated 1.5 percent of the existing 14 percent hotel tax to arts and culture. (It passed.) The institution also invited museum audiences to participate in a rally for support of arts funding, coordinated with the trade group Americans for the Arts and its Arts Advocacy Day.

In addition to innovativeness, event management is another hallmark of a successful endeavor. Museums used systems like Eventbrite, Google Calendar, and similar platforms to manage RSVPs to events. This allowed the organizations to modify large spaces when lower attendance was expected, such as by spreading out tables or screening some of the

vacant space with plants or displays. Conversely, museums dealt with larger-than-anticipated crowds by designating overflow spaces, such as a separate room where attendees could watch a video of a speaker when the lecture hall was full. A few tips from interviewees included setting up places for selfies from museum participants. Museum staffers also photographed attendees to provide visuals for future communication. For instance, one culture-centered museum said that they always posted photographs from exhibit openings on social media so that the diversity of museum enthusiasts was apparent.

In summary, interview comments, email programs, and website content revealed that US museums can be commended on the wide variety of inventive themes, audiences served, and links to their missions. Museums were savvy about balancing regular, low-cost, minimally staffed activities such as book clubs with high-cost, complex events such as galas. Given the small staffs of most museums, they demonstrated creativity in resource use.

How did prospective attendees learn about upcoming events? Often it was via traditional media, social media, or websites, described in prior chapters. However, another communication tactic often paired with events were controlled tools. As summarized in Chapter 5, these are print or digital forms of communication for which the public relations professional has full authority over what is said, the visual content, and how it is distributed. The following reviews museum professionals' comments about controlled tools.

Controlled Tools

One museum practitioner noted that they mailed postcards for each new exhibit to members and donors, plus sent a newsletter twice per year. Another distributed a quarterly printed newsletter to donors, sponsors, and anyone else who subscribed. Some museums dispatched printed newsletters and others transmitted e-versions. Although controlled tools were often used in conjunction with museum events, others were stand-alone communication tactics that promoted a host of activities.

E-Media Successes and List Management

A typical method for reaching museum members and others on museum listservs were e-blasts. Emailed digital postcards or newsletters required fewer staff hours compared to many other tasks, except for the challenges of list management. As one professional relying on them said, "I have to maximize every dollar." One interviewee maintained a regular distribution schedule, sending three email blasts per week.

Depending on the platform used, these emails could be personalized or not. One institution's e-blasts sometimes featured rotating, dynamic photos—others were visually static. Many practitioners noted that the success of e-blasts rests largely on maintaining a good list and they were inventive about expanding it. A natural method of expanding the list was capturing information from event attendees. As one said, "Every time people come to your events, you get their emails and Facebook contacts." Another said her museum always captured the email addresses of event attendees so that "they can connect with them again." Responsibly, they also offered an opt-out function for those who did not want to receive emails.

One of the most resourceful ideas instituted by a Chicago museum was placing a tablet on a stand in the lobby that allowed visitors to sign up for Facebook, which also set up an email subscription. An outside vendor managed it for the organization. The communicator said they increased the museum's social media subscribers and email listserv within the first five months of installation.

Although several museums were innovative about their methods for building a list, most bemoaned the challenges of keeping them current. As one professional noted, they had 10,000 email addresses, but only 20 percent of their e-blasts were opened. They had to determine whether that was because there was low interest among recipients, or whether they were not opened because receivers were already aware of the information distributed by another communication tactic. For instance, a museum member may have put the exhibit opening on his calendar based on a newsletter item, and thus did not open the museum email on the same topic.

If finances permit it, a museum can contract with a commercial company to assist in email management and evaluation. Practitioners can assess the costs, advantages, and disadvantages among vendors such as Mailchimp®, Marketo (an Adobe company), Oracle Eloqua, or BrightEdge, to name a few.

Paid Advertising

Given that museum marketing books cover paid advertising in detail, this text has focused on other public relations tactics. However, museum interviewees revealed several paid advertising techniques that were effective for their institutions. Mentioned in several cities were pole banner advertisements, which were flags positioned throughout the urban areas promoting the museum or an exhibit. Professionals in Southern California pointed out that commuters are in their cars for major portions of the day, so such outdoor advertising was efficient. In a more concentrated urban center, tourists frequented open-top tourist buses, and public relations practitioners said they found that tourists became aware of their museums by observing their banners while touring the city. Outdoor advertising on buses was another way to increase awareness among tourists and city dwellers. Other methods of tourist promotion were logos or advertisements on tourist maps, advertising in tourism guidebooks, or providing rack cards (brochures) in visitor bureaus' brochure racks. Some practitioners experimented with social media advertising and other digital forms, although there was no consensus about effectiveness. Of course, paid advertising in general market or ethnic media were other options, but infrequent among small museums given affordability.

In short, some paid advertising was included in communication programming, but it was rarer than the other strategies and tactics discussed elsewhere in the text or the controlled tools and events described in this chapter. Compared to their digital counterparts, events and controlled tools could be perceived as twentieth-century strategies, but they continue to serve museums admirably in the contemporary communication environment.

PART THREE

CONCLUSIONS

The Future of Museum Communication Research and Practice

THIS BOOK HAS THREE foundational assumptions. The first is that to fulfill the obligations of their nonprofit organizational charters, museums must serve society. The second is that public relations must likewise benefit humanity in order to meet the definition of a profession, per the guidelines in the Code of Athens or the Public Relations Society of America standards (e.g., Watson 2014). And third, because the population of the United States is increasingly diverse, US museums must work to establish and maintain relationships with a variety of stakeholders, with public relations central to that effort. Otherwise, the commitments of the nonprofit undertaking and the conceptualization of the criteria to be a professional are not met. Moreover, even the institutions with the broadest collections and educational programming cannot uphold their missions if activities are not communicated, and organization-public relationships do not exist without communication.

The goal of the information shared throughout these chapters is to enable museum communicators to consider their jobs broadly, so that they seek not only to attain the direct goals of the organizations that pay their

salaries but recognize their social covenants with their communities. Like experts in most nonprofit organizations, practitioners must work wisely to overcome staffing and budget limitations. However, museum communicators are also challenged by the plethora of new technologies that they must master in order to succeed. As this volume has highlighted, this goal is complicated by the varying old and new communication technologies used by current museum stakeholders and those the institutions desire to attract. As a museum professional said, at one end of the continuum is the museum member who still has the ten-year-old brochure listing outdated admission prices, and at the other end of the spectrum is the college student who relies on this morning's social media for planning her day.

The text aims to contribute to scholarly research about public relations and museums, but it also translates this research into useful information for museum communicators. A summary of highlights is presented next.

Contributions to Research

One strength of the book's research is the mixed methods approach, relying on qualitative and quantitative primary research, plus secondary research in select topics. Much of the primary data are garnered from in-depth, in-person interviews with ethnic museum professionals. These research participants are the experts on culture-specific communication. The knowledge they share is deep and thoughtful, and useful not only for professionals at other culture-centric museums but perhaps even more importantly for practitioners at mainstream museums. No other study to date has conducted qualitative interviews with such a large group of US museum communicators.

The quantitative data, on the other hand, were based on content analyses of three types of museum digital communication—websites, digital newsrooms, and social media. Quantitative data provides more "surface" knowledge than the deep descriptions of qualitative data, but each content analysis dataset represented a look at more than 200 US museums. Although large metropolitan museums have been included in prior content analyses, and studies have been devoted to website analysis for African American and other ethnic museums, no other content analyses have examined three types of platforms and compared mainstream art and history institutions along with African American, American Indian, and other culture-specific museums.

In brief, the study makes five main research contributions. First, the qualitative data support the conceptualization of the public relations discipline's societal role and the role of practitioners as cultural intermediaries, at least for ethnic organizations. Second, the qualitative data delineate the many dimensions of identities among museum publics and elucidate why museum communicators must understand them. Third, the interviews illuminate how museums can employ counterstereotypes in communication. Although media research has explored counterstereotypes, public relations research has not done this yet. Fourth, the quantitative data illustrate that museums are incorporating more Web 2.0 and social media in their communication programming and the results provide details on various elements. And fifth, although usage is low among many institutions, the data demonstrate the potential of digital newsrooms for museums, especially given the rapidly changing US media landscape.

Also employing secondary research in new ways, one chapter integrated the cultural aesthetics literature and some studies on cross-cultural design into public relations research and practices. Few public relations studies have been devoted to visual communication or the aesthetics of target publics, and this furnishes one contribution to that research.

Contributions to Practice

As interviews showed, practitioners cannot broaden a museum's reach as they would like if they do not employ contemporary communication practices in a professional manner. Additionally, like those in other organizations, museum public relations experts continue to be stymied by how to evaluate their work and how to demonstrate more than mere implementation success to their managements. Thus, the book contributes five main findings to museum public relations practice. First, a reorientation and application of classic public relations planning and evaluation models were applied to museum communication. Second, the chapters clarified terms used inconsistently by digital and social media companies and showed practitioners how to think about them in communication as well as in evaluation of digital and social media tactics. Third, the book delivers a unique taxonomy of strategies and tactics tied to public relations theories about one-way, two-way, and networked communication. Fourth, the text provides strategic

planning examples of abstract concepts such as public relations' societal role and the practitioner role of cultural intermediary. This allows these intangible ideas to have merit in practice. Fifth, it offers many rubrics to guide communication and evaluation best practices, especially for digital tactics such as websites, digital newsrooms, and social media. Finally, the book delivers countless ideas for practitioners, recognizing that most do not have time to look at hundreds of other museums' websites or social media for inspiration. Even those active in their local professional communication associations do not have the wherewithal to gain expertise from many museum practitioners in multiple cities.

As noted earlier, museums have been urged to diversify their missions and their employees. However, institutions cannot fire all their experts in nineteenth-century European art or all their male Caucasian directors and then start over. Nor do most have the space or budgets to amass enormous new collections of diverse art and artifacts. Thus, while management and collection profiles evolve, the area most nimble to develop special programs and embrace intercultural communication is the communications function of the museum. This text's goal is to enable that office to succeed, and thus propel the museum forward.

In summary, museum experts agree that the institutions should no longer be cloistered enclaves where a select few indulge in beauty and knowledge (e.g., Grams & Farrell 2008; Hooper-Greenhill 1997). Contemporary museums are welcoming enterprises open to all where true participation and organization relationships with the public are fostered. The wisdom and delights that the institutions convey contribute to their communities and societal improvements. Communicators are the bridging agents to this success.

APPENDIX A
Methodology: Interviews

Interviews

THE GOAL OF IN-DEPTH interviews is to generate co-created data from the views of the research participants (Dixon, Singleton, & Straits 2016), rather than have most of the research control under the auspices of the researchers. According to Lindlof and Taylor (2011), interviews are "well suited to understanding the social actor's experience, knowledge, and worldviews" (173). In the present study the author served as interviewer. The interviewer's professional public relations and media experience, including work in a museum communications office, assisted in building rapport with the interviewees.

Human Subject Protections and Protocols

The research was approved by the Institutional Review Board of the researcher's university. The informed consent document was emailed in advance to each interviewee for review prior to the interview. At the outset of each interview, the researcher provided two hard copies for signatures, leaving one with the interviewee and taking one for the research files. After receiving permission to record, digital audio devices were used for all the interviews. Interviews ranged from 45 to 75 minutes. All 22 interviews were fully transcribed, generating 328 pages of transcripts.

Rationale for Choice of Cities

Communicators from ethnic museums in the four largest immigration gateway cities in the United States were asked to participate in the research

(Department of Homeland Security 2016). Museums were found in the *Official Museum Directory* (2015). In addition to having large numbers of ethnic museums, the study's locales have different demographics. According to the US Census at the time of the interview planning:

	Los Angeles	Chicago	New York	San Francisco
African American	9.6%	32.9%	25.5%	6.1%
Hispanic	48.5%	28.9%	28.6%	15.1%
Asian	11.3%	5.5%	25.5%	33.3%

Cities also vary by subgroups, such as Hispanics including Puerto Ricans or Mexican Americans. Residents of European descent such as Ukrainian Americans or Italian Americans also differed in each city, ranging from new immigrants to multigenerational citizens. In short, these cities feature diverse populations, certainly one reason for the preponderance of ethnic museums located there. Thus, this purposive sample was constructed to provide maximum variation in two ways. First, the cities chosen boast numerous types of culture-specific museums (reflecting different historical periods of US immigration) and include African American museums. Second, cities' demographics differ.

Interview Analysis

The transcripts were the primary dataset. The researcher also collected collateral materials at the museums such as brochures, newsletters, catalogs, postcards, flyers, and the like, which provided back-up information on current events and exhibits mentioned in the interviews. The transcripts were hand-coded.

Constant comparison analysis was used to reduce the data (Bernard, Wutich, & Ryan 2017; McCracken 1988). In the first (open) phase, after reading through all the interviews to gain understanding of the remarks, interview responses were grouped into categories. The units of analysis

were phrases that represented a coherent thought or idea (not necessarily complete sentences; in other cases, more than one sentence). Although key concepts from the research questions were used as starting points for groupings, they did not function as absolute concepts. In the second phase (integration and elaboration), the researcher reviewed the data again to determine any categorical overlap. Transcripts were read multiple times during this process. In the third phase (reduction) the most interesting themes and sub-themes were chosen for the book. Finally, quotes from interviews (including quotes that might represent or diverge from the main patterns) were chosen to illustrate the most compelling ideas related to identity and allow interviewees' own voices to speak in the research. Anonymity was preserved by using generic titles for the research participants and general descriptors for the organizations. However, to improve accuracy and validity, some participants were asked to serve as member checks for direct or paraphrased quotes. Participants ranged in age from a recent college graduate to professionals with more than thirty years of experience. Five interviewees were men and seventeen were women.

APPENDIX B
Methodology: Content Analyses

Sample

TO ANALYZE MUSEUMS' DIGITAL media and social media, 227 institutions were selected for the study. The sampling frame was the *Official Museum Directory* (2017), published by the American Alliance of Museums. With more than 35,000 individual and institutional members, the Alliance is the main museum professional organization in the United States. The goal was to include mainstream art and history museums, along with culture-specific organizations.

To find specialty museums that identified as ethnic, American Indian, or African American museums, the researchers examined *Directory* categories of "culturally specific," "folk art," "arts and crafts," "history," and "art." Duplicates and those not meeting the criteria were deleted, as were museums without websites. Some museums had social media but not websites; thus the website and social media analyses differ slightly in sample size. This procedure initially resulted in 45 American Indian, 43 African American, and 42 other ethnic museums (such as Swedish or Mexican museums). These were the sample sizes for each genre in the social media analysis. The sample size for the website and digital newsroom analyses was 224 due to technological issues. For example, some museums did not have a working website at the time of data collection but employed functional social media. Thus, for Chapters 6 and 8, the sample sizes were 45 American Indian, 41 African American, and 42 other culture-specific museums.

A purposive sample was developed for the mainstream museums, with the aim of selecting museums from each state where possible and generating samples that were roughly equal to the ethnic museums. First, the

art museum category in the *Directory* was searched, and the largest art museum in each state's capital city was selected. If there was not an art museum in the capital, the next largest city in the state was chosen. If not already selected, institutions on top museum lists were added. Next, the history museum category in the *Directory* was searched, using the same procedure. After deleting museums that lacked websites, this generated a sample of 56 mainstream art museums and 41 mainstream US history museums in the United States and Puerto Rico, which was the sample used for the social media analysis. Sample sizes for Chapters 6 and 8 included the 56 art museums and 40 history museums, due to a technological issue while data were collected.

Omitted from all five genres were museums that were sub-organizations of universities, churches, or the National Park Service, as the research target was standalone museums. To be included in the sample, the institutions were required to meet Burns's definition of a professional museum (2013): to have a permanent collection, to be open on a regular schedule, and to not simply be a historic site. The United States and all its territories were included in the initial sampling frame, but only two of Puerto Rico's institutions met the criteria.

Data were collected from October 2018 through April 2019, guided by protocols in Riffe, Lacy, and Fico (2014).

Measurement: Websites

The codesheet had thirteen variables that measured interactive features and informational features, one that assessed a mobile application, and seven that coded visual and multimodal dynamism. These measures were guided by prior content analyses of websites, as discussed extensively in the literature review. Open-ended comments about the website elements were also noted on the codesheets.

Measurement: Digital Newsrooms

The codesheet measured interactive features, informational features, and usability/navigation of the online pressrooms, following prior content

analyses of pressrooms (González Herrero & Ruiz de Valbuena 2006; Callison 2003; Moon & Hyun 2014; Reber & Kim 2006; Yeon et al. 2005). As the results tables display, the codesheet had ten informational variables (guided by Pettigrew & Reber 2011) and four interactivity variables. Twelve other variables logged the availability of downloadable visuals, including logos, photos, videos, and graphics. Another coded whether downloadable audio files were present, and one variable delineated whether materials could be accessed via a log-in system. Open-ended coder comments noted navigation and usability highlights or problems.

Extant research has not discussed media restrictions, perhaps to under-score the importance of welcoming online pressrooms. Thus, this research also investigated whether museum online pressrooms included any policy statements about video or still photography.

Measurement: Social Media

Thirteen variables measured the use of social media platforms and net-worked travel sites such as TripAdvisor used by museums in the study. As related in the social media chapter, Google + was included on the codesheet because it was a viable platform when the codesheet was developed in summer 2018. However, it was not included in the final analysis because the platform was cancelled. Open-ended comments by coders also noted broken links and additional networked platforms not included on the codesheet, such as Reddit.

REFERENCES

Abernathy, Penelope Muse. 2018. *The Expanding News Desert*. Chapel Hill: University of North Carolina Press.

Adams, G. Donald. 1983. *Museum Public Relations*. Nashville: American Association for State and Local History.

Aiello, Giorgia, and Crispin Thurlow. 2006. "Symbolic Capitals: Visual Discourse and Intercultural Exchange in the European Capital of Culture Scheme." *Language and Intercultural Communication* 6, no. 2: 148–62.

American Alliance of Museums. 2002. *Mastering Civic Engagement: A Challenge to Museums*. Washington, DC: American Alliance of Museums.

American Alliance of Museums. 2015. *The Official Museum Directory*. Washington, DC.

American Alliance of Museums. 2017. *The Official Museum Directory*. Washington, DC.

American Alliance of Museums. 2019. "Museum Facts & Data." https://www.aam-us.org /programs/about-museums/museum-facts-data. Accessed March 27, 2019.

Anderson, Monica, and Madhumitha Kumar. 2019. *Digital Divide Persists Even as Lower-Income Americans Make Gains in Tech Adoption*. Washington, DC: Pew Research Center. May 7, 2019. https://www.pewresearch.org/fact-tank/2019/05/07/digital-divide -persists-even-as-lower-income-americans-make-gains-in-tech-adoption.

Anholt, Simon. 2012. "Beyond the Nation Brand: The Role of Image and Identity in International Relations." *Exchange: The Journal of Public Diplomacy* 2, no. 1: 6–12.

Appiah, Osei, Silvia Knobloch-Westerwick, and Scott Alter. 2013. "Ingroup Favoritism and Outgroup Derogation: Effects of News Valence, Character Race, and Recipient Race on Selective News Reading." *Journal of Communication* 63, no. 3 (June): 517–34.

Aronczyk, Melissa. 2013. *Branding the Nation: The Global Business of National Identity*. New York: Oxford University Press.

Atwater, Deborah F., and Sandra L. Herndon. 2003. "Cultural Space and Race: The National Civil Rights Museum and MuseumAfrica." *Howard Journal of Communications* 14, no. 1: 15–28.

Ballangee-Morris, Christine. 2008. "Indigenous Aesthetics: Universal Circles Related and Connected to Everything Called Life." *Art Education* 61, no. 2: 30–33.

Banning, Stephen A., and Mary Schoen. 2007. "Maximizing Public Relations with the Organization-Public Relationship Scale: Measuring a Public's Perception of an Art Museum." *Public Relations Review* 33, no. 4 (November): 437–39.

Benecke, D. R., Z. Simpson, S. Le Roux, C. J. Skinner, N. Janse van Rensburg, J. Sibeko, S. Bvuma, and J. Meyer. 2017. "Cultural Intermediaries and the Circuit of Culture: The Digital Ambassadors Project in Johannesburg, South Africa." *Public Relations Review* 43, no. 1 (March): 26–34.

Berg, Charles Ramírez. 2002. *Latino Images in Film: Stereotypes, Subversion, Resistance.* Austin: University of Texas Press.

Berger, Maurice. 1992. *How Art Becomes History: Essays on Art, Society, and Culture in Post-New Deal America.* New York: Icon Editions.

Berkowitz, Dan, and Douglas B. Adams. 1990. "Information Subsidy and Agenda-Building in Local Television News." *Journalism Quarterly* 67, no. 4 (December): 723–31.

Bernard, H. Russell, Amber Y. Wutich, and Gery W. Ryan. 2017. *Analyzing Qualitative Data: Systematic Approaches.* 2nd ed. Thousand Oaks, CA: Sage.

Bhabha, Homi K. 1994. *The Location of Culture.* New York: Routledge.

Billeaudeaux, Brigitte, and Jennifer Schnabel. 2016. "Engaging User Audiences in the Digital Landscape." In *Positioning Your Museum as a Critical Community Asset: A Practical Guide,* edited by Robert P. Connolly and Elizabeth Bollwerk, 165–74. Lanham, MD: Rowman & Littlefield.

Blair, Sheila S., and Jonathan M. Bloom. 2003. "The Mirage of Islamic Art." *Art Bulletin* 85, no. 1: 152–84.

Blalock, Nicole, Jameson D. Lopez, and Elyssa Figari. 2015. "Acts of Visual Sovereignty: Photographic Representations of Cultural Objects." *American Indian Culture and Research Journal* 39, no. 3: 83–98.

Blythe, June. 1947. "Can Public Relations Help Reduce Prejudice?" *Public Opinion Quarterly* 11, no. 3 (Fall): 342–60.

Bogle, Donald. 2002. *Toms, Coons, Mulattoes, Mammies, and Bucks: An Interpretive History of Blacks in American Films.* 4th ed. New York: Continuum.

Boorstin, Daniel J. 1964. *The Image: A Guide to Pseudo-Events in America.* New York: Harper & Row.

Bourdieu, Pierre. 1984. *Distinction: A Social Critique of the Judgment of Taste.* London: Routledge.

Branscombe, Nyla R., and Daniel L. Wann. 1994. "Collective Self-Esteem Consequences of Outgroup Derogation When a Valued Social Identity is on Trial." *European Journal of Social Psychology* 24, no. 6 (November/December): 641–57.

Brock, André. 2012. "From the Blackhand Side: Twitter as a Cultural Conversation." *Journal of Broadcasting and Electronic Media* 56, no. 4: 529–49.

Broom, Glen M. 2009. *Cutlip & Center's Effective Public Relations.* 10th ed. Upper Saddle River, NJ: Prentice-Hall.

Broom, Glen M., and David M. Dozier. 1990. *Using Research in Public Relations: Applications to Program Management.* Englewood Cliffs, NJ: Prentice-Hall.

Broom, Glen M., Shawna Casey, and James Ritchey. 1997. "Toward a Concept and Theory of Organization-Public Relationships." *Journal of Public Relations Research* 9, no. 2: 83–98.

Brown, Kenon A., Candace White, and Damion Waymer. 2011. "African-American Students' Perceptions of Public Relations Education and Practice: Implications for Minority Recruitment." *Public Relations Review* 37, no. 5 (December): 522–29.

Bureau of Labor Statistics. 2016. *Leisure Time on an Average Day.* Washington, DC: US Department of Labor. https://www.bls.gov/tus/charts/leisure.htm.

Bureau of Labor Statistics. 2019. "Occupational Outlook Handbook." U. S. Department of Labor. https://www.bls.gov/ooh/media-and-communication/reporters-correspondents -and-broadcast-news-analysts.htm and https://www.bls.gov/ooh/media-and -communication/photographers.htm#tab-6.

Burns, Andrea A. 2013. *From Storefront to Monument: Tracing the Public History of the Black Museum Movement.* Amherst: University of Massachusetts Press.

Buttlar, Lois J., and Lubomyr R. Wynar. 1996. *Guide to Information Resources in Ethnic Museum, Library, and Archival Collections in the United States.* Westport, CT: Greenwood Press.

Cabosky, Joseph. 2016. "Social Media Opinion Sharing: Beyond Volume." *Journal of Consumer Marketing* 33, no. 3: 172–81.

Caerols-Mateo, Raquel, Mónica Viñarás-Abad, and Juan Enrique Gonzálvez-Valles. 2017. "Social Networking Sites and Museums: Analysis of the Twitter Campaigns for International Museum Day and Night of Museums." *Revista Latina de Comunicación Social* 72: 220–34.

Callison, Coy. 2003. "Media Relations and the Internet: How Fortune 500 Company Web Sites Assist Journalists in News Gathering." *Public Relations Review* 29, no. 1 (March): 29–41.

Cameron, Glen T., Lynne M. Sallot, and Patricia A. Curtin. 1997. "Public Relations and the Production of News: A Critical Review and Theoretical Framework." In *Communication Yearbook 20*, edited by Brant R. Burleson, 111–55. Thousand Oaks, CA: Sage.

Capriotti, Paul. 2010. "Museums' Communication in Small- and Medium-Sized Cities." *Corporate Communications: An International Journal* 15, no. 3: 281–98.

Capriotti, Paul. 2013. "Managing Strategic Communication in Museums: The Case of Catalan Museums." *Communication & Society/Comunicación y Sociedad* 26, no. 3: 98–116.

Capriotti, Paul, Carmen Carretón, and Antonio Castillo. 2016. "Testing the Level of Interactivity of Institutional Websites: From Museums 1.0 to Museums 2.0." *International Journal of Information Management* 36, no. 1: 97–104.

Capriotti, Paul, and Alfonso González Herrero. 2017. "From 1.0 Online Pressrooms to 2.0 Social Newsrooms at Museums Worldwide." *Communication & Society* 30, no. 2: 113–29.

Capriotti, Paul, and Hugo Pardo Kuklinski. 2012. "Assessing Dialogic Communication through the Internet in Spanish Museums." *Public Relations Review* 38, no. 4 (November): 619–26.

Cárdenas, Gilberto. 2010. "Unfinished Journey: Mexican Migration through the Visual Arts." In *Art in the Lives of Immigrant Communities in the United States,* edited by Paul DiMaggio and Patricia Fernández-Kelly, 155–75. New Brunswick, NJ: Rutgers University Press.

Carneiro, Larissa, and Melissa A. Johnson. 2015. "Ethnic Past and Ethnic Now: The Representation of Memory in Ethnic Museum Websites." *Public Relations Inquiry* 4, no. 2 (May): 163–79.

Carter, Richard F. 1962. "Stereotyping as a Process." *Public Opinion Quarterly* 26, no. 1 (Spring): 77–91.

Chapinksi, Benjamin. 1979. "Ethnics and Their Media: A Specific Documentation of Polonia in the United States." *Gazette: International Journal for Communication Studies* 25, no. 2 (May): 87–95.

Chen, Guo-Ming, and William J. Starosta. 2005. *Foundations of Intercultural Communication.* 2nd ed. Lanham, MD: University Press of America.

Chen, Yea-Wen, and Mary Jane Collier. 2012. "Intercultural Identity Positioning: Interview Discourses from Two Identity-Based Nonprofit Organizations." *Journal of International and Intercultural Communication* 5, no. 1: 43–63.

Cohen, Randy, William Schaffer, and Benjamin Davidson. 2003. "Arts and Economic Prosperity: The Economic Impact of Nonprofit Arts Organizations and Their Audiences." *Journal of Arts Management, Law, and Society* 33, no. 1: 17–31.

Conclave (2013). Complete Social Media Measurement Standards. https://docs.wixstatic.com /ugd/0b15ae_c4b5f3e188e143cca1ca263376fbb132.pdf.

Connolly, Robert P., and Elizabeth A. Bollwerk. 2016. *Positioning Your Museum as a Critical Community Asset: A Practical Guide.* Lanham, MD: Rowman & Littlefield.

Cooks, Bridget R. 2006. "Pan-African Politics in African American Visual Art: Where Have We Been? Where Are We Going?" *International Journal of Media & Cultural Politics* 2, no. 2 (July): 183–99.

Cooks, Bridget R. 2011. *Exhibiting Blackness: African Americans and the American Art Museum.* Amherst: University of Massachusetts Press.

Correa, Teresa. 2010. "Framing Latinas: Hispanic Women through the Lens of Spanish-Language and English-Language News Media." *Journalism* 11, no. 4 (August): 425–43.

Cuillier, David, and Susan Dente Ross. 2007. "Gambling with Identity: Self-Representation of American Indians on Official Tribal Websites." *Howard Journal of Communications* 18, no. 3: 197–219.

Curtin, Patricia A. 1999. "Reevaluating Public Relations Information Subsidies: Market-Driven Journalism and Agenda-Building Theory and Practice." *Journal of Public Relations Research* 11, no. 1: 53–90.

Curtin, Patricia. 2011. "Discourses of American Indian Racial Identity in the Public Relations Materials of the Fred Harvey Company: 1902–1936." *Journal of Public Relations Research* 23, no. 4: 368–96.

Curtin, Patricia A., and Kenn T. Gaither. 2007. *International Public Relations: Negotiating Culture, Identity, and Power.* Thousand Oaks, CA: Sage.

Curtin, Patricia A., and Eric Rhodenbaugh. 2001. "Building the News Media Agenda on the Environment: A Comparison of Public Relations and Journalistic Sources." *Public Relations Review* 27, no. 2 (Summer): 179–95.

Davalos, Karen Mary. 2001. *Exhibiting Mestizaje: Mexican (American) Museums in the Diaspora.* Albuquerque: University of New Mexico Press.

Davis, Kimberly Chabot. 2004. "Oprah's Book Club and the Politics of Cross-Racial Empathy." *International Journal of Cultural Studies 7*, no. 4 (December): 399–419.

Davis, Patricia. 2013. "Memoryscapes in Transition: Black History Museums, New South Narratives, and Urban Regeneration." *Southern Communication Journal 78*, no. 2: 107–27.

Daymon, Christine, and Caroline Hodges. 2009. "Researching the Occupational Culture of Public Relations in Mexico." *Public Relations Review 35*, no. 4 (November): 429–33.

DeLorme, Denise E., and Fred Fedler. 2003. "Journalists' Hostility to Public Relations: An Historical Analysis." *Public Relations Review 29*, no. 2 (June): 99–124.

De Moya, Maria, and Rajul Jain. 2013. "When Tourists are Your 'Friends': Exploring the Brand Personality of Mexico and Brazil on Facebook." *Public Relations Review 39*, no. 1 (March): 23–29.

De Moya, Maria, and Vanessa Bravo. 2016. "The Role of Public Relations in Ethnic Advocacy and Activism: A Proposed Research Agenda." *Public Relations Inquiry 5*, no. 3 (September): 233–51.

Department of Homeland Security. 2016. *Yearbook of Immigration Statistics: 2016*. Washington, DC: US Department of Homeland Security, Office of Immigration Statistics. https://www .dhs.gov/immigration-statistics/yearbook/2016 February 1.

Diggs-Brown, Barbara, and R. S. Zaharna. 1995. "Ethnic Diversity in the Public Relations Industry." *Howard Journal of Communications 6*, no. 1–2: 114–23.

DiMaggio, Paul, and Patricia Fernández-Kelly. 2010. *Art in the Lives of Immigrant Communities in the United States*. New Brunswick, NJ: Rutgers University Press.

DiStasio, Marcia W. 2012. "The Annual Earnings Press Release's Dual Role: An Examination of Relationships with Local and National Media Coverage and Reputation." *Journal of Public Relations Research 24*, no. 2: 123–43.

DiStaso, Marcia W., Tina McCorkindale, and Alexa Agugliaro. 2015. "America's Most Admired Companies Social Media Industry Divide." *Journal of Promotion Management 21*, no. 2: 163–89.

Dixon, Jeffrey C., Royce A Singleton, and Bruce C. Straits. 2016. *The Process of Social Research*. New York: Oxford University Press.

Dixon, Travis L., and Christina L. Azocar. 2007. "Priming Crime and Activating Blackness: Understanding the Psychological Impact of Overrepresentation of Blacks as Lawbreakers on Television News." *Journal of Communication 57*, no. 2 (June): 229–53.

Dixon, Travis L., and Daniel Linz. 2000. "Race and the Misrepresentation of Victimization on Television News." *Communication Research 27*, no. 5 (October): 547–73.

Dozier, David M., and Martha M. Lauzen. 2000. "Liberating the Intellectual Domain from the Practice: Public Relations, Activism, and the Role of the Scholar." *Journal of Public Relations Research 12*, no. 1: 3–22.

Driskell, David C., ed. 1995. *African American Visual Aesthetics: A Postmodernist View*. Washington, DC: Smithsonian Institution.

Drotner, Kirsten, and Kim Christian Schrøder. 2013. *Museum Communication and Social Media: The Connected Museum.* New York: Routledge.

Duke, Shearlean. 2002. "Wired Science: Use of World Wide Web and E-mail in Science Public Relations." *Public Relations Review* 28, no. 3 (August): 311–24.

Durand, Jorge, and Douglas S. Massey. 2010. "Miracles on the Border: The Votive Art of Mexican Migrants to the United States." In *Art in the Lives of Immigrant Communities in the United States,* edited by Paul DiMaggio and Patricia Fernández-Kelly, 214–28. New Brunswick, NJ: Rutgers University Press.

Edwards, Lee. 2006. "Rethinking Power in Public Relations." *Public Relations Review* 32, no. 3 (September): 229–31.

Edwards, Lee. 2009. "Symbolic Power and Public Relations Practice: Locating Individual Practitioners in Their Social Context." *Journal of Public Relations Research* 21, no. 3: 251–72.

Edwards, Lee. 2013. "Institutional Racism in Cultural Production: The Case of Public Relations." *Popular Communication* 11, no. 3: 242–56.

Edwards, Lee. 2015. *Power, Diversity, and Public Relations.* London: Routledge.

Entman, Robert M., and Andrew Rojecki. 2000. *The Black Image in the White Mind: Media and Race in America.* Chicago: University of Chicago Press.

Faber, Ronald J., Thomas C. O'Guinn, and Timothy P. Meyer. 1986. "Diversity in the Ethnic Media Audience: A Study of Spanish Language Broadcasting." *International Journal of Intercultural Relations* 10, no. 3: 347–59.

Fatima Oliveira, Maria de. 2013. "Multicultural Environments and Their Challenges to Crisis Communication." *Journal of Business Communication* 50, no. 3 (July): 253–77.

Fidelity Charitable. 2017. *Overcoming Barriers to Giving.* Boston, MA: FMR, LLC. https://www.fidelitycharitable.org/insights/overcoming-barriers-to-giving.html.

Fleming, John E. 1994. "African-American Museums, History, and the American Ideal." *Journal of American History* 81, no. 3 (December): 1020–26.

Freedman, Harry A., and Karen Feldman. 2007. *Black Tie Optional: A Complete Special Events Resource for Nonprofit Organizations.* 2nd ed. Hoboken, NJ: John Wiley & Sons.

French, Ylva, and Sue Runyard. 2011. *Marketing and Public Relations for Museums, Galleries, Cultural and Heritage Attractions.* New York: Routledge.

Fujioka, Yuki. 2005. "Black Media Images as a Perceived Threat to African American Ethnic Identity: Coping Responses, Perceived Public Perception, and Attitudes towards Affirmative Action." *Journal of Broadcasting & Electronic Media* 49, no. 4: 450–67.

Gandy, Oscar H., Jr. 1982. *Beyond Agenda Setting: Information Subsidies and Public Policy.* Norwood, NJ: Ablex Publishing.

Gans, Herbert J. 2009. "Reflections on Symbolic Ethnicity: A Response to Y. Anagnostou." *Ethnicities* 9, no. 1 (March): 123–30.

Gay, Geneva. 1987. "Expressive Ethos of Afro-American Culture." In *Expressively Black: The Cultural Basis of Ethnic Identity,* edited by Geneva Gay and Willie L. Baber, 1–16. New York: Praeger.

Gay, Geneva, and Willie L. Baber, eds. 1987. *Expressively Black: The Cultural Basis of Ethnic Identity.* New York: Praeger.

Gayle, Addison, Jr. 1971. *The Black Aesthetic.* Garden City, NY: Doubleday.

Gibson, Dirk C. 2002. "Posibilidad y Problema: An Historical/Critical Analysis of Hispanic Public Relations." *Public Relations Review* 28, no. 1 (February): 63–85.

Goldman, Seth K. 2012. "Effects of the 2008 Obama Presidential Campaign on White Racial Prejudice." *Public Opinion Quarterly* 76, no. 4 (Winter): 663–87.

González Herrero, Alfonso, and Miguel Ruiz de Valbuena. 2006. "Trends in Online Media Relations: Web-Based Corporate Press Rooms in Leading International Companies." *Public Relations Review* 32, no. 3 (September): 267–75.

Grams, Diane, and Betty Farrell, eds. 2008. *Entering Cultural Communities: Diversity and Change in the Nonprofit Arts.* New Brunswick, NJ: Rutgers University Press.

Grantham, Bill. 2009. "Craic in a Box: Commodifying and Exporting the Irish Pub." *Continuum: Journal of Media and Cultural Studies* 23, no. 2: 257–67.

Gregory, Anne, and Tom Watson. 2008. "Defining the Gap between Research and Practice in Public Relations Program Evaluation—Towards a New Research Agenda." *Journal of Marketing Communications* 14, no. 5: 337–50.

Grunig, James E. 2009. "Paradigms of Global Public Relations in an Age of Digitalization." *Prism* 6, no. 2: http://praxis.massey.ac.nz/prismon-line journ.html.

Grunig, James E., and Todd Hunt. 1984. *Managing Public Relations.* New York: Holt, Rhinehart, and Winston.

Grunig, James E., and Fred C. Repper. 1992. "Strategic Management, Publics, and Issues." In *Excellence in Public Relations and Communication Management,* edited by James E. Grunig, 117–58. Hillsdale, NJ: Lawrence Erlbaum Associates.

Grunig, Larissa A., James E. Grunig, and William P. Ehling. 1992. "What Is an Effective Organization?" In *Excellence in Public Relations and Communication Management,* edited by James E. Grunig, 65–90. Hillsdale, NJ: Lawrence Erlbaum Associates.

Guillory, Jamie E., and S. Shyam Sundar. 2014. "How Does Web Site Interactivity Affect Our Perceptions of an Organization?" *Journal of Public Relations Research* 26, no. 1: 44–61.

Gutiérrez, Félix F. 1977. "Spanish-Language Media in America: Background, Resources, History." *Journalism History* 4, no. 2: 34–41.

Gutiérrez, Félix F., and Jorge R. Schement. 1979. *Spanish-Language Radio in the Southwestern United States.* Austin: University of Texas Center for Mexican American Studies.

Hachigian, David, and Kirk Hallahan. 2003. "Perceptions of Public Relations Web Sites by Computer Industry Journalists." *Public Relations Review* 29, no. 1 (March): 43–62.

Hall, Edward T. 1976. *Beyond Culture.* New York: Doubleday.

Haro-de-Rosario, Arturo, Alejandro Sáez-Martín, and María del Carmen Caba-Pérez. 2018. "Using Social Media to Enhance Citizen Engagement with Local Government: Twitter or Facebook?" *New Media & Society* 20, no. 1 (January): 29–49.

Harris, Michael D. 2003. *Colored Pictures: Race and Visual Representation.* Chapel Hill: University of North Carolina Press.

Hart, Donn V. 1977. "The Filipino American Press in the United States." *Journalism Quarterly* 54, no. 1 (March): 135–39.

Hebdige, Dick. 1979. *Subculture: The Meaning of Style*. London: Methuen and Co.

Heller, Steven. 2014. *Design Literacy: Understanding Graphic Design*. 3rd ed. New York: Allworth Press.

Herrera, Andrea O'Reilly. 2011. *Cuban Artists across the Diaspora: Setting the Tent against the House*. Austin: University of Texas Press.

Hershey, R. Christine, and Vanessa Schnaidt. 2019. *Communication Toolkit: A Guide to Navigating Communications for Social Impact*. 4th ed. Santa Monica, CA: Cause Communications.

Higgins, Joan Wharf, and Ashley Hodgins. 2008. "The Grape Escape—A FUNdraising Bike Tour for the Multiple Sclerosis Society." *Journal of Nonprofit & Public Sector Marketing* 19, no. 2: 48–67.

Hilden, Patricia. 2000. "Race for Sale: Narratives of Possession in Two 'Ethnic' Museums." *Drama Review* 44, no. 3 (Fall): 11–36.

Hodges, Caroline. 2006. "'PRP Culture': A Framework for Exploring Public Relations Practitioners as Cultural Intermediaries." *Journal of Communication Management* 10, no. 1: 80–93.

Hofstede, Geert. 2001. *Culture's Consequences: Comparing Values, Behaviors, Institutions, and Organizations Across Nations*. 2nd ed. Thousand Oaks, CA: Sage.

Holt, Lanier Frush. 2013. "Writing the Wrong: Can Counter-Stereotypes Offset Negative Media Messages about African Americans?" *Journalism & Mass Communication Quarterly* 90, no. 1 (March): 108–25.

Hon, Linda Childers. 1997. "'To Redeem the Soul of America': Public Relations and the Civil Rights Movement." *Journal of Public Relations Research* 9, no. 3: 163–212.

Hon, Linda. 2015. "Digital Advocacy in the Justice for Trayvon Campaign." *Journal of Public Relations Research* 27, no. 4: 299–321.

Hon, Linda. 2016. "Social Media Framing within the Million Hoodies Movement for Justice." *Public Relations Review* 42, no. 1 (March): 9–19.

Hon, Linda Childers, and Brigitta Brunner. 2000. "Diversity Issues and Public Relations." *Journal of Public Relations Research* 12, no. 4: 309–40.

Hon, Linda Childers, and James E. Grunig. 1999. "Guidelines for Measuring Relationships in Public Relations." Gainesville, FL: Institute for Public Relations Research: 1–40. www.institute forpr.org.

Hong, Soo Yeon. 2008. "The Relationship Between Newsworthiness and Publication of News Releases in the Media." *Public Relations Review* 34, no. 3 (September): 297–99.

Hooper-Greenhill, Eilean. 1997. *Cultural Diversity: Developing Museum Audiences in Britain*. London: Leicester University Press.

Hume, Margee. 2011. "How Do We Keep Them Coming? Examining Museum Experiences Using a Services Marketing Paradigm." *Journal of Nonprofit & Public Sector Marketing* 23, no. 1: 71–94.

Hyland, Angus. 2006. "Introduction." In C/ID: Visual Identity and Branding for the Arts, edited by Angus Hyland and Emily King, 9–10. London: Lawrence King.

Ingenhoff, Diana, and A. Martina Koelling. 2010. "Web Sites as a Dialogic Tool for Charitable Fundraising NPOs: A Comparative Study." International Journal of Strategic Communication 4, no. 3: 171–88.

Institute of Museum and Library Services. May 19, 2014. "Government Doubles Official Estimate: There Are 35,000 Active Museums in the U.S." Museum Universe Data File. Washington, DC: IMLS. https://www.imls.gov/news-events/news-releases /government-doubles-official-estimate-there-are-35000-active-museums-us. Accessed January 15, 2018.

International Council of Museums. 2018. Museum Definition. http://icom.museum/the-vision /museum-definition. Accessed January 31, 2018.

Jamal, Amaney. 2010. "Inside and Outside the Box: The Politics of Arab American Identity and Artistic Representations." In Art in the Lives of Immigrant Communities in the United States, edited by Paul DiMaggio and Patricia Fernandez-Kelly, 72–88. New Brunswick, NJ: Rutgers University Press.

Jandt, Fred E. 2018. An Introduction to Intercultural Communication: Identities in a Global Community. 9th ed. Thousand Oaks, CA: Sage.

Jansen-Verbeke, Myriam, and Johan van Rekom. 1996. "Scanning Museum Visitors: Urban Tourism Marketing." Annals of Tourism Research 23, no. 2: 364–75.

Jeffres, Leo W., and K. Kyoon Hur. 1980. "The Forgotten Media Consumer—The American Ethnic." Journalism & Mass Communication Quarterly 57, no. 1 (March): 10–17.

Jeffres, Leo W., and K. Kyoon Hur. 1981. "Communication Channels within Ethnic Groups." International Journal of Intercultural Relations 5, no. 2: 115–32.

Jeffries-Fox, Bruce. 2005. A Guide to Measuring Event Sponsorships. Gainesville, FL: Institute for Public Relations. https://instituteforpr.org/wp-content/uploads/2005 _EventSponsorships-Bruce-Jeffries-Fox.pdf.

Johnson, Melissa A. 1999. "Pre-Television Stereotypes: Mexicans in U.S. Newsreels, 1919–1932." Critical Studies in Mass Communication 16, no. 4: 417–35.

Johnson, Melissa A. 2010. "Incorporating Self-Categorization Concepts into Ethnic Media Research." Communication Theory 20, no. 1 (February): 105–24.

Johnson, Melissa A., and Larrisa Carneiro. 2014. "Communicating Visual Identities on Ethnic Museum Websites." Visual Communication 13, no. 3 (August): 357–72.

Johnson, Melissa A., Prabu David, and Dawn Huey-Ohlsson. 2003. "Beauty in Brown: Skin Color in Latina Magazines." In Brown and Black Communication: Latino and African American Conflict and Convergence in Mass Media, edited by Diana I. Rios and A. N. Mohamed, 159–73. Westport, CT: Praeger.

Johnson, Melissa A., and Kelly N. Martin. 2014. "When Navigation Trumps Visual Dynamism: Hospital Website Usability and Credibility." Journal of Promotion Management 20, no. 5: 666–87.

Johnson, Melissa A., and Keon M. Pettiway. 2017. "Visual Expressions of Black Identity: African American and African Museum Websites." *Journal of Communication* 67, no. 3 (June): 350–77.

Johnson, Melissa A., and William Sink. 2013. "Ethnic Museum Public Relations: Cultural Diplomacy and Cultural Intermediaries in the Digital Age." *Public Relations Inquiry* 2, no. 3 (September): 355–76.

Johnson, Melissa A., and William Sink. 2015. "Ethnic Museum Websites, Cultural Projection, and Self-Categorization Concepts." *Howard Journal of Communications* 26, no. 2: 206–25.

Kabassi, Katerina. 2017. "Evaluating Websites of Museums: State of the Art." *Journal of Cultural Heritage* 24 (March–April): 184–96.

Kay, Cristóbal. 2007. "Land, Conflict, and Violence in Latin America." *Peace Review: A Journal of Social Justice* 19, no. 1: 5–14.

Kelly, Lynda. 2013. "The Connected Museum in the World of Social Media." In *Museum Communication and Social Media: The Connected Museum*, edited by Kirsten Drotner and Kim Christian Schrøder, 54–71. New York: Routledge.

Kelly, Meghan, and Russell Kennedy. 2016. "Recognizing Appropriate Representation of Indigenous Knowledge in Design Practice." *Visible Language* 50, no. 1 (April): 153–73.

Kelly-Holmes, Helen, and Sari Pietikäinen. 2014. "Commodifying Sámi Culture in an Indigenous Tourism Site." *Journal of Sociolinguistics* 18, no. 4 (September): 518–38.

Kent, Michael L., and Maureen Taylor. 1998. "Building Dialogic Relationships through the World Wide Web." *Public Relations Review* 24, no. 3 (Autumn): 321–34.

Kern-Foxworth, Marilyn. 1989. "Status and Roles of Minority PR Practitioners." *Public Relations Review* 15, no. 3 (Autumn): 39–47.

Kim, Young Yun. 2006. "From Ethnic to Interethnic: The Case for Identity Adaptation and Transformation." *Journal of Language and Social Psychology* 25, no. 3 (September): 283–300.

Kotler, Neil, and Phillip Kotler. 1998. *Museum Strategy and Marketing: Designing Missions, Building Audiences, Generating Revenue and Resources.* San Francisco: Jossey-Bass.

Kottasz, Rita. 2006. "Understanding the Influences of Atmospheric Cues on the Emotional Responses and Behaviors of Museum Visitors." *Journal of Nonprofit and Public Sector Marketing* 16, no. 1/2: 95–121.

Landon, Kaia, Caroline Wallis, and Peter Davies, eds. 2010. *Twitter for Museums: Strategies and Tactics for Success.* Edinburgh: MuseumsEtc.

Lazzeretti, Luciana, and Francesco Capone. 2015. "Museums as Societal Engines for Urban Renewal. The Event Strategy of the Museum of Natural History in Florence." *European Planning Studies* 23, no. 8: 1548–67.

Leaman, Oliver. 2011. "Making Sense of the Arab World Aesthetically." *Journal of Aesthetic Education* 45, no. 4 (Winter): 109–21.

Lee, Hyunmin, and Hyojung Park. 2013. "Testing the Impact of Message Interactivity on Relationship Management and Organizational Reputation." *Journal of Public Relations Research* 25, no. 2: 188–206.

Lee, Nicole M., and Patrick F. Merle. 2018. "Media Relations and Universities: An Assessment of Digital Newsrooms." *Journal of Marketing for Higher Education* 28, no. 2: 232–46.

Lehman, Kim. 2009. "Australian Museums and the Modern Public: A Marketing Context." *Journal of Arts Management, Law, and Society* 39, no. 2: 87–100.

Len-Ríos, María E. 1998. "Minority Public Relations Practitioner Perceptions." *Public Relations Review* 24, no. 4 (Winter): 535–55.

Lester, Paul Martin. 1996. *Images That Injure: Pictorial Stereotypes in the Media.* Westport, CT: Praeger.

L'Etang, Jacquie. 2012. "Public Relations, Culture and Anthropology—Towards an Ethnographic Research Agenda." *Journal of Public Relations Research* 24, no. 2: 165–83.

Leuthold, Steven. 1998. *Indigenous Aesthetics: Native Art, Media and Identity.* Austin: University of Texas Press.

Lin, Jan. 1998a. "Globalization and the Revalorizing of Ethnic Places in Immigration Gateway Cities." *Urban Affairs Review* 34, no. 2 (November): 313–39.

Lin, Jan. 1998b. *Reconstructing Chinatown: Ethnic Enclave, Global Change.* Minneapolis: University of Minnesota Press.

Lindlof, Thomas R., and Bryan C. Taylor. 2011. *Qualitative Communication Research Methods.* 3rd ed. Thousand Oaks, CA: Sage.

Ling, Amy. 1999. *Yellow Light: The Flowering of Asian American Arts.* Philadelphia: Temple University Press.

Linville, Darren L., Sara E. McGee, and Laura K. Hicks. 2012. "Colleges' and Universities' Use of Twitter: A Content Analysis." *Public Relations Review* 38, no. 4 (November): 636–38.

Lipton, Ronnie. 2002. *Designing Across Cultures: How to Create Effective Graphics for Diverse Ethnic Groups.* Cincinnati: HOW Design Books.

Liu, Shuang, Zala Volčič, and Cindy Gallois. 2011. *Introducing Intercultural Communication: Global Cultures and Contexts.* London: Sage.

Logan, Nneka. 2011. "The White Leader Prototype: A Critical Analysis of Race in Public Relations." *Journal of Public Relations Research* 23, no. 4: 442–57.

López, Ximena, Ilaria Margapoti, Roberto Maragliano, and Giuseppe Bove. 2010. "The Presence of Web 2.0 Tools on Museum Websites: A Comparative Study Between England, France, Spain, Italy, and the USA." *Museum Management and Curatorship* 25, no. 2: 235–49.

Loukaitou-Sideris, Anastasia, and Carl Grodach. 2004. "Displaying and Celebrating the 'Other': A Study of the Mission, Scope, and Roles of Ethnic Museums in Los Angeles." *Public Historian* 26, no. 4 (Fall): 49–71.

Loureiro, Sandra Maria Correia, and Eduardo Sarmento Ferreira. 2018. "Engaging Visitors in Cultural and Recreational Experiences at Museums." *Anatolia* 29, no. 4: 581–92.

Lovejoy, Kristen, and Gregory D. Saxton. 2012. "Information, Community, and Action: How Nonprofit Organizations Use Social Media." *Journal of Computer-Mediated Communication* 17, no. 3 (April): 337–53.

Maasri, Zeina. 2012. "The Aesthetics of Belonging: Transformations in Hizbullah's Political Posters." *Middle East Journal of Culture and Communication* 5, no. 2: 149–89.

Macnamara, Jim. 2014. "Journalism-PR Relations Revisited: The Good News, the Bad News, and Insights into Tomorrow's News." *Public Relations Review* 40, no. 5 (December): 739–50.

Macnamara, Jim, and Robert Crawford. 2013. "The Construction of Australia Day: A Study of Public Relations as New Cultural Intermediaries." *Continuum: Journal of Media and Cultural Studies* 27, no. 2: 294–310.

Madden, Thomas J., Kelly Hewett, and Martin S. Roth. 2000. "Managing Images in Different Cultures: A Cross-National Study of Color Meanings and Preferences." *Journal of International Marketing* 8, no. 4 (December): 90–107.

Martin, Kelly N., and Melissa A. Johnson. 2010. "Digital Credibility and Digital Dynamism in Public Relations Blogs." *Visual Communication Quarterly* 17 no. 3: 162–74.

Martínez, David. 2015. "This is (Not) Indian Painting." *American Indian Quarterly* 39, no. 1: 25–51.

McCombs, Maxwell E., and Donald L. Shaw. 1972. "The Agenda-Setting Function of Mass Media." *Public Opinion Quarterly* 36, no. 2 (Summer): 176–87.

McCracken, Grant. 1988. *The Long Interview*. Newbury Park, CA: Sage.

McCue, Andy. 1975. "Evolving Chinese Language Dailies Serve Immigrants in New York City." *Journalism Quarterly* 52, no. 2 (June): 272–76.

McLean, Fiona. 1997. *Marketing the Museum*. London: Routledge.

Meyer, Leroy N. 2001. "In Search of Native American Aesthetics." *Journal of Aesthetic Education* 35, no. 4 (Winter): 25–46.

Miller, Sally M. 1987. *The Ethnic Press in the United States*. New York: Greenwood.

Mokhtar, Muhammad Fauzi, and Azilah Kasim. 2011. "Motivations for Visiting and Not Visiting Museums among Young Adults: A Case Study on UUM Students." *Journal of Global Management* 3, no. 1: 43–58.

Moon, Soo Jung, and Ki Deuk Hyun. 2014. "Online Media Relations as an Information Subsidy: Quality of Fortune 500 Companies' Websites and Relationships to Media Salience." *Mass Communication and Society* 17, no. 2: 258–73.

Moreno, C. 2006. "An Historical Survey: Afro-Mexican Depictions and Identity in the Visual Arts." In *The African Presence in Mexico*, edited by Claudia Herrera, 60–95. Chicago: Mexican Fine Arts Center Museum.

Moriarty, Sandra E., and Lisa Rohe. 1991. "Cultural Palettes: An Exercise in Sensitivity for Designers." *Journalism Educator* 46, no. 4 (December): 32–37.

Morris, Kate, and Bill Anthes. 2017. "Indigenous Futures." *Art Journal* 76, no. 2: 6–9.

Morrison, Keith. 1995. "The Global Village of African American Art." In *African American Visual Aesthetics*, edited by David C. Driskell, 17–43. Washington, DC: Smithsonian Institution Press.

Moshagen, Morten, and Meinald T. Thielsch. 2010. "Facets of Visual Aesthetics." *International Journal of Human-Computer Studies* 68, no. 10 (October): 689–709.

Moynihan, C. 2019. "With New Plans to Hire, El Museo del Barrio Reaches out to Critics." *New York Times*, March 28, 2019. https://www.nytimes.com/2019/03/28/arts/with-plans-for-new-hire-el-museo-del-barrio-reaches-out-to-critics.html.

Murphree, Vanessa. D. 2004. "'Black Power': Public Relations and Social Change in the 1960s." *American Journalism* 21, no. 3 (Summer): 13–32.

Nakamura, Lisa. 2002. *Cybertypes: Race, Ethnicity, and Identity on the Internet.* New York: Routledge.

Nakamura, Lisa. 2007. *Digitizing Race: Visual Cultures of the Internet.* Minneapolis: University of Minnesota Press.

National Press Photographers Association. 2017. "Drone Code of Ethics." National Press Photographers Association, https://www.nppa.org/document/drone-code-ethics-2017.

Neilson, Leighann C. 2003. "The Development of Marketing in the Canadian Museum Community, 1840–1989." *Journal of Macromarketing* 23, no. 1 (June): 16–30.

Nielsen Insights. 2019. "Nielsen TV: Getting to Know Millennial Videogamers." July 22, 2019. https://www.nielsen.com/us/en/insights/video/2019/nielsen-tv-getting-to-know -millennial-video-gamers.

Nixon, Sean, and Paul du Gay. 2002. "Who Needs Cultural Intermediaries?" *Cultural Studies* 16, no. 4: 495–500.

Noriega, Chon A., and Pilar Tompkins Rivas. 2011. "Chicano Art in the City of Dreams: A History in Nine Movements." In *L.A. Xichano,* edited by Chon A. Noriega, Terezita Romo, and Pilar Tompkins Rivas, 71–102. Los Angeles: UCLA Chicano Studies Research Center Press.

Noriega, Chon A., Terezita Romo, and Pilar Tompkins Rivas, P., eds. 2011. *L. A. Xicano.* Los Angeles: UCLA Chicano Studies Research Center Press.

Norris, Wendy Leigh, and Diane Grams. 2008. "High-Tech Transactions and Cyber-Communities." In *Entering Cultural Communities: Diversity and Change in the Nonprofit Arts,* edited by Diane Grams and Betty Farrell, 171–93. New Brunswick, NJ: Rutgers University Press.

Oetzel, John G. 2009. *Intercultural Communication: A Layered Approach.* Upper Saddle River, NJ: Pearson.

Oh, Jeeyun, and S. Shyam Sundar. 2015. "How Does Interactivity Persuade? An Experimental Test of Interactivity on Cognitive Absorption, Elaboration, and Attitudes." *Journal of Communication* 65, no. 2 (April): 213–36.

Ongiri, Amy Abugo. 2010. *Spectacular Blackness: The Cultural Politics of the Black Power Movement and the Search for a Black Aesthetic.* Charlottesville: University of Virginia Press.

Orbe, Mark P., and Tabatha L. Roberts. 2012. "Co-Cultural Theorizing: Foundations, Applications & Extensions." *Howard Journal of Communications* 23, no. 4: 293–311.

Orbe, Mark P., and Karen E. Strother. 1996. "Signifying the Tragic Mulatto: A Semiotic Analysis of Alex Haley's Queen." *Howard Journal of Communications* 7, no. 2: 113–26.

Osterman, Mark, M. Thirunarayanan, Elizabeth C. Ferris, Lizette C. Pabon, Natalie Paul, and Rhonda Berger. 2012. "Museums and Twitter: An Exploratory Qualitative Study of How Museums Use Twitter for Audience Development and Engagement." *Journal of Educational Multimedia and Hypermedia* 21, no. 3: 241–55.

Ott, Holly K., Michail Vafeiadis, Sushma Kumble, and T. Franklin Waddell. 2016. "Effect of Message Interactivity on Product Attitudes and Purchase Intentions." *Journal of Promotion Management* 22, no. 1: 89–106.

Paek, Hye Jin, and Hemant Shah. 2003. "Racial Ideologies, Model Minorities, and the 'Not-So-Silent Partner': Stereotyping of Asian Americans in U.S. Magazine Advertising." *Howard Journal of Communications* 14, no. 4: 225–43.

Pallas, John, and Anastasios A. Economides. 2008. "Evaluation of Art Museums' Web Sites Worldwide." *Information Services & Use* 28, no. 1: 45–57.

Pallud, Jessie, and Detmar W. Straub. 2014. "Effective Website Design for Experience-Influenced Environments: The Case of High Culture Museums." *Information & Management* 51, no. 3 (April): 359–73.

Papper, Bob. 2019. "2019 Research: Local TV and Radio News Strengths." Radio and Television News Association, May 15, 2019. http://RTDNA.org/research.

Park, Robert Erza. 1970. *The Immigrant Press and Its Control.* Westport, CT: Greenwood.

Partin, William. 2020. "The 2010s Were a Banner Year for Big Money and Tech—and Esports Reaped the Rewards. *Washington Post,* January 28, 2020. https://www.washington post.com/video-games/esports/2020/01/28/2010s-were-banner-decade-big-money -tech-esports-reaped-rewards.

Pasztory, Esther. 1989. "Identity and Difference: The Uses and Meanings of Ethnic Styles." *Studies in the History of Art* 27, Symposium Papers 12: 14–39, 4.

Patton, Pamela. 2015 A. *Envisioning Others: Race, Color and the Visual in Iberia and Latin America.* Leiden: Brill.

Pauwels, Luc. 2012. "A Multimodal Framework for Analyzing Websites as Cultural Expressions." *Journal of Computer-Mediated Communication* 17, no. 3 (April): 247–65.

Pettigrew, Justin E., and Bryan H. Reber. 2011. "Journalists' Opinions and Attitudes about Dialogic Components of Corporate Websites." *Public Relations Review* 37, no. 4 (November): 422–24.

Pew Research Center. 2013. "Newspaper Photographers Feel the Brunt of Job Cuts." Washington, DC: Pew Research Center. November 11, 2013. https://www.pewresearch.org/fact -tank/2013/11/11/at-newspapers-photographers-feel-the-brunt-of-job-cuts.

Pew Research Center. 2018. "Mobile Fact Sheet." Washington, DC: Pew Research Center. February 5, 2018. https://www.pewinternet.org/fact-sheet/mobile.

Pieczka, Magda. 2000. "Objectives and Evaluation in Public Relations Work: What Do They Tell Us about Expertise and Professionalism?" *Journal of Public Relations Research* 12, no. 3: 211–33.

Pierroux, Palmyre, and Synne Skjulstad. 2011. "Composing a Public Image Online: Art Museums and Narratives of Architecture in Web Mediation." *Computers and Composition* 28, no. 3 (September): 205–14.

Pincus, J. David, Tony Rimmer, Robert E. Rayfield, and Fritz Cropp. 1993. "Newspaper Editors' Perceptions of Public Relations: How Business, News, and Sports Editors Differ." *Journal of Public Relations Research* 5, no. 1: 27–45.

Pitel, Deborah. 2016. *Marketing on a Shoestring Budget: A Guide for Small Museums and Historic Sites.* Lanham, MD: Rowman & Littlefield.

Pollack, Barbara. 2019. "Exhibiting Change: When Some of the Best-Attended Exhibitions Are Protests, Where Do Institutions Go from Here?" *ArtNews*, May 21, 2019. http://www .artnews.com/2019/05/21/museum-protest-change.

Pompper, Donnalyn. 2004. "Linking Ethnic Diversity & Two-Way Symmetry: Modeling Female African American Practitioners' Roles." *Journal of Public Relations Research* 16, no. 3: 269–99.

Pompper, Donnalyn. 2007. "The Gender-Ethnicity Construct in Public Relations Organizations: Using Feminist Standpoint Theory to Discover Latinas' Realities." *Howard Journal of Communications* 18, no. 4: 291–311.

Pusa, Sophia, and Liisa Uusitalo. 2014. "Creating Brand Identity in Art Museums: A Case Study." *International Journal of Arts Management* 17, no. 1 (Fall): 18–30.

Qiu, Jing, and Nancy Muturi. 2016. "Asian American Public Relations Practitioners' Perspectives on Diversity." *Howard Journal of Communications* 27, no. 3: 236–49.

Ramasubramanian, Srividya. 2007. "Media-Based Strategies to Reduce Racial Stereotypes Activated by News Stories." *Journalism & Mass Communication Quarterly* 84, no. 2 (June): 249–64.

Ramasubramanian, Srividya. 2011. "The Impact of Stereotypical Versus Counterstereotypical Media Exemplars on Racial Attitudes, Causal Attributions, and Support for Affirmative Action." *Communication Research* 38, no. 4 (August): 497–516.

Reber, Bryan H., and Jun Kyo Kim. 2006. "How Activist Groups Use Websites in Media Relations: Evaluating Online Press Rooms." *Journal of Public Relations Research* 18, no. 4: 313–33.

Rentschler, Ruth, and Anne-Marie Hede, eds. 2007. *Museum Marketing: Competing in the Global Marketplace*. London: Butterworth-Heinemann.

Riffe, Daniel, Stephen Lacy, and Frederick Fico. 2014. *Analyzing Media Messages: Using Quantitative Content Analysis in Research*. 3rd ed. New York: Routledge.

Riggins, Stephen Harold, ed. 1992. *Ethnic Minority Media: An International Perspective*. Newbury Park, CA: Sage.

Rogers, Everett M. 2003. *The Diffusion of Innovations*. 5th ed. New York: Free Press.

Rosenthal, Nicolas G. 2018. "Rewriting the Narrative: American Indian Artists in California, 1960s–1980s." *Western Historical Quarterly* 49, no. 4 (Winter): 409–36.

Roshco, Bernard. 1967. "What the Black Press Said Last Summer." *Columbia Journalism Review* 6, no. 3: 4–9.

Ruffins, Faith Davis. 1997. "Culture Wars Won and Lost: Ethnic Museums on the Mall, Part I: The National Holocaust Museum and the National Museum of the American Indian." *Radical History Review* 68 (Spring): 79–100.

Ruffins, Faith Davis. 1998. "Culture Wars Won and Lost, Part II: The National African-American Museum Project." *Radical History Review* 70 (Winter): 78–101.

Rybalko, Svetlana, and Trent Seltzer. 2010. "Dialogic Communication in 140 Characters or Less: How Fortune 500 Companies Engage Stakeholders Using Twitter." *Public Relations Review* 36, no. 4 (November): 336–41.

Saffer, Adam J., Erich J. Sommerfeldt, and Maureen Taylor. 2013. "The Effects of Organizational Twitter Interactivity on Organization-Public Relationships." *Public Relations Review* 39, no. 3 (September): 213–15.

Said, Edward W. 2003. *Orientalism.* New York: Vintage Books.

Sallot, Lynne M., and Elizabeth A. Johnson. 2006. "To Contact . . . or Not? Investigating Journalists' Assessments of Public Relations Subsidies and Contact Preferences." *Public Relations Review* 32, no. 1 (March): 83–86.

Sandell, Richard. 2007. *Museums, Prejudice and the Reframing of Difference.* London: Routledge.

Schmitt, Bernd, and Alex Simonson. 1997. *Marketing Aesthetics: The Strategic Management of Brands, Identity, and Image.* New York: Free Press.

Schneeweis, Adina. 2015. "Communicating the Victim: Nongovernmental Organizations Advocacy Discourses for Roma Rights." *Communication, Culture, & Critique* 8, no. 2 (June): 235–53.

Searson, Eileen M., and Melissa A. Johnson. 2010. "Transparency Laws and Interactive Public Relations: An Analysis of Latin American Government Websites." *Public Relations Review* 36, no. 2 (June): 120–26.

Seletzky, Michal, and Sam Lehman-Wilzig. 2010. "Factors Underlying Organizations' Successful Press Release Publication in Newspapers: Additional PR Elements for the Evolving 'Press Agentry' and 'Public Information' Models." *International Journal of Strategic Communication* 4, no. 4: 244–66.

Servaes, Jan. 2016. "Guanxi in Intercultural Communication and Public Relations." *Public Relations Review* 42, no. 3 (September): 459–64.

Sha, Bey-Ling. 2006. "Cultural Identity in the Segmentation of Publics: An Emerging Theory of Intercultural Public Relations." *Journal of Public Relations Research* 18, no. 1: 45–65.

Smith, A. 2018. "Social Media Use in 2018." Washington, DC: Pew Research Center. March 1, 2018. http://www.pewinternet.org/2018/03/01/social-media-use-in-2018.

Smithsonian Institution. 1994. *Willful Neglect: The Smithsonian Institution and U.S. Latinos.* Washington, DC: Smithsonian Institution.

Springston, Jeffrey K., and Victoria L. Champion. 2004. "Public Relations and Cultural Aesthetics: Designing Health Brochures." *Public Relations Review* 30, no. 4 (Winter): 483–91.

Steiner, Harry, and Ken Haas. 1995. *Cross-Cultural Design: Communicating in the Global Marketplace.* London: Thames & Hudson.

Steuer, Jonathan. 1992. "Defining Virtual Reality: Dimensions Determining Telepresence." *Journal of Communication* 42, no. 4 (December): 73–93.

Straubaar, Joseph D. 2008. "Global, Hybrid, or Multiple? Cultural Identities in the Age of Satellite TV and the Internet." *Nordicom Review* 29, no. 2: 11–29.

Straughan, Dulcie. 2006. "'Lifting as We Climb': The Role of the National Association Notes in Furthering the Issues Agenda of the National Association of Colored Women, 1987–1920." *Media History Monographs* 8, no. 2: 1–19.

Stroman, Carolyn A. 1986. "Television Viewing and Self-Concept among Black Children." *Journal of Broadcasting & Electronic Media* 30, no. 1: 87–93.

Stylianou-Lambert, Theopisti, Nikolaos Boukas, and Marina Christodoulou-Yerali. 2014. "Museums and Cultural Sustainability: Stakeholders, Forces, and Cultural Policies." *International Journal of Cultural Policy* 20, no. 5: 566–87.

Subervi-Vélez, Federico A. 1986. "The Mass Media and Ethnic Assimilation and Pluralism: A Review and Research Proposal with Special Focus on Hispanics." *Communication Research* 13, no. 1 (January): 71–96.

Sze, Lena. 2010. "Chinatown Then and Neoliberal Now: Gentrification Consciousness and the Ethnic-Specific Museum." *Identities: Global Studies in Culture and Power* 17, no. 5: 510–29.

Tajfel, Henry, and John C. Turner. 1979. "The Social Identity Theory of Intergroup Behavior." In *The Social Psychology of Intergroup Relations*, edited by Austin G. William and Stephen Worchel, 7–24. Monterey, CA: Brooks/Cole.

Tamura, Eileen H. 2009. "Ethnic Museums in Hawai'i: Exhibits, Interpreters, and Reenactments." *Journal of American Ethnic History* 28, no. 3 (Spring): 66–73.

Tan, Alexis, Yuki Fujioka, and Gerdean Tan. 2000. "Television Use, Stereotypes of African Americans and Opinions on Affirmative Action: An Affective Model of Policy Reasoning." *Communication Monographs* 67, no. 4: 362–71.

Taylor, Maureen, and Michael L. Kent. 2014. "Dialogic Engagement: Clarifying Foundational Concepts." *Journal of Public Relations Research* 26, no. 5: 384–98.

Thackara, Tess. 2019. "Native Art, Women's Work." *New York Times*, June 2, 2019, 18–19.

Thomson, Kristin, Kristen Purcell, and Lee Rainie. 2013. "Arts Organizations and Digital Technologies." Washington, DC: Pew Research Center. January 4. https://www.pew internet.org/2013/01/04/arts-organizations-and-digital-technologies.

Tindall, Natalie T.J. 2009. "In Search of Career Satisfaction: African-American Public Relations Practitioners, Pigeonholing, and the Workplace." *Public Relations Review* 35, no. 4 (November): 443–45.

Toledano, Margalit, and Murray Riches. 2014. "Brand Alliance and Event Management for Social Causes: Evidence from New Zealand." *Public Relations Review* 40, no. 5 (December): 807–14.

Turk, Judy Van Slyke. 1985. "Information Subsidies and Influence." *Public Relations Review* 11, no. 3 (Autumn): 10–25.

Turner, John C., Penelope J. Oakes, S. Alexander Haslam, and Craig McGarty. 1994. "Self and Collective: Cognition and Social Context." *Personality and Social Psychology Bulletin* 20, no. 5 (October): 454–63.

US Census. 2018. "American Fact Finder: Hispanic or Latino by Type, 2010." https://factfinder .census.gov/faces/tableservices/jsf/pages/productview.xhtml?src=CF. Accessed August 10, 2018.

US Census Bureau. *American Fact Finder*. 2010. http://www.census.gov.

US General Services Administration. 2020. https://section508.gov.

Valentini, Chiara. 2007. "Global Versus Cultural Approaches in Public Relationship Management: The Case of the European Union." *Journal of Communication Management* 11, no. 2: 117–33.

Valentini, Chiara, Dean Kruckeberg, and Kenneth Starck. 2012. "Public Relations and Community: A Persistent Covenant." *Public Relations Review* 38, no. 5 (December): 873–79.

Vardeman-Winter, Jennifer. 2011. "Confronting Whiteness in Public Relations Campaigns and Research with Women." *Journal of Public Relations Research* 23, no. 4: 412–41.

Vargas, George. 2010. *Contemporary Chican@ Art: Color and Culture for a New America.* Austin: University of Texas Press.

Verboord, Marc, and Susanne Janssen. 2015. "Arts Journalism and Its Packaging in France, Germany, The Netherlands and the United States, 1955–2005." *Journalism Practice* 9, no. 6: 829–52.

Veresiu, Ela, and Markus Giesler. 2018. "Beyond Acculturation: Multiculturalism and the Institutional Shaping of an Ethnic Consumer Subject." *Journal of Consumer Research* 45, no. 3 (October): 553–70.

Wallace, Margot A. 2006. *Museum Branding: How to Create and Maintain Image, Loyalty, and Support.* Lanham, MD: Rowman & Littlefield.

Wallace, Margot A. 2010. *Consumer Research for Museum Marketers: Audience Insights Money Can't Buy.* Lanham, MD: AltaMira.

Watkins, Brandi A. 2017. "Experimenting with Dialogue on Twitter: An Examination of the Influence of the Dialogic Principles of Engagement, Interaction, and Attitude." *Public Relations Review* 43, no. 1 (March): 163–71.

Watson, Steven. 1995. *The Harlem Renaissance: Hub of African-American Culture, 1920–1930.* New York: Pantheon Books.

Watson, Tom. 2012. "The Evolution of Public Relations Measurement and Evaluation." *Public Relations Review* 38, no. 3 (September): 390–98.

Watson, Tom. 2014. "IPRA Code of Athens—The First International Code of Public Relations Ethics: Its Development and Implementation Since 1965." *Public Relations Review* 40, no. 4 (November): 707–14.

Waymer, Damion. 2012. *Culture, Social Class and Race in Public Relations: Perspectives and Applications.* Lanham, MD: Lexington Books.

Westermann, Mariet, Roger Schonfeld, and Liam Sweeney. 2019. "Art Museum Staff Demographic Survey 2018." New York: Andrew W. Mellon Foundation.

Wolf, Katharina. 2016. "Diversity in Australian Public Relations: An Exploration of Practitioner Perspectives." *Asia Pacific Public Relations Journal* 17, no. 2: 62–77.

Wolseley, Roland E. 1971. *The Black Press, USA.* Ames: Iowa State University.

Würtz, Elizabeth. 2006. "Intercultural Communication on Web Sites: A Cross-Cultural Analysis of Web Sites from High-Context Cultures and Low-Context Cultures." *Journal of Computer-Mediated Communication* 11, no. 1 (November): 274–99.

Yavuz, Nilay, and Eric W. Welch. 2014. "Factors Affecting Openness of Local Government Websites: Examining the Differences across Planning, Finance, and Police Departments." *Government Information Quarterly* 31, no. 4: 574–83.

Yeon, Hye Min, Youjin Choi, and Spiro Kiousis. 2005. "Interactive Communication Features on Nonprofit Organizations' Webpages for the Practice of Excellence in Public Relations." *Journal of Website Promotion* 1, no. 4: 61–83.

Zaharna, R. S. 2000. "Intercultural Communication and International Public Relations: Exploring Parallels." *Communication Quarterly* 48, no. 1: 85–100.

Zaharna, R. S. 2001. "'In-Awareness' Approach to International Public Relations." *Public Relations Review* 27, no. 2 (Summer): 135–48.

Zerfass, Ansgar, Dejan Verčič, and Markus Wiesenberg. 2016. "The Dawn of a New Golden Age for Media Relations? How PR Professionals Interact with the Mass Media and Use New Collaboration Practices." *Public Relations Review* 42, no. 4 (November): 499–508.

Zoch, Lynn M., and Juan-Carlos Molleda. 2006. "Building a Theoretical Model of Media Relations Using Framing, Information Subsidies, and Agenda-Building." In *Public Relations Theory II*, edited Carl H. Botan and Vincent Hazleton, 279–309. Mahwah, NJ: Lawrence Erlbaum.

Zulu, Itibari M. 2014. "The African American Museum and Library at Oakland: An Interview with Curator and Director Rick Moss." *Journal of Pan African Studies* 7, no. 3: 245–53.

Zyglidopoulos, Stelios, Pavlos C. Symeou, Philemon Bantimaroudis, and Eleni Kampanellou. 2012. "Cultural Agenda Setting: Media Attributes and Public Attention of Greek Museums." *Communication Research* 39, no. 4: 480–98.

INDEX

Page references in *italics* refer to figures and tables.

MELISSA A. JOHNSON is a professor in the Department of Communication at North Carolina State University. She holds a doctorate from the School of Media and Journalism at the University of North Carolina–Chapel Hill, an MBA from National University in San Diego, and a BA in communication from Simmons University in Boston. Prior to joining NC State, she taught at UNC–Chapel Hill, San Diego State University, and Elon University.

Dr. Johnson is a past president of the San Diego Press Club and the Publicity Club of San Diego and a former board member of the North Carolina Public Relations Society of America chapter. Along with her academic work, she has more than a dozen years of communication practitioner experience. Dr. Johnson serves on the editorial boards of the *Journal of Public Relations Research*, the *Howard Journal of Communications*, and the *International Journal of Hispanic Media*.